CW00758578

THE LOST
BEATLES
PHOTOGRAPHS

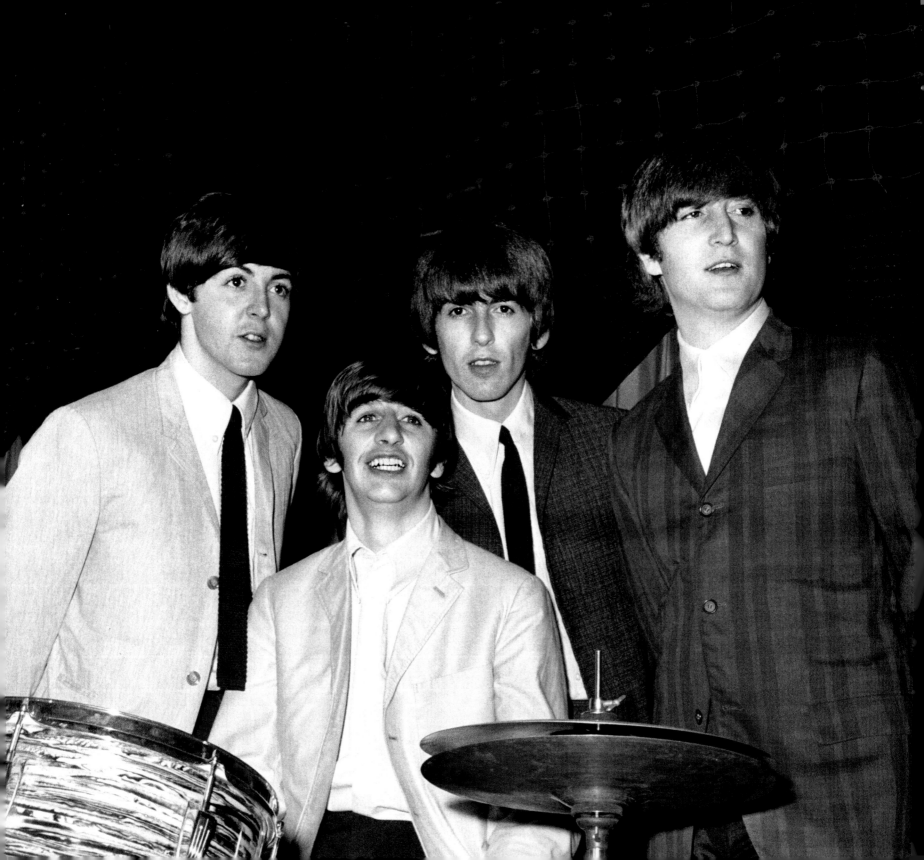

THE LOST BEATLES PHOTOGRAPHS

THE BOB BONIS ARCHIVE, 1964–1966

BY **LARRY MARION**

FOREWORD BY **LARRY KANE**

PHOTOGRAPHS BY **BOB BONIS**

itbooks

AN IMPRINT OF HARPERCOLLINS PUBLISHERS

For more information about these photographs and
The Beatles' gear, go to www.NFAgallery.com.

With painstaking effort and research we have identified the dates and locations of all of the photographs to the best of our ability. If you have more or different information about any of the photographs, we would appreciate hearing from you. We can be reached at info@NFAgallery.com and we will endeavor to make appropriate corrections in future editions of this book.

ALSO BY LARRY MARION:
The Lost Rolling Stones Photographs: The Bob Bonis Archive, 1964–1966

DESIGNED BY PAULA RUSSELL SZAFRANSKI

Library of Congress Cataloging-in-Publication Data has been applied for.

ISBN 978-0-06-196078-9

12 13 14 15 OV/QGF 10 9 8 7 6 5 4

ALTHOUGH I WAS not born until years after these photographs were taken, I grew up with them around my home. A few of them seemed to be permanent fixtures on the walls of my house, while others rotated as my father would swap them for different ones from time to time, depending on his mood. But my dad never moved the one of George Harrison tuning his Epiphone Casino backstage at a 1966 show in Philadelphia. It always stayed in the same place in his office. To me these pictures were just shots that my dad took, which hung next to family photographs.

Dad had a deep love for photography and his camera was always within reach. He had a natural eye and an innate talent for capturing a moment and composing a picture.

He was very fortunate to be in the right place at the right time, and now we can all benefit from his talent for capturing the excitement of all three of The Beatles' U.S. tours.

I hope you enjoy these photographs and take pleasure in the memories and excitement he captured that have remained hidden and unpublished until now.

It is with great pride that I dedicate *The Lost Beatles Photographs: The Bob Bonis Archive, 1964–1966* to my father, who introduced me to the British Invasion, and to my mother, Phyllis, who was the primary rocker of the family.

Alex Bonis
March 2011

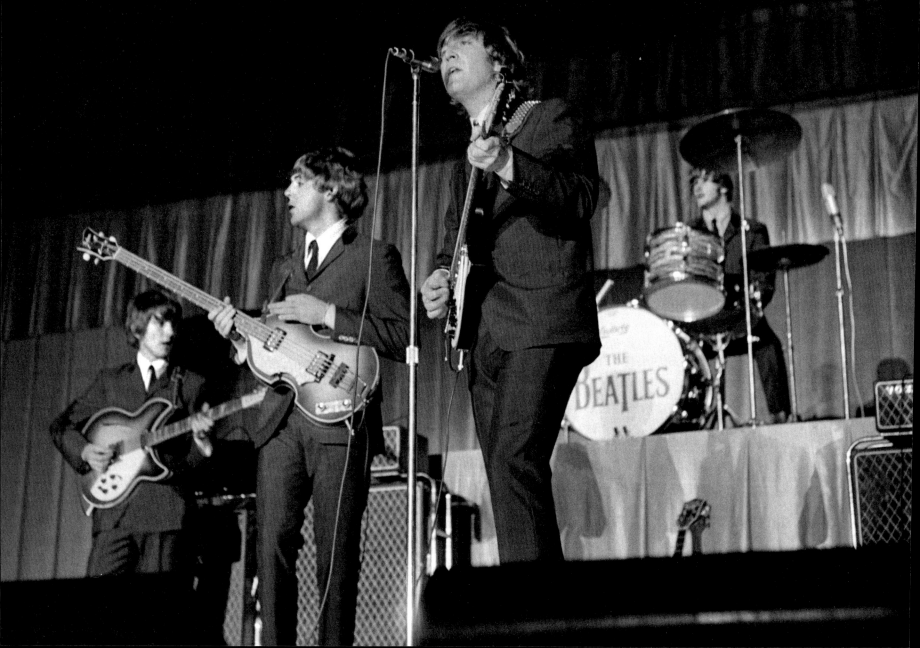

CONTENTS

PREFACE ix

FOREWORD BY LARRY KANE xi

ABOUT THE PHOTOGRAPHS xii

BOB BONIS xiii

INTERVIEW WITH GARY JAMES xx

SEATTLE TACOMA AIRPORT, WASHINGTON—AUGUST 22, 1964 xxii

BEL AIR, LOS ANGELES, CALIFORNIA—AUGUST 23–25, 1964 4

MAPLE LEAF GARDENS PRESS CONFERENCE, TORONTO, CANADA—SEPTEMBER 7, 1964 16

KANSAS CITY, MISSOURI—SEPTEMBER 17, 1964 20

HOUSTON, TEXAS—AUGUST 19, 1965 34

BLOOMINGTON, MINNESOTA—AUGUST 21, 1965 44

PORTLAND, OREGON—AUGUST 22, 1965 58

EN ROUTE TO COW PALACE, SAN FRANCISCO, CALIFORNIA—AUGUST 30, 1965 66

DETROIT, MICHIGAN—AUGUST 13, 1966 70

PHILADELPHIA, PENNSYLVANIA—AUGUST 16, 1966 96

MEMPHIS, TENNESSEE—AUGUST 19, 1966 112

CINCINNATI, OHIO—AUGUST 21, 1966 124

ST. LOUIS, MISSOURI—AUGUST 21, 1966 146

APPENDIX: THE BEATLES' U.S. TOUR DATES 167

ACKNOWLEDGMENTS 169

This book would not have been possible without and is also dedicated to:

John Lennon,

Paul McCartney,

George Harrison,

Ringo Starr,

Brian Epstein,

Mal Evans

PREFACE

BOB BONIS is a name that might escape even the most hard-core Beatles or Rolling Stones fans. Although he held significant positions in both of these bands' histories, he preferred to remain anonymous throughout his life. From 1964 through 1966—spanning all three of The Beatles' U.S./North American tours, and The Rolling Stones' first five U.S./North American tours—Bob served as tour manager for the two most important bands in the history of rock 'n' roll.

An avid photographer, Bob always traveled with his Leica M3 camera, taking beautiful and intimate photographs of the people and the places he encountered. While working with The Beatles, The Stones, and several other musicians in the rock, pop, and jazz fields, he had the opportunity to exercise his passion for photography. Thus he took more than five thousand candid photographs of the bands and musicians with whom he worked. During his lifetime he allowed only a handful of these images to be published, in teen magazines.

On the twentieth anniversary of The Beatles' arrival in America, Bob granted a few interviews with regional newspapers. When friends would drop by his home, he would often pull out some of these photos, proud to show the images he had captured with these bands. He consistently rebuffed offers to publish the photos or to write his memoirs, feeling that it was a privilege to have had such an experience. Bob did not want to appear to capitalize on his good fortune, or to exploit the relationship that he had with these iconic acts.

Bob passed away in 1992. Fifteen years later, his son, Alex, decided it was time for other people to enjoy the memorabilia and photographs his father had saved. Through his pursuit to find the best means to achieve this feat, he eventually met me, Larry Marion. At the time I was working with several auction houses as a specialist in rock and music memorabilia. The items that Bob had saved (some are pictured in this book) were sold at auction sometime later. The slides, negatives, and their copyrights were acquired by a company dedicated to honor Bob's life, his career, and his extraordinary talent with the camera. Alex and I are two of the founding partners of this company, 2269 Productions, Inc. Not Fade Away Gallery (NFAgallery.com) was created in New York City to release, show, and exclusively represent these phenomenal images, and to make prints available for fans and collectors around the world.

We are proud to present the photographic legacy of Bob Bonis in this special volume, The Lost Beatles Photographs: The Bob Bonis Archive, 1964–1966. We hope you enjoy these rare and wonderful images that are presented here, most for the first time since they were captured on film more than forty years ago.

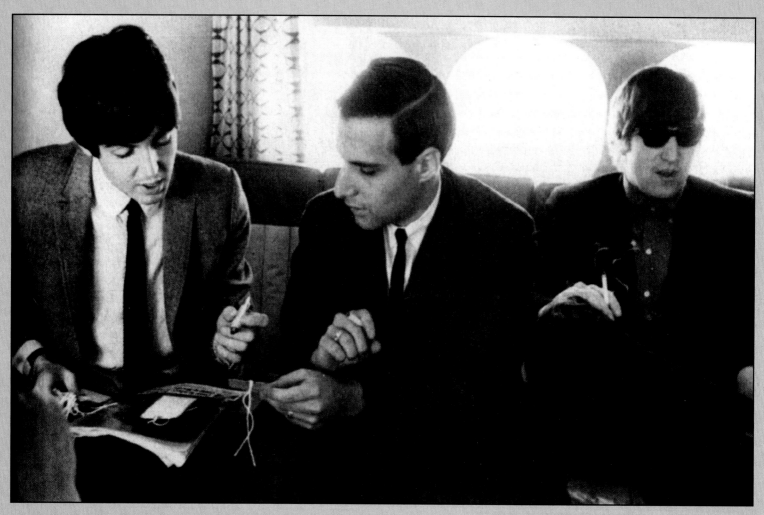

Paul McCartney, Larry Kane, and John Lennon on the chartered plane for the 1964 U.S. tour.

FOREWORD BY LARRY KANE

Bob and the Boys

Through a career of fifty years as a broadcast journalist, I witnessed firsthand many "managers." Some of them could be described as political handlers, others the men and women in charge of major undertakings, still others serving as efficient advance operators who handled security for presidents and the like. They were all, for the most part, efficient and stressed.

The "coolest" road manager I ever met was Bob Bonis. Bob was a good-looking and quietly personable man who managed The Beatles' history-making American tours from 1964 through 1966. I covered the 1964 and 1965 versions, and shared the planes and the hotels and the cars with Bob and the "boys," as The Beatles were called by their inside circle.

Bob was very necessary to manager Brian Epstein and the boys. He knew the pitfalls and opportunities of American touring, thanks to his experience with The Rolling Stones. He was aware that security for John, Paul, George, and Ringo was not adequate. He'd give everyone advance warning, but few listened. The result was chaos in almost every city. It was fantastic news fodder for me, but it was extremely dangerous. Bob was also the man who coordinated almost everything in every city. In the process, this man, about ten years older than The Beatles, grew to really love them as people and performers. They returned the favor.

It was difficult to be easily respected by The Beatles. They were busy and in a constant state of high anxiety. They had never seen such crowds before and had not even come close in their British experience to the mass hysteria that followed them. Bob gave them a sense of assurance and, like me, treated them as individuals rather than superstars. Their friendship grew quickly, and Bob, not especially a fan of rock 'n' roll, soon became a fan of The Beatles'

music. In fact, after an early concert on the 1964 tour, when chaos broke out in Vancouver, Bob was amazed at the energy in the air: "These guys are amazing. They are electric. I mean look at those girls. I think the girls want them if you know what I mean, but what makes it so unstoppable . . . is the music. Ya mix the music with the men, and what have you got? Hysteria."

At a later date, he offered his assessment of the boys, not as performers, but as people: "I've never met a more together band. They are really nice guys, and considering the adulation . . . they are handling it real well."

Bob also had a different perspective in preserving history from me. Most of us on those tours never really sensed the history we were living. For example, I brought an Instamatic camera. Bob had much more intuition than I did. He brought along a fine camera and took a lot of pictures, many of them some of the best in capturing the mood and adventure and even the strain of the touring foursome, which would become the greatest musical team of all time.

These images get as close to the "fabs" as you will ever get. When the galleys were sent to me, they brought so many flashbacks of the men, the music, and the people we traveled with.

Bob Bonis was one of them, and he has left behind a photo history that is invaluable. He had a total access pass to the greatest show on earth. I know. I was right there with him. This is a book for the ages, all of them!

Enjoy.

Larry Kane

PHILADELPHIA, 2011

Larry Kane is a veteran broadcast anchor and the author of Ticket to Ride *and* Lennon Revealed. *He was the only American journalist who traveled with The Beatles to every stop on the 1964 and 1965 tours.*

ABOUT THE PHOTOGRAPHS

ALTHOUGH BOB Bonis was not a professional photographer, his natural talent, his innate sense of composition, and the love he felt for his subjects shine through in his images. Bob's job as U.S. tour manager for all three of The Beatles' U.S. tours, between 1964 and 1966, kept him extremely busy, especially as Beatlemania was in full bloom. He brought his Leica M3 camera (and mostly Kodak Tri-X and Ektachrome film) along for his personal enjoyment, though he only had time to capture sporadic concerts and events. He was not trying to document the experience or record history—though he did shoot almost nine hundred photographs of John, Paul, George, and Ringo—but rather exercise his passion to take beautiful photographs, and as you will see in the pages that follow, he succeeded.

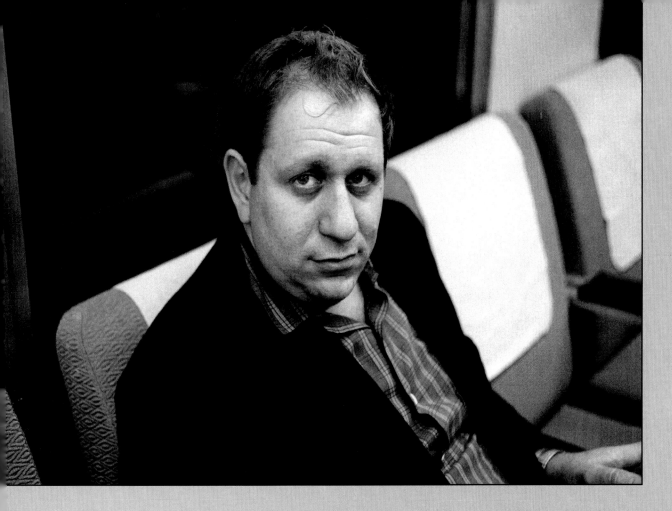

BOB BONIS

BOB BONIS (December 26, 1932–July 6, 1992) began his career in the music business in the late 1950s as a talent agent at Music Corporation of America (MCA) in New York City. He would go on to hold an extraordinary position at a pivotal time in rock history, as U.S. tour manager for all three of The Beatles' U.S. tours, as well as The Rolling Stones' first five U.S. tours in 1964, 1965, and continuing through 1966. His personal passion was photography, and he was a talented amateur. His Leica M3 camera went everywhere with him, and he documented the people he met and the places he visited. Bob captured the extraordinary, unguarded photographs that are published here for the very first time.

The combination of a gifted eye for composition and unequaled access to some of the most significant performers of the twentieth century yielded a truly remarkable archive that includes intimate and iconic images of both The Beatles and The Rolling Stones, never before published or seen by the public. In addition to more than 3,500 photos of The Beatles and The Stones, Bob photographed Simon & Garfunkel, The Hollies, Cream (recording in the studio), The Lovin' Spoonful, Buddy Rich, Frank Sinatra, and many of the jazz greats with whom he worked over the years.

The Bob Bonis Archive offers thousands of candid photos of The Beatles and The Stones in concert, backstage, rehearsing, tuning up, waiting to go on, clowning around, dressing and relaxing, on vacations, en route to shows or cities, getting their hair cut, bowling, recording in the studio, at press events, and just hanging

around being themselves. The unguarded nature of these images reflects Bob's close friendships with the bands and offers a private, behind-the-scenes look into the early days of the British Invasion era of rock 'n' roll.

When MCA dissolved the talent agency, Bob started a jazz management firm working with a variety of jazz and big band performers including Benny Goodman, Count Basie, Harry Belafonte, Gerry Mulligan, and others. Standing six foot one and weighing more than two hundred pounds, Bob cut an intimidating figure, and earned a reputation for being able to deal with the wise guys that ran a lot of the jazz clubs.

Because of this ability, he was tapped to serve as The Rolling Stones' tour manager for their first-ever U.S. tour. Interviewed for a mid-1980s radio special *The Rolling Stones: Past and Present*, Bob explained, "A friend of mine, Norman Weiss, asked me to take care of these wise guys that are coming in from England as a special favor because I had a reputation for really taking care of troublemakers. Boy what a horrible reputation they had . . . I said, 'Well come on,' you know, I had my own management firm and I really wasn't that interested in going on the road anymore. I had done that before. And Norman said, 'Really, you have to, really they're great,' and he pulls out this article from the [*Melody Maker*]. It was 'Would You Let Your Sister Marry a Rolling Stone?' or whatever, and I said, 'That's a great sales pitch, thanks.' Anyway,

I finally went with them and of course they were not in the least a problem. Terrible for their image, I know, but they were really great."

Bob did a fantastic job of getting The Stones where they needed to be on time—quite a feat considering that the "bad boys" of the British Invasion worked hard to cultivate their reputation for trouble. His personal experience with them was quite the opposite, and they developed a great friendship that lasted long after his role as their tour manager ended. His success with The Stones led the band's management in England to recommend him to Brian Epstein for the same role with The Beatles, a job he would hold for all three of their U.S. tours.

A private man, Bob never sought publicity and had no aspirations to publish his photos or to write a book about his experiences with the two greatest, most important bands in the history of rock 'n' roll. He never participated in the fan culture or went to any of the conventions. He allowed only a handful of his photographs to be published in teen magazines in the sixties, but after that, he wasn't interested in pursuing attention based on his past exploits. For over forty years, the negatives and slides have been safely stored away, unknown to anyone but his wife, son, and friends. Most of the photographs in this book are being published here for the very first time.

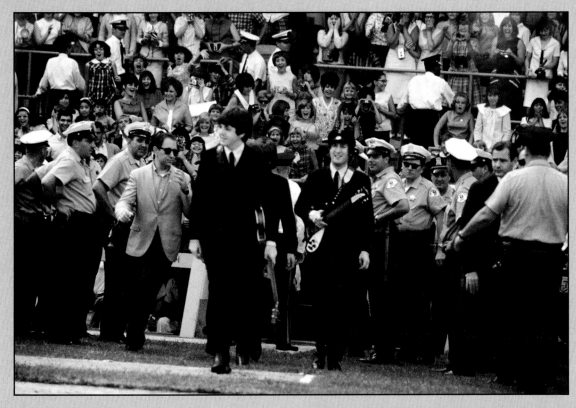

Bob Bonis escorts The Beatles onto the field to take the stage at Comiskey Park, Chicago, Illinois, August 20, 1965.

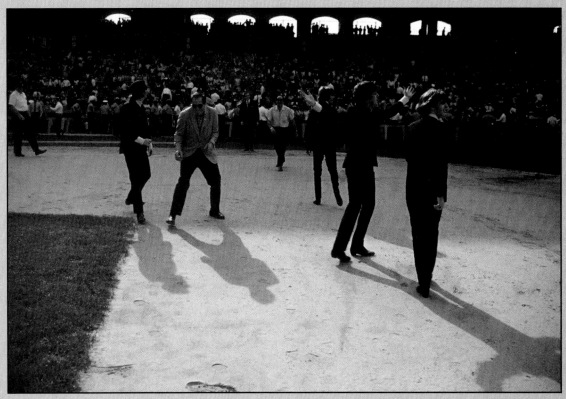

Bob does a jig as The Beatles greet their fans on the baseball diamond at Comiskey Park.

OFFICIAL BEATLES PARTY

IDENTIFICATION PASS

ISSUED TO

Bob Bonis

VALID THROUGHOUT TOUR, AUGUST 1965

Ed Leffler　　GAC

AUTHORIZED SIGNATURE　　NEMS/GAC

Bob Bonis's 1965 tour identification card.

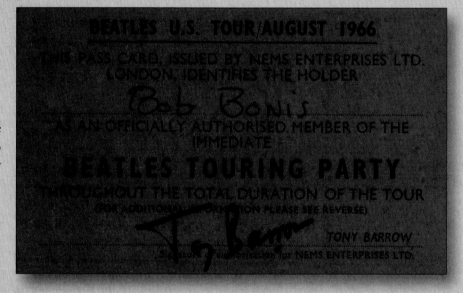

Bob's 1966 tour pass. The rarest of tour passes, only five red passes were ever issued, to Bob Bonis, Brian Epstein, Tony Barrow, Mal Evans, and Neil Aspinall.

BEATLES U.S. TOUR/AUGUST 1966

THIS PASS CARD, ISSUED BY NEMS ENTERPRISES LTD. LONDON, IDENTIFIES THE HOLDER

Bob Bonis

AS AN OFFICIALLY AUTHORISED MEMBER OF THE IMMEDIATE

BEATLES TOURING PARTY

THROUGHOUT THE TOTAL DURATION OF THE TOUR

(FOR ADDITIONAL INFORMATION PLEASE SEE REVERSE)

TONY BARROW

Signature authorisation for NEMS ENTERPRISES LTD.

Tony Barrow
Press and Public Relations

NEMS ENTERPRISES LTD.
Sutherland House,
5/6 Argyll Street,
London, W.1.　　*Regent 3261.*

Tony Barrow was The Beatles' informal part-time press and publicity consultant from October 1962 through May 1963 while he worked for Decca Records. Brian Epstein then hired him as the full-time head of press and public relations for NEMS Enterprises, where he opened Epstein's London office. He is credited with coining the phrase "The Fab Four," using it in an early press release, and he suggested that The Beatles put out Christmas messages to their fan clubs. He toured with The Beatles in 1965 and 1966, arranging and conducting their daily press conferences.

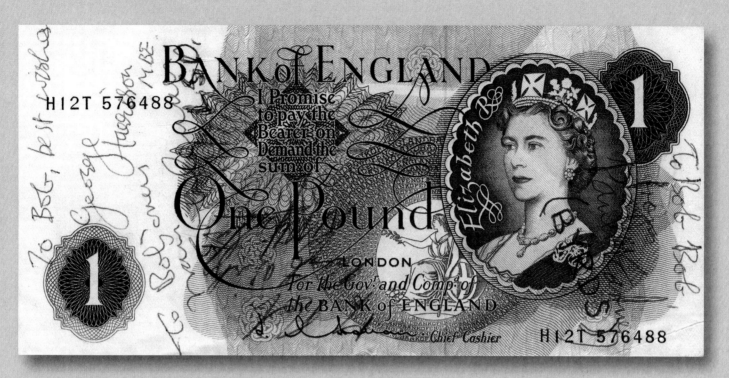

A pound note signed by The Beatles to Bob Bonis. Indicative of their fondness for Bob and their well-known sense of humor, George signed "To Bob, Best Wishes, George Harrison, MBE"; John Lennon's nickname for Bob Bonis was "Boners," so he signed "To Bob'oners, from John Lennon, LSD"; Paul then signed it "To Bob Bob, from Paul McCartney (BYRDS)"; and Ringo signed "To Bob, Best Wishes, Ringo Starr."

A thank-you note card, handwritten by George Harrison to Bob Bonis.

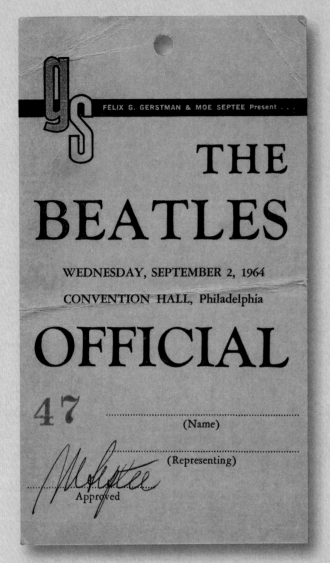

A pass to an unidentified press conference.

A badge issued by a Holiday Inn on the 1964 or 1965 tour to identify Bob as an official member of The Beatles' touring party.

This "official" pass to The Beatles' September 2, 1964, concert at Philadelphia's Convention Hall was issued by the concert's promoters, Felix Gerstman and Moe Septee of GS Promotions. Local promoters' credentials such as these didn't necessarily give the recipient access to meet The Beatles or to attend the press conference. That access could only be granted with the required NEMS and GAC credentials. The Beatles' visit to Philly lasted barely five hours, having made the trip from the previous stop in Atlantic City inside a fish truck to escape the fans who had surrounded their hotel. Once safely out of town, they were transferred to a bus and driven directly to Convention Hall.

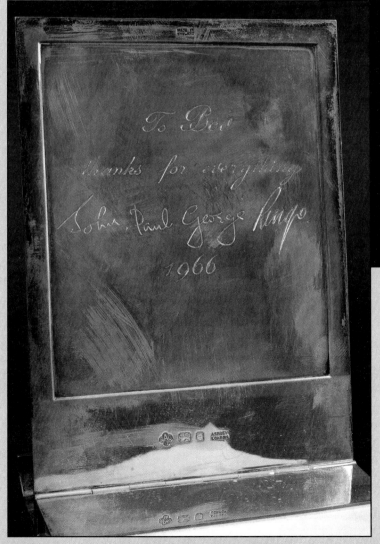

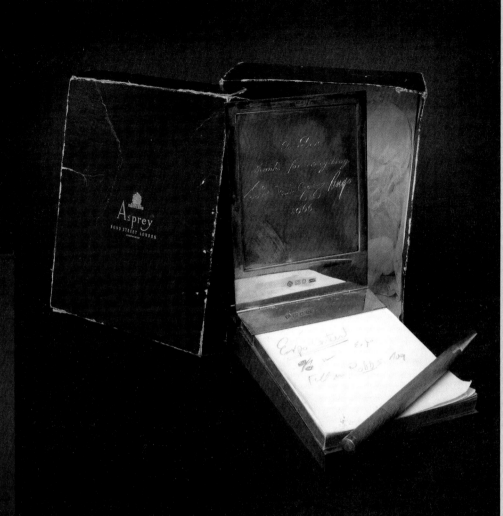

At the end of their third and final tour of the United States, The Beatles, knowing this was their last tour, presented Bob Bonis with an Asprey London silver-plated desk set inscribed on the inside cover with their facsimile signatures. It reads:

To Bob

Thanks for everything

John Paul George Ringo

1966

INTERVIEW WITH GARY JAMES

Gary James has interviewed over 1,300 entertainment personalities since 1978. Gary interviewed Bob Bonis in 1989, and here, with his kind permission, is an excerpt of that interview.

Q—We know you did the '64 tour, but how many tours and how many years were you associated with The Beatles?

Bonis—'64, '65, '66. Only the American tours. The Stones were the ones I went to Europe with. The Stones had first crack at me. According to the press, The Stones and Beatles were supposed to be bitter enemies, whereas they were quite friendly. They made sure that they never toured roughly at the same time, or if they did, they were continents apart.

Q—Who in The Beatles' organization recommended you to Brian Epstein?

Bonis—Well, it was partially The Stones. The Stones had just won the *Melody Maker* poll for the Best New Group in England. The Beatles won the Best in World category because The Beatles had been formed a couple of years earlier. I took The Stones on their first American tour, which was June of '64, before the big Beatles tour. They sent a *Melody Maker* reporter with us for two weeks . . . The Stones had a terrible reputation, which they worked very hard to get. They were no problem at all actually. The point was, if The Beatles were the goody two-shoes, The Stones were like the horrible kids. They went out of their way to make sure that's the reputation they got, as did their manager, publicist Andy Oldham. So, in other words, the guy from *Melody Maker* was sending back reports saying, "You're not going to believe this, but there's a guy named Mike Douglas in Cleveland who has a show in the morning, and this guy Bob Bonis has 'em down there at 7 A.M. on time." Or, this guy Bob Bonis did such and such. [The Stones] were really great. They were no problem. The point is, all we had to do was go over what the agency wanted, what their management wanted, and if there was something they were really dead set against, we didn't do it. That's all. So, all of that stuff was going back to England, and so Brian [Epstein] saw some of that and called The Stones' management office, who gave me a hearty recommendation.

Q—How tough was it for a groupie to get past The Beatles' security?

Bonis—Almost impossible. In '65, and '66, we carried ex-FBI guys to stay by the elevator. Brian was super, super worried about their image. You couldn't get in, unless it was something like Seattle, where girls were hiding in the bathroom.

Q—What about the stories of orgies taking place on the tour, and hookers being brought back to the hotel rooms after the concerts?

Bonis—One disc jockey, thinking he'd do a favor, did bring a bunch back in Atlantic City, and The Beatles wouldn't touch them.

So what happened is, the press and the disc jockeys took care of the young ladies. Brian was super conscious of anything the press would love to grab, and it would be that of course.

Q—So what would The Beatles do after a concert, when they were back in their hotel rooms?

Bonis—In Atlantic City we saw a couple of movies, or we'd play cards. In Atlantic City I went out and got a Monopoly set. We'd play that for hours.

Q—Did The Beatles get on each other's nerves a lot? They were always so closely confined in their hotel rooms.

Bonis—No. It was surprising. They always had a suite. George and Ringo stayed together in one room, and John and Paul in the other bedroom, and a big, big room in between . . . I was shocked that everything went so well.

Q—Were you there when Elvis and The Beatles met each other?

Bonis—I was there in LA, yes, but I did not go. I mean it was just a very private situation. Malcolm [Evans] went, because oddly enough, he was an Elvis freak. But that was about it. There was no problem. I didn't have to go everywhere with them, especially in places like LA. I was the one who went with George to the Whisky a Go Go when we had that big scene.

Q—Why didn't The Beatles like disc jockey Murray the K?

Bonis—Because he kept calling himself the Fifth Beatle. That was the only thing. It got to them after a while. They kept reading about the Fifth Beatle and they knew how hard they worked to get there.

Q—Some of the questions asked of The Beatles at press conferences were absolutely ridiculous. They were beyond stupid.

Bonis—Those press conferences were fixed. Brian allowed roughly one or two press people on the plane that paid usually by the week . . . They didn't just come on, the way the press does now. He made them pay, I think, $1,000 a week. Those people got the stories. The press conferences were a total bore. Questions like, "Do you sleep in your pajamas?" and a lot of that junk . . . The plane people, or someone like myself, would scream from the back a prearranged question that would at least make it a little more interesting. And we'd wait for some kind of funny answer. The guys were unaware of what our questions were, but they knew they'd get some different questions from us, just to make it more interesting for them. Otherwise, they'd be bored to tears. Same questions, city after city.

Q—Were The Beatles as funny off-camera, as they were in *A Hard Day's Night*?

Bonis—Frankly, I found them even funnier. You know, they would do a show that would have me on the floor. They would do a whole Palladium show for you—Beatles at The Palladium, with the old-time comics and the songs . . . in the hotel suite with acoustic guitars. Never in the dressing room . . . with other people around. It was hilarious. It would've been classic if it had been filmed. They were all funny. Maybe John a little deeper and more biting than the others, but they were all funny—even Ringo and quiet George.

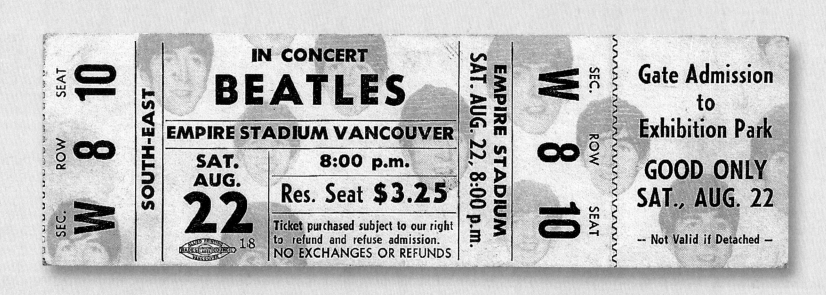

SEC. W ROW 8 SEAT 10

SOUTH-EAST

IN CONCERT
BEATLES

EMPIRE STADIUM VANCOUVER

SAT. AUG. **22**

18

8:00 p.m.

Res. Seat **$3.25**

Ticket purchased subject to our right to refund and refuse admission. NO EXCHANGES OR REFUNDS

EMPIRE STADIUM SAT. AUG. 22, 8:00 p.m.

SEC. W ROW 8 SEAT 10

Gate Admission to Exhibition Park

GOOD ONLY SAT., AUG. 22

-- Not Valid if Detached --

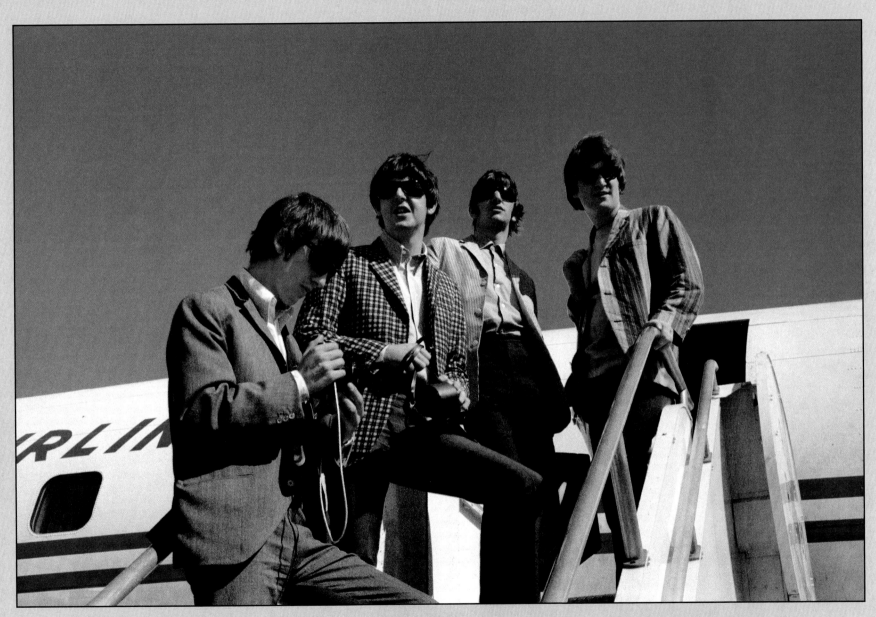

At Seattle Tacoma Airport, The Beatles boarded their chartered American Flyer Airlines Lockheed Electra plane bound for Vancouver, British Columbia, to give their first-ever Canadian concert, at the Empire Stadium, on August 22, 1964. It would be the fourth show on their first U.S. tour.

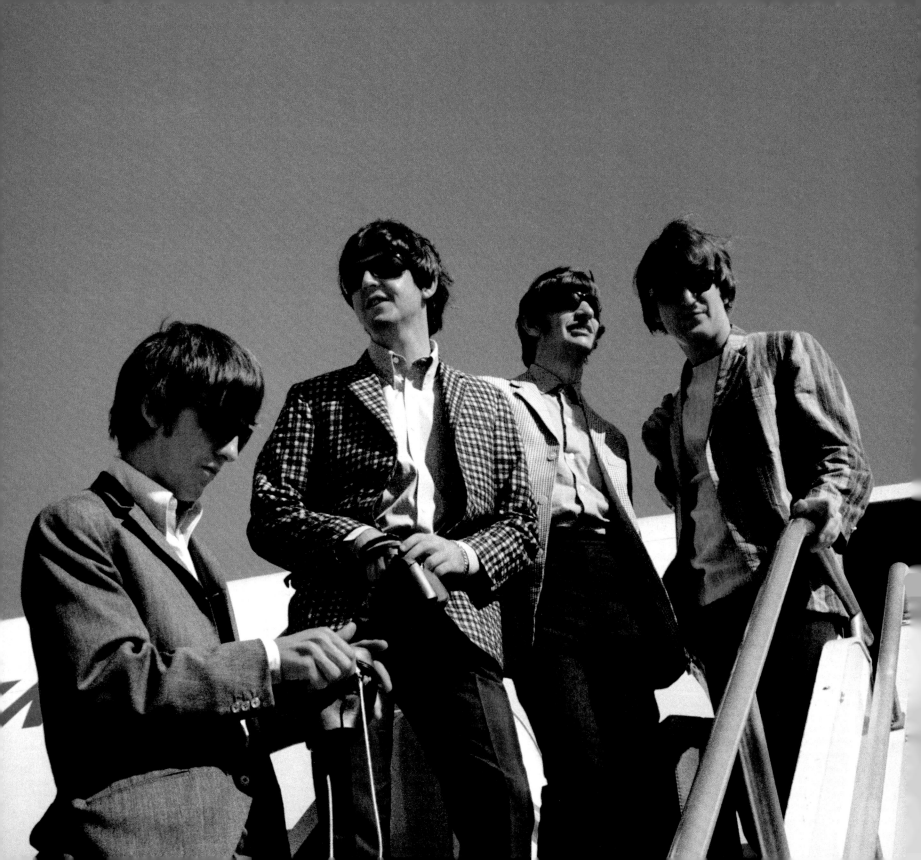

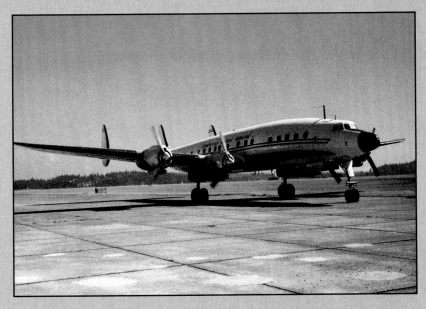

The Lockheed Electra that was chartered for The Beatles' 1964 U.S. tour.

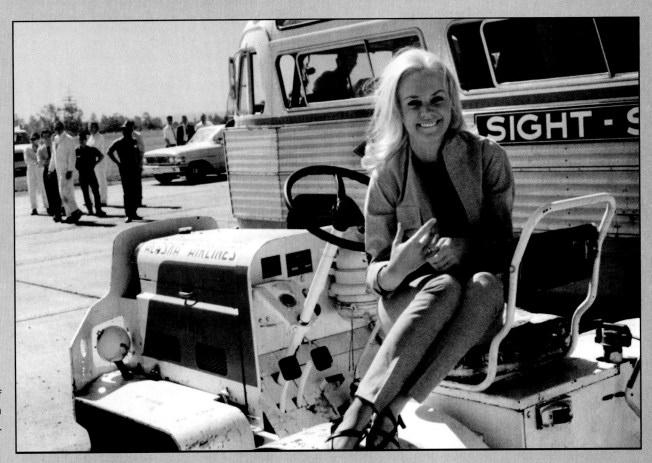

Jackie DeShannon, one of the opening acts on The Beatles' 1964 tour.

BEL AIR, LOS ANGELES, CALIFORNIA

356 St. Pierre Road, Brown Canyon

AUGUST 23–25, 1964

AFTER THE concert in Vancouver, The Beatles immediately went to the airport and flew to Los Angeles, arriving at 3:55 A.M. for their now-famous concert at the Hollywood Bowl on August 23 and a few days of R&R before flying to their next concert at Red Rocks in Colorado. Fearing a deluge of frenzied fans, the Ambassador Hotel canceled The Beatles' reservations and Lockheed Airport in Burbank refused to let their plane land. British actor Reginald Owen stepped in to save them by renting them his Bel Air mansion at $1,000 for four days. During their stay there, The Beatles were invited to the Whisky a Go Go club by Jane Mansfield. At the club they were ambushed by the press and an infamous incident occurred when an annoyed George Harrison threw a drink at one of the photographers but accidentally hit the actress and sex symbol Mamie Van Doren instead.

During this stay at Owen's home, Ringo played cowboy with a toy gun that was reportedly a gift from Elvis Presley. The Beatles also met Burt Lancaster. "I loved meeting Burt Lancaster," Ringo said in an interview. "He was great. The first time in LA, we'd rented a huge house and I turned into a cowboy. I had a poncho and two toy guns and was invited over to Burt Lancaster's, and that was how I went. I was all, 'Hold it up there now, Burt, this town ain't big enough for both of us,' and he said, 'What have you got there? Kids' stuff.' Later he sent me two real guns, and a real holster: he didn't like me playing with kids' guns. I just wanted to be a cowboy."

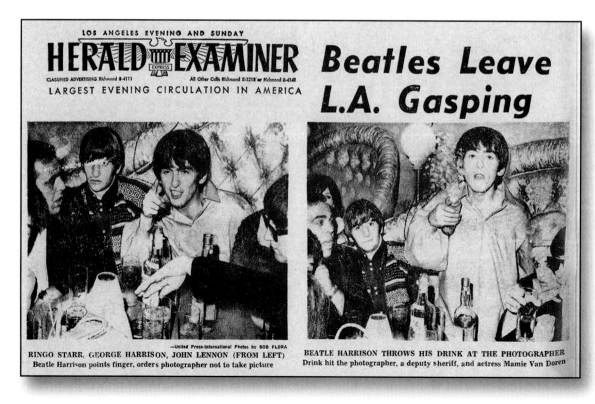

LOS ANGELES EVENING AND SUNDAY

HERALD EXAMINER

CLASSIFIED ADVERTISING Richmond 8-4111 All Other Calls Richmond 8-1212 or Richmond 8-4141

LARGEST EVENING CIRCULATION IN AMERICA

Beatles Leave L.A. Gasping

—United Press-International Photos by BOB FLORA
RINGO STARR, GEORGE HARRISON, JOHN LENNON (FROM LEFT)
Beatle Harrison points finger, orders photographer not to take picture

BEATLE HARRISON THROWS HIS DRINK AT THE PHOTOGRAPHER
Drink hit the photographer, a deputy sheriff, and actress Mamie Van Doren

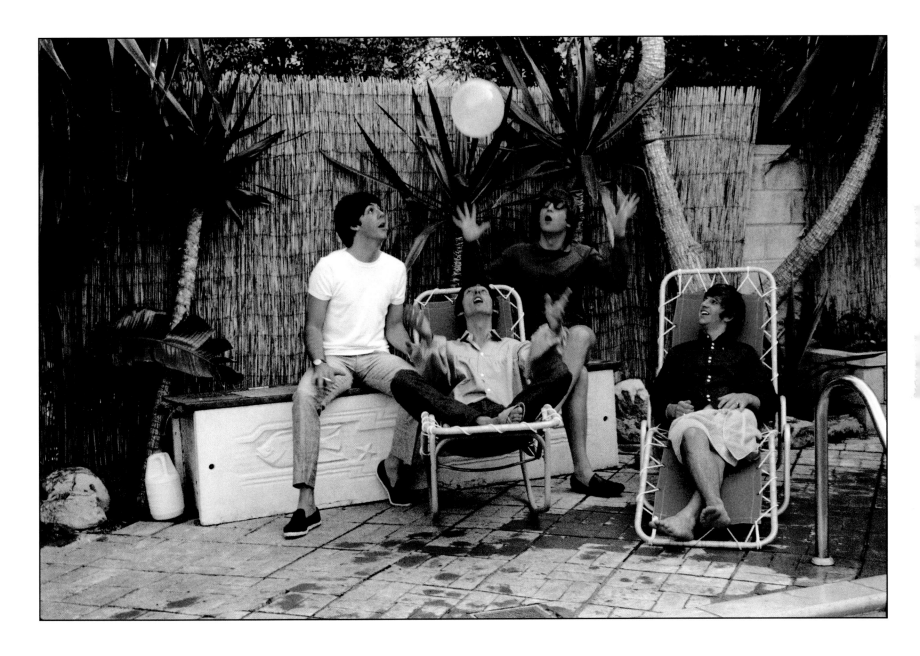

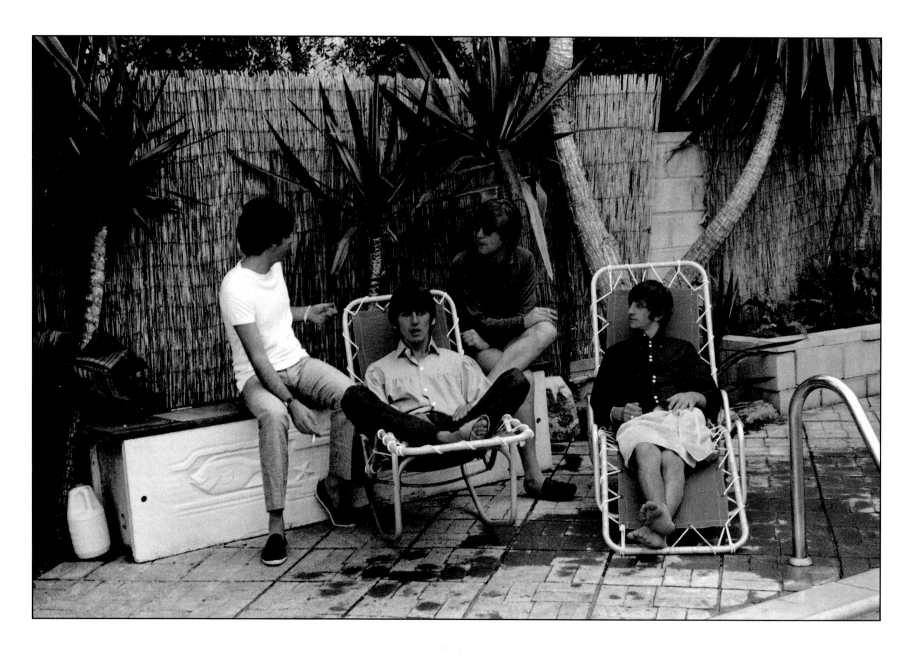

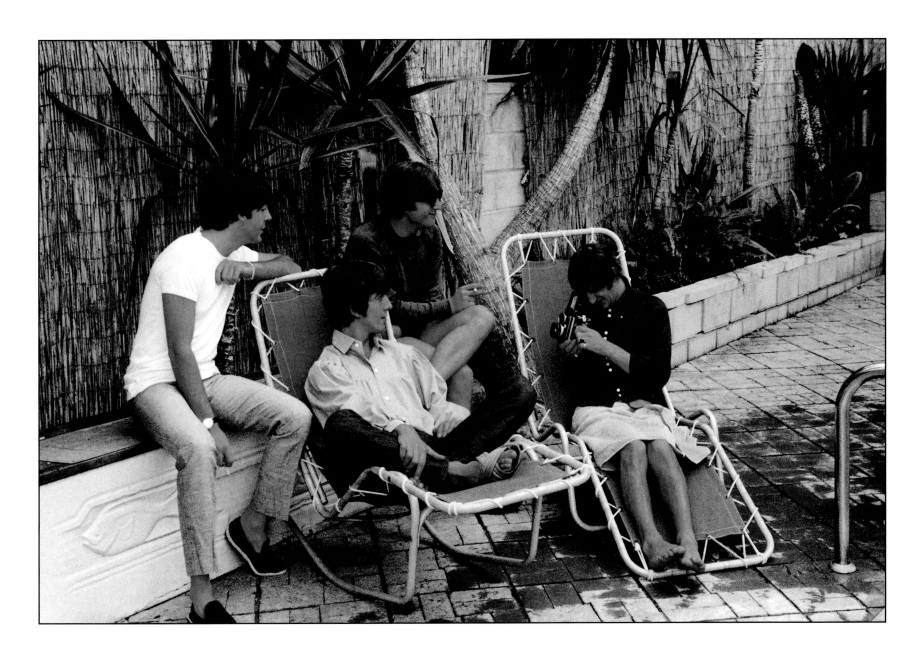

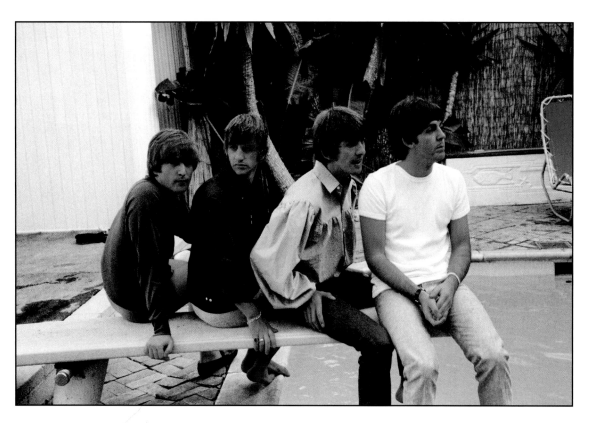
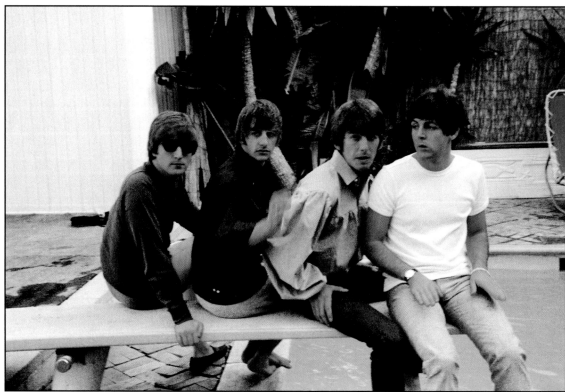

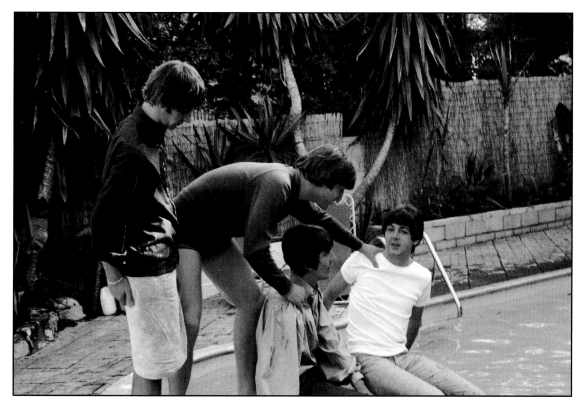

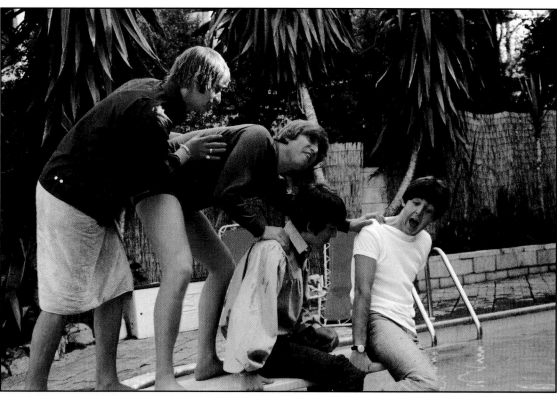

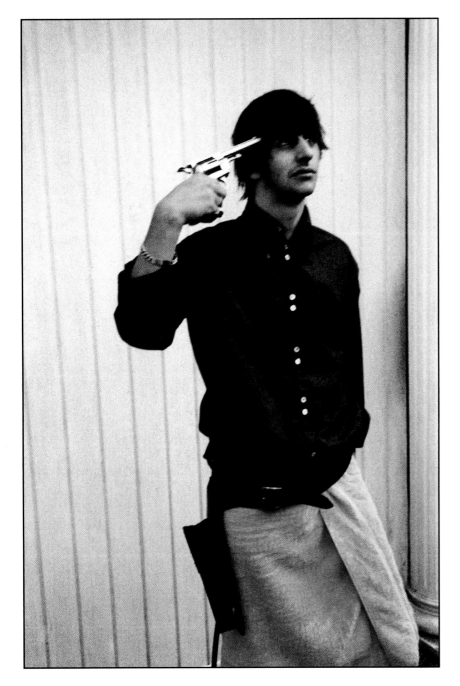
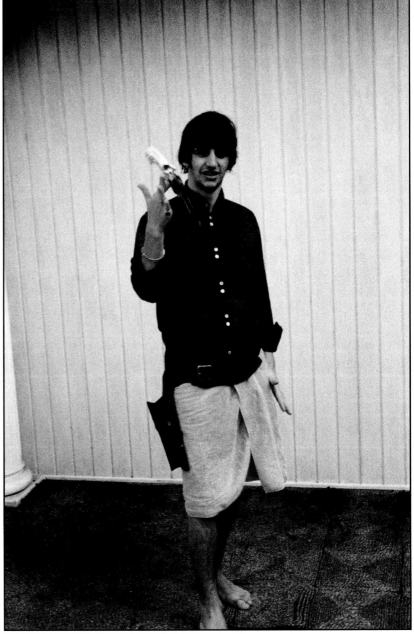

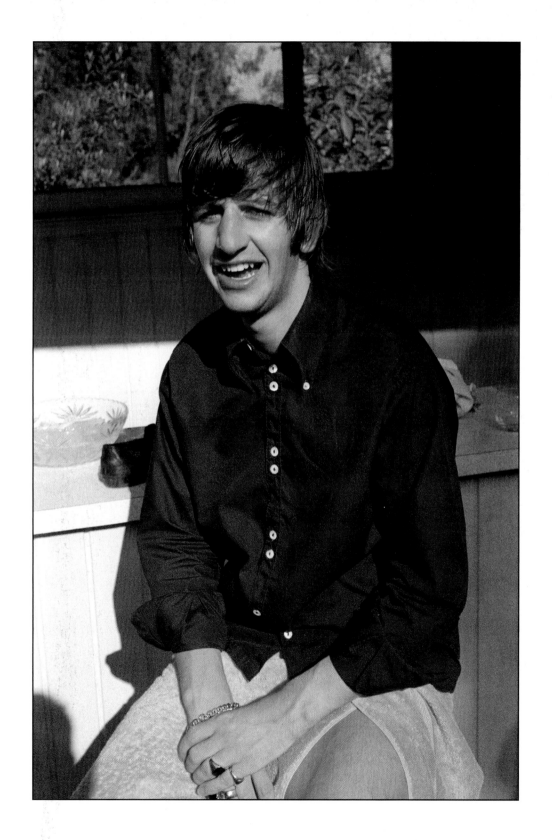

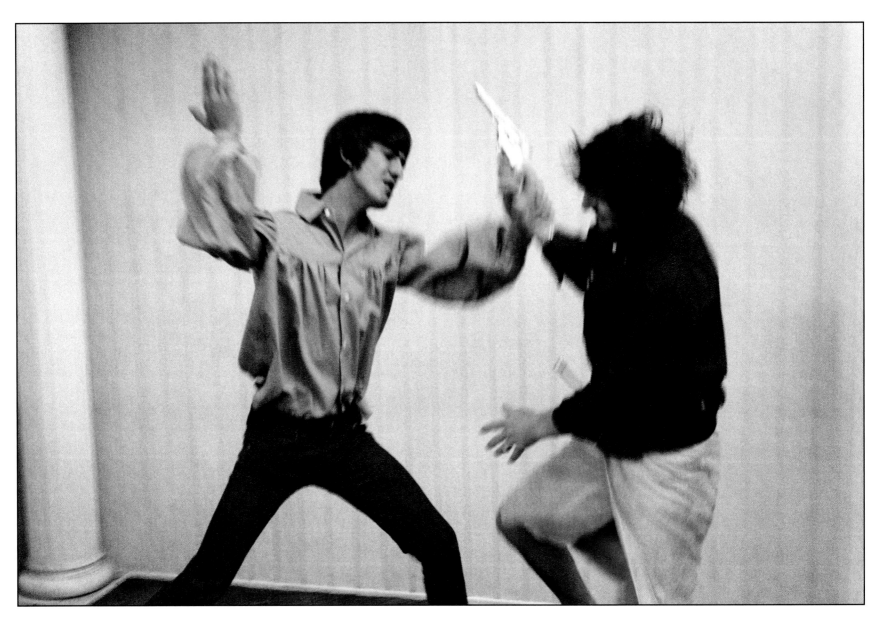

George and Ringo have a mock fight for the camera. George is wearing the same shirt that he was wearing at Whisky a Go Go the night before.

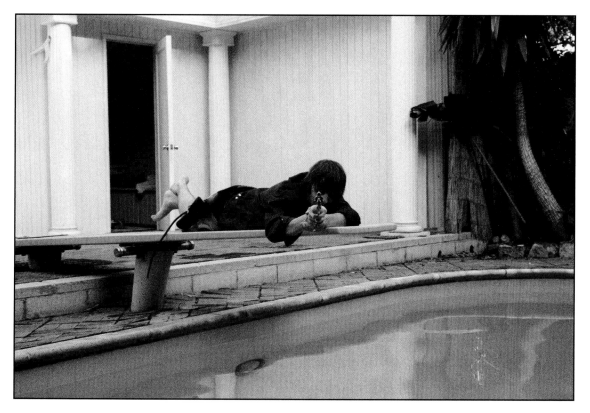
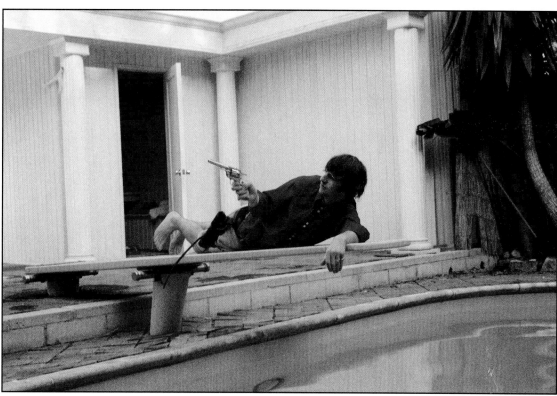

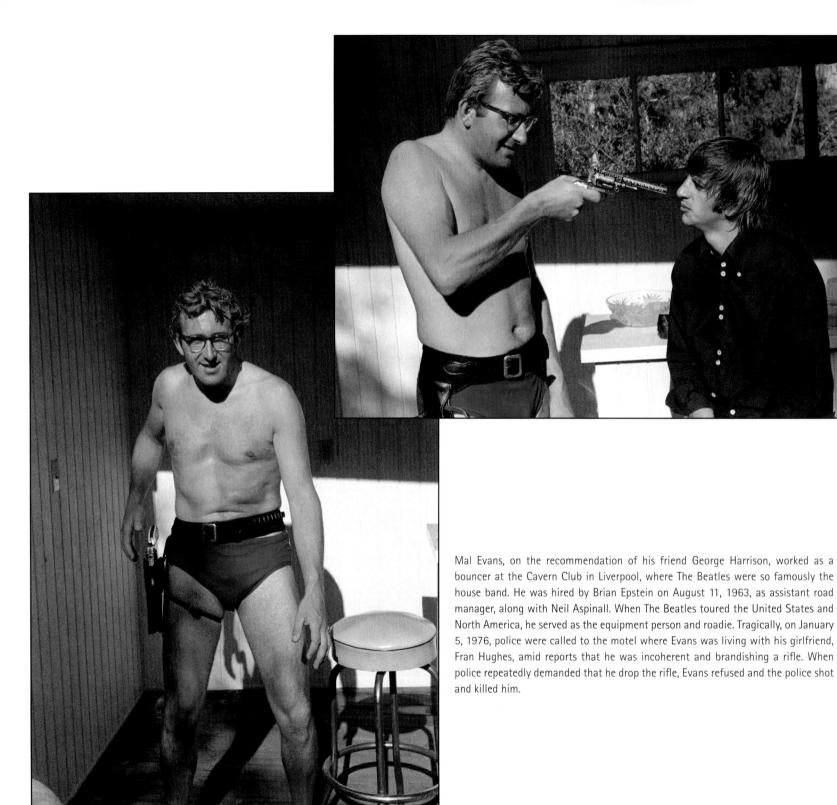

Mal Evans, on the recommendation of his friend George Harrison, worked as a bouncer at the Cavern Club in Liverpool, where The Beatles were so famously the house band. He was hired by Brian Epstein on August 11, 1963, as assistant road manager, along with Neil Aspinall. When The Beatles toured the United States and North America, he served as the equipment person and roadie. Tragically, on January 5, 1976, police were called to the motel where Evans was living with his girlfriend, Fran Hughes, amid reports that he was incoherent and brandishing a rifle. When police repeatedly demanded that he drop the rifle, Evans refused and the police shot and killed him.

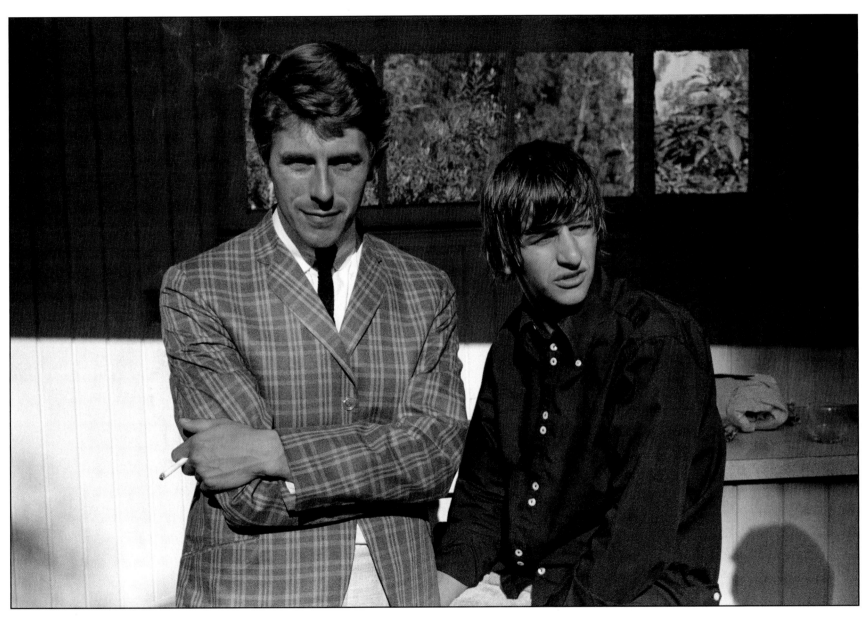

Press officer Derek Taylor (with Ringo) was a British journalist when Brian Epstein hired him away from his newspaper job to write press releases and to act as media liaison for the band. He served as press officer for The Beatles' U.S. tour in 1964 but resigned after the tour and moved to California, where he formed his own public relations company.

MAPLE LEAF GARDENS PRESS CONFERENCE, TORONTO, CANADA

SEPTEMBER 7, 1964

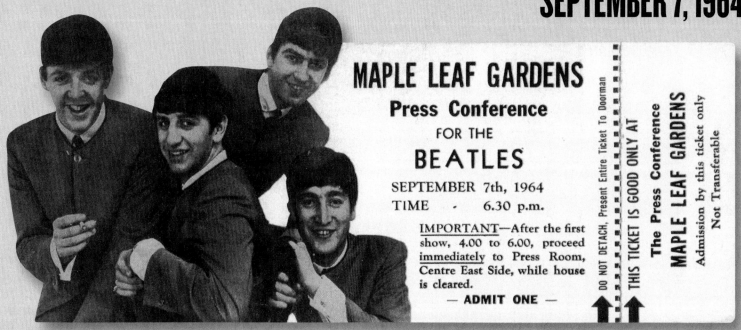

MAPLE LEAF GARDENS

Press Conference

FOR THE

BEATLES

SEPTEMBER 7th, 1964
TIME - 6.30 p.m.

IMPORTANT—After the first show, 4.00 to 6.00, proceed immediately to Press Room, Centre East Side, while house is cleared.

— ADMIT ONE —

DO NOT DETACH, Present Entire Ticket To Doorman

THIS TICKET IS GOOD ONLY AT

The Press Conference
MAPLE LEAF GARDENS
Admission by this ticket only
Not Transferable

THE BEATLES flew into Toronto in their chartered Electra airplane and, after signing autographs for immigration officials, checked into the King Edward Hotel. A few hours later, they left the hotel by the back entrance and boarded a police wagon to the Maple Leaf Gardens, where two shows were scheduled and four thousand policemen and Mounties provided security.

At the Gardens, they took the stage after 5:30 P.M., following opening acts The Bill Black Combo, The Exciters, Clarence "Frogman" Henry, and Jackie DeShannon. In between their two shows, The Beatles posed for photos with local DJs, fan club presidents, and Miss Canada, and held a press conference for reporters. After the onstage press conference, they performed a second show. The Beatles played for 35,552 fans that day, who paid $4.00, $5.00, or $5.50, depending on their seats. The Beatles would perform at the Gardens each of their three tours of the United States and North America in 1964, 1965, and 1966.

The Beatles' set list for this tour was typically: "Twist and Shout," "You Can't Do That," "All My Loving," "She Loves You," "Things We Said Today," "Roll Over Beethoven," "Can't Buy Me Love," "If I Fell," "I Want to Hold Your Hand," "Boys," "A Hard Day's Night," "Long Tall Sally." On some shows they would open with "I Saw Her Standing There," omit "She Loves You," and close with "Twist and Shout."

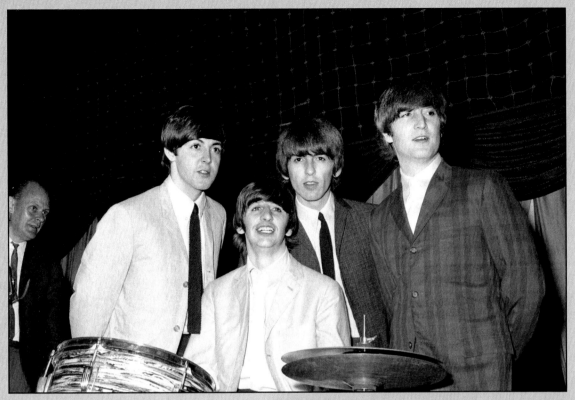
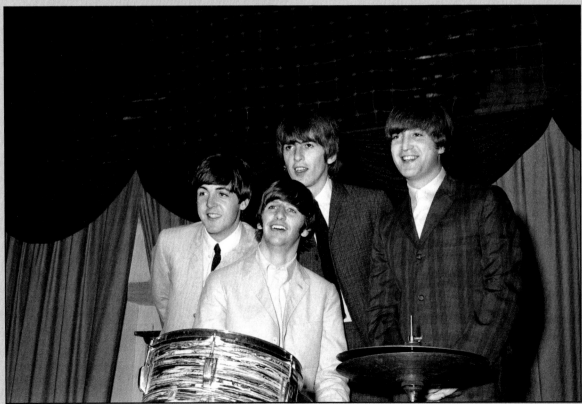

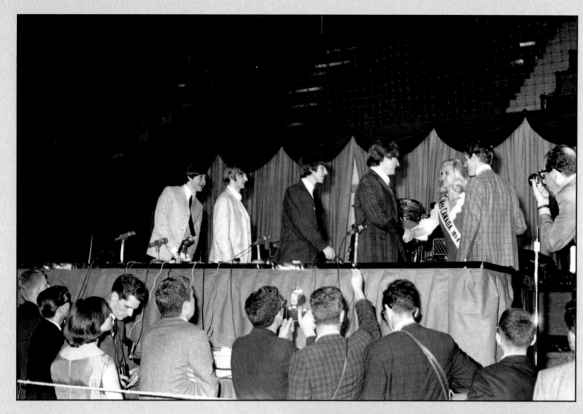

The Beatles are introduced to Miss Canada 1964, Carol Ann Balmer, for a photo opportunity.

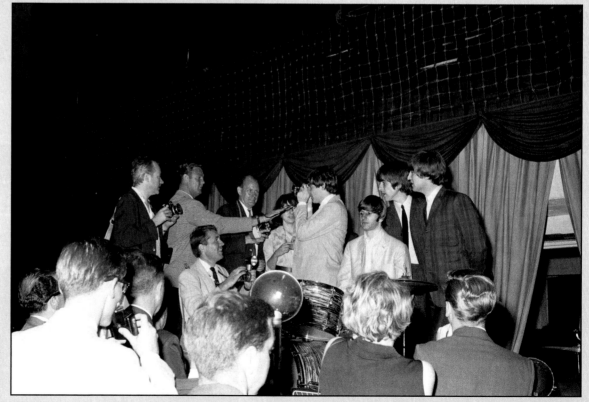

The Beatles became known for their senses of humor, cheeky responses, and playfulness at the press conferences held on every stop of the tour.

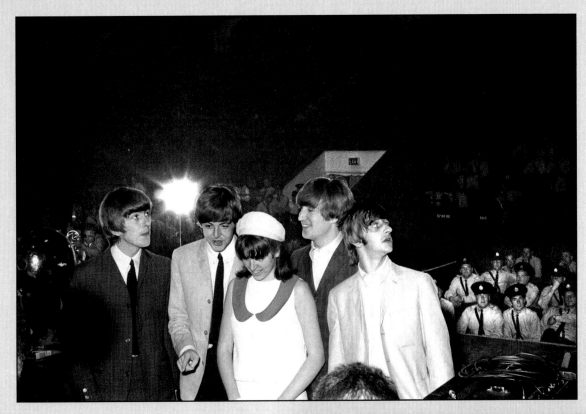

Some of the four thousand policemen and Mounties who were assigned to security were allowed to view the press conference.

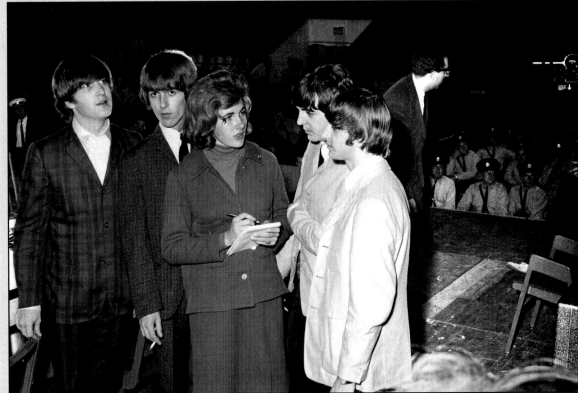

When The Beatles performed two shows at the same venue, the press conference would be scheduled during the break between shows. In addition to the press, The Beatles would invite the heads of the local Beatles fan clubs. The band was unique in that their organization sponsored and often funded their fan clubs, one of Brian Epstein's savvy moves to promote the band.

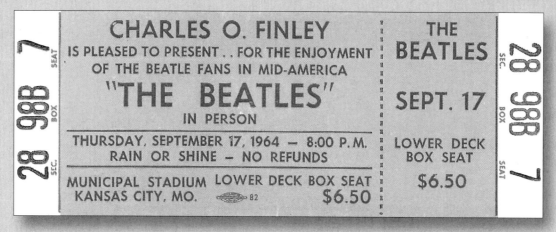

CHARLES O. FINLEY
IS PLEASED TO PRESENT.. FOR THE ENJOYMENT
OF THE BEATLE FANS IN MID-AMERICA
"THE BEATLES"
IN PERSON

THURSDAY, SEPTEMBER 17, 1964 — 8:00 P.M.
RAIN OR SHINE — NO REFUNDS

MUNICIPAL STADIUM LOWER DECK BOX SEAT
KANSAS CITY, MO. 82 $6.50

THE
BEATLES

SEPT. 17

LOWER DECK
BOX SEAT

$6.50

28 98B 7 SEC. BOX SEAT
28 98B 7 SEC. BOX SEAT

WHEN THE itinerary for The Beatles' first full U.S. tour was announced, Kansas City fans were very disappointed that their city was not on the list. Charles O. Finley, owner of the Kansas City Athletics baseball team and Municipal Stadium, swore that he would bring The Beatles to his hometown.

Finley began his campaign by meeting with Brian Epstein in San Francisco at the opening show of the tour. He asked Epstein to bring the band to Kansas City, first offering $50,000 and then raising the offer to $100,000. Epstein refused. A week later, Finley scheduled another meeting with Epstein in Los Angeles. Epstein explained that The Beatles had only one day open in their schedule and wanted to go sightseeing in New Orleans. Finley tore up his check for $100,000 and wrote a new one for $150,000. Astonished at the offer, Epstein said he would have to defer to the group. When asked if they would give up their day off, Lennon, speaking for the group, replied, "We'll do whatever you want." To Kansas City they went, and in return for giving up their day off, The Beatles earned the highest amount ever paid at that time for a musical concert, a staggering $4,838 per minute of performance.

When the band arrived at the Muehlebach Hotel in Kansas City on the day of their performance, Finley was waiting for them. He wanted The Beatles to play for longer than their standard thirty- to thirty-five-minute set, and he was willing to pay more. Finley attempted to negotiate with Epstein, but John Lennon did all the talking for the band and gleefully turned down Finley's increasing offers. John told him, "Chuck, you shouldn't have spent so much money on us." Perhaps as an insult to Finley—you can't buy us, but we love the fans, so we'll play this song for *them*—The Beatles did add a song to their set that night: the Leiber and Stoller song made famous by Wibert Harrison, "Kansas City / Hey Hey Hey Hey."

Kansas City was the only show on the tour that didn't sell out. The town media hated Finley and refused to promote the show, so only 20,214 of the 35,561 seats were sold. Finley lost $40,000 because of the ticket shortage, but he had promised that if the show didn't make a profit he would donate $25,000 to the Children's Mercy Hospital, making his losses total $65,000. Finley said afterward, "I don't consider it any loss at all. The Beatles were brought here for the enjoyment of the children in this area, and watching them last night, they had complete enjoyment. I'm happy about that. Mercy Hospital benefited by $25,000. The hospital gained, and I had a great gain by seeing the children and the hospital gain."

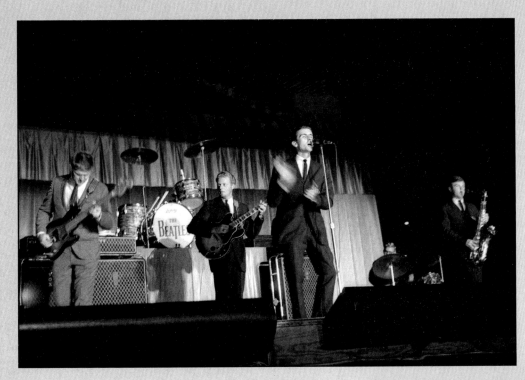

The Bill Black Combo was the first opening act on the 1964 U.S. tour and also served as backing band for the other acts on the tour, including The Righteous Brothers (who had quit the tour before this show), The Exciters, Clarence "Frogman" Henry (who replaced The Righteous Brothers), and Jackie DeShannon.

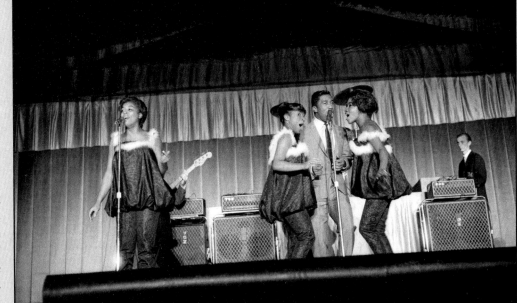

The Exciters were next up on the bill. The Exciters (lead singer Brenda Reid; her husband, Herb Rooney; Carolyn Johnson; and Lillian Walker) had a top ten hit in 1962 with the Leiber–Stoller song "Tell Him" and also recorded the original version of "Do Wah Diddy Diddy," shortly before the more popular Manfred Mann was released.

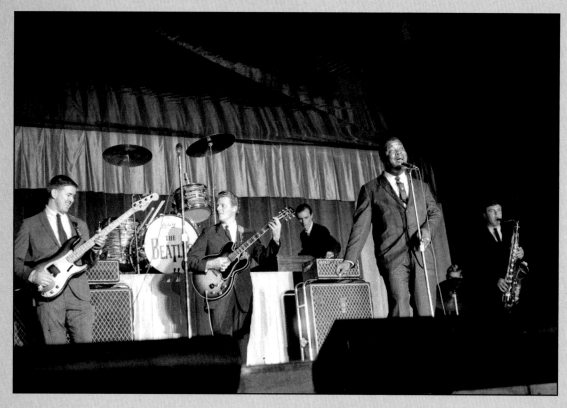

New Orleans–born Clarence "Frogman" Henry was next up in the show. Henry acquired the moniker "Frogman" because of his trademark croak in his 1956 hit song "Ain't Got No Home," which includes the line "I can sing like a frog."

Jackie DeShannon was the final opening act. She had a hit in 1963 with "Needles and Pins," a huge success for The Searchers the following year. After the tour she released the LP *Breakin' It Up on The Beatles Tour,* a record designed to capitalize on her association with the band.

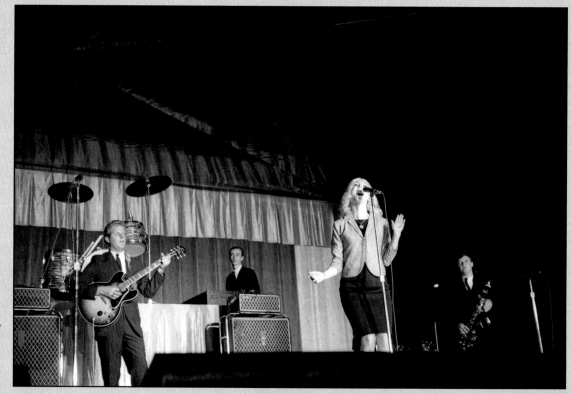

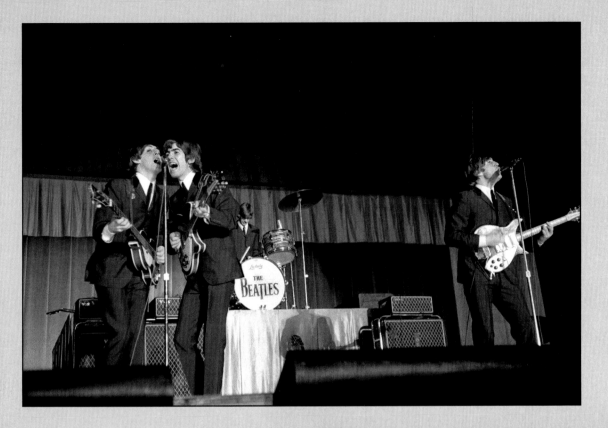
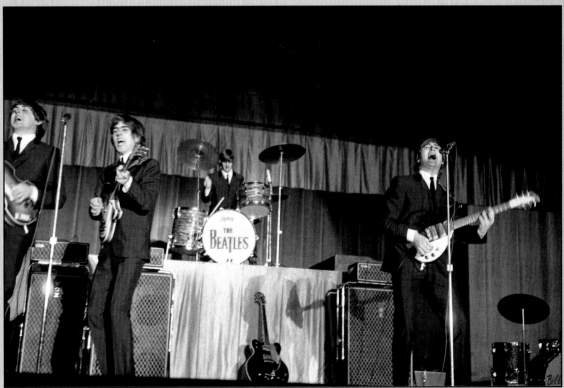

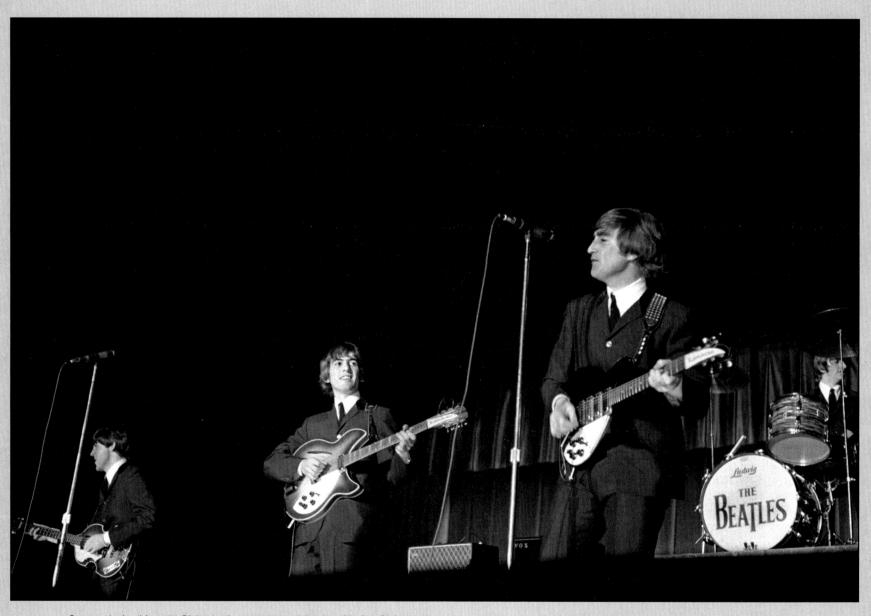

George playing his 1963 Rickenbacker 360-12 model guitar, his first Rickenbacker twelve-string and a gift from the company. It would significantly contribute to the sound of the 1960s. George used it to record both "A Hard Day's Night" and "Help!," and played it in concert in both 1964 and 1965.

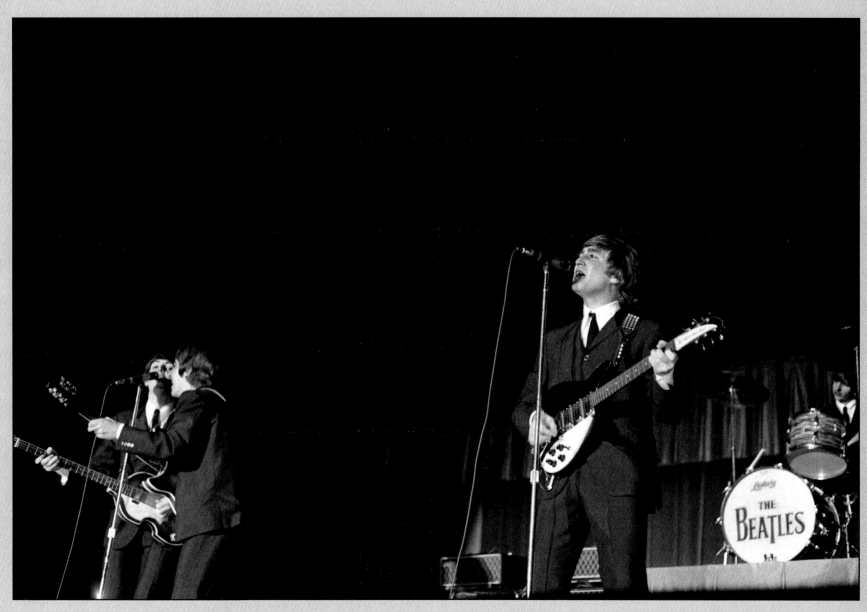

John playing his 1964 Rickenbacker 325 model guitar, built specially for him by the company. John had fallen in love with the Rickenbacker 325 after seeing Jean "Toots" Thielemans play one in the George Shearing Quintet in 1959.

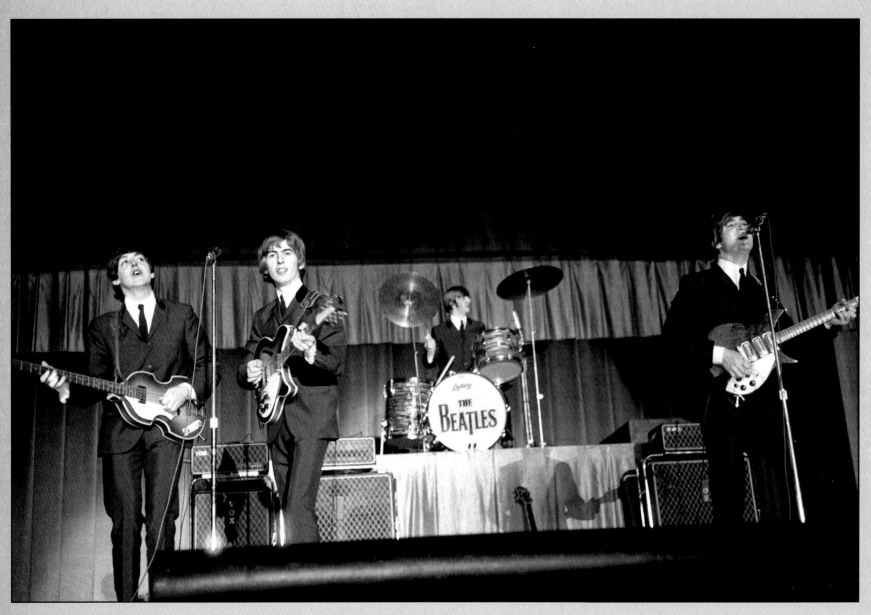

Paul McCartney playing his 1963 violin-shaped, hollow-body Hofner model 500/1 bass. It would come to be known as the "Beatle Bass." It was stolen in 1968 during the filming of the promotional short for the song "Revolution," at which point McCartney went back to using his original 1961 model, which he still uses extensively today.

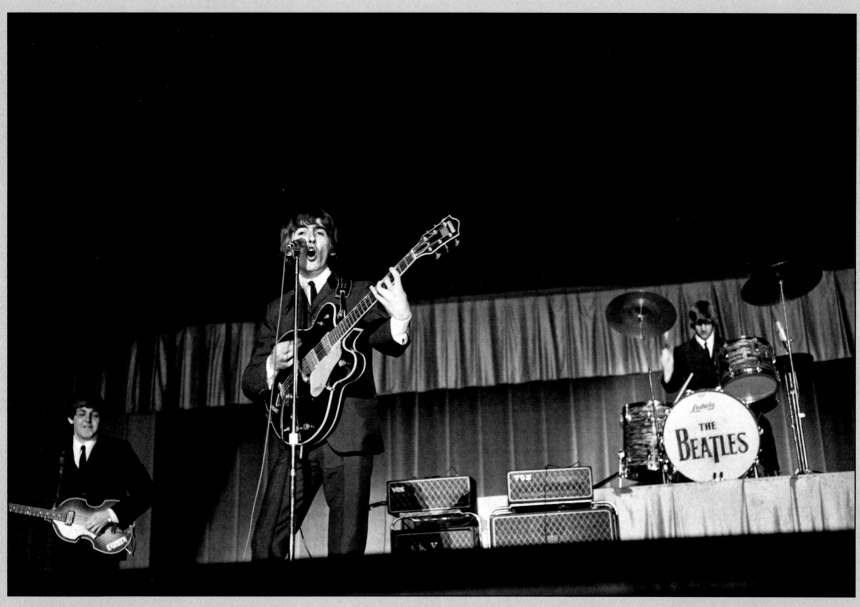

Ringo is playing his Ludwig Black Oyster Pearl colored drum set with The Beatles' drop-T logo drumhead number four. He had seven different drop-T Beatles logo drumheads over the years. This was his third Ludwig set and the first with a twenty-two-inch kick drum (the first two were twenty inches).

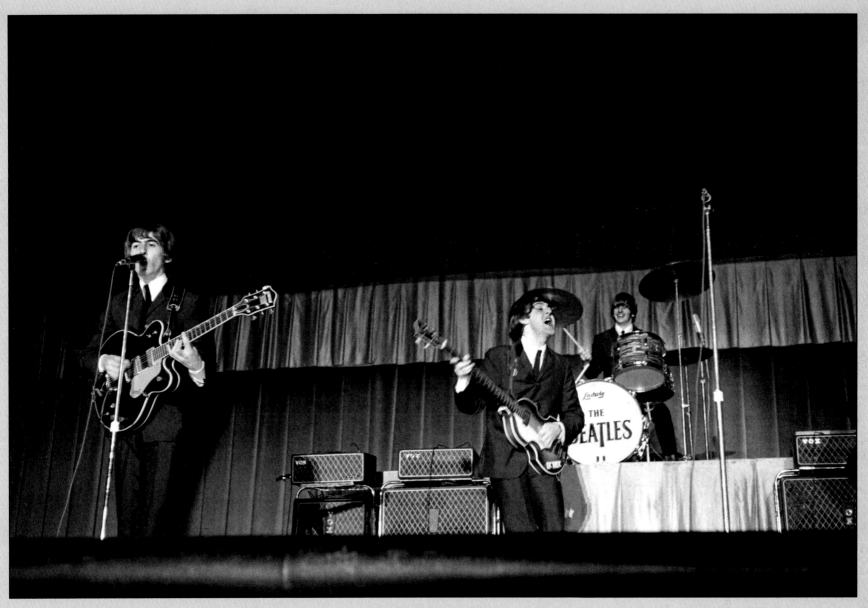

George acquired two Chet Atkins Country Gentleman guitars in 1963. Here he is playing his Gretsch 6122 Country Gentleman, his main guitar during the 1964 U.S. tour. American country musician Chet Atkins, whom George Harrison admired, had collaborated with Gretsch in the design of this guitar and endorsed Gretsch guitars. The guitar model was named after one of Chet's instrumental songs.

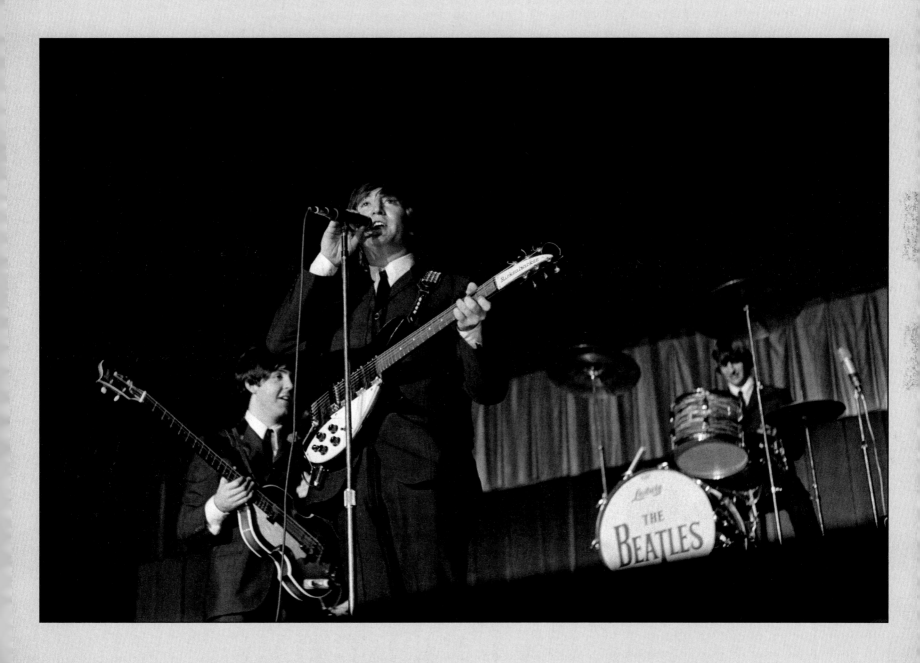

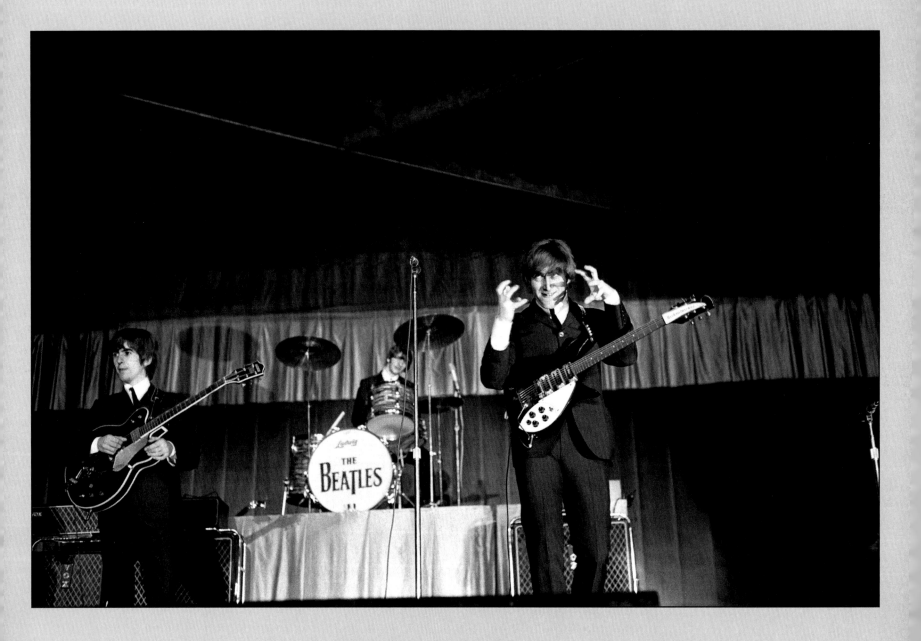

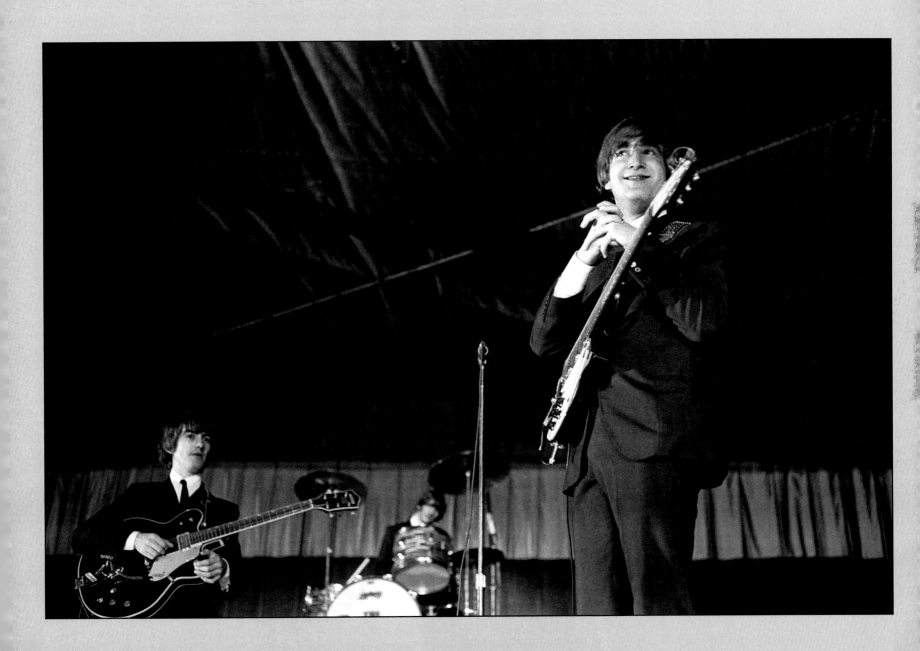

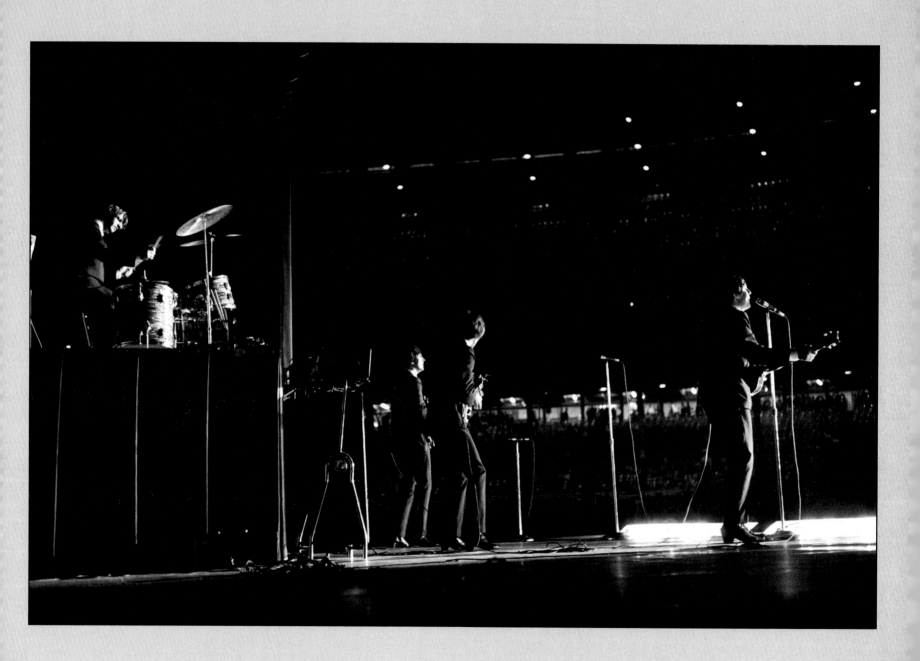

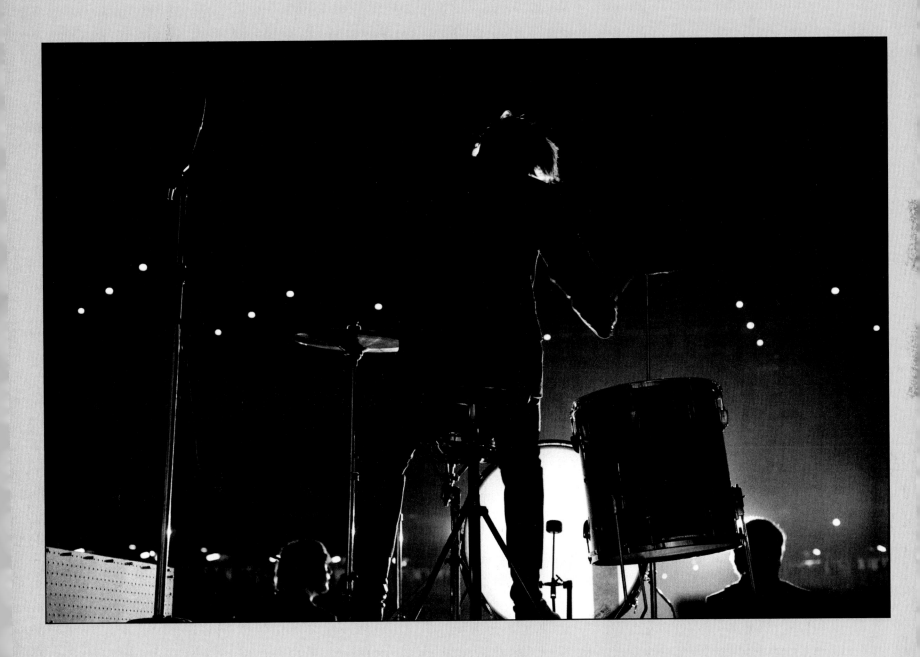

KILT № 7598 KILT

THIS TICKET NOT FOR RESALE — NOT GOOD IF DETACHED

Radio Station KILT
Presents
The Sixth Annual Back-To-School Show
Sponsored By
THE VARIETY BOYS CLUB OF HOUSTON
STARRING THE BEATLES
(IN PERSON)
AND ALL-STAR SUPPORTING CAST
Master of Ceremonies: RUSS KNIGHT—The Weird Beard
GENERAL ADMISSION TICKET: $5.00
SAM HOUSTON COLISEUM — 3:30 P.M.
THURSDAY, AUGUST 19, 1965 • HOUSTON

KILT № 7598 KILT

DURING THE Beatles' second tour of the United States, their second film, *HELP!*, premiered, adding more frenzy to the already hysterical fan response to the band.

Four days after their historic Shea Stadium concert, The Beatles performed two shows at the Sam Houston Coliseum in Houston with a capacity of 9,200 general admission seats for each sold-out show. The show, presented by Houston radio station KILT, was advertised as the "Sixth Annual Back-to-School Show."

The Beatles took Houston by storm. "Bedlam began when their plane hit the tarmac," wrote Jeff Millar of the *Houston Chronicle*.

"The Beatles took good-naturedly the non-stop screaming that made their singing all but unintelligible. At the afternoon performance, John Lennon, who wore one of the group's famous coal miner caps onstage, waved back wildly at the girls flailing their arms at him and his shaggy companions . . .

"They took with equal grace the barrage of crumpled soft drink cups that littered the bandstand. Nobody missed a note as cups caromed off their faces. George Harrison adroitly dodged the largest object hurled, apparently someone's right tennis shoe."

As they left Houston, John Lennon cracked, "We've only been to Dallas and here. And we almost got killed both places."

The opening acts for this tour were Brenda Holloway, The King Curtis Band, Cannibal and the Headhunters, and Sounds Incorporated (with a troupe of disco dancers). The set for each show was identical: "Twist and Shout," "She's a Woman," "I Feel Fine," "Dizzy Miss Lizzy," "Ticket to Ride," "Everybody's Trying to Be My Baby," "Can't Buy Me Love," "Baby's in Black," "I Wanna Be Your Man," "A Hard Day's Night," "Help!," "I'm Down."

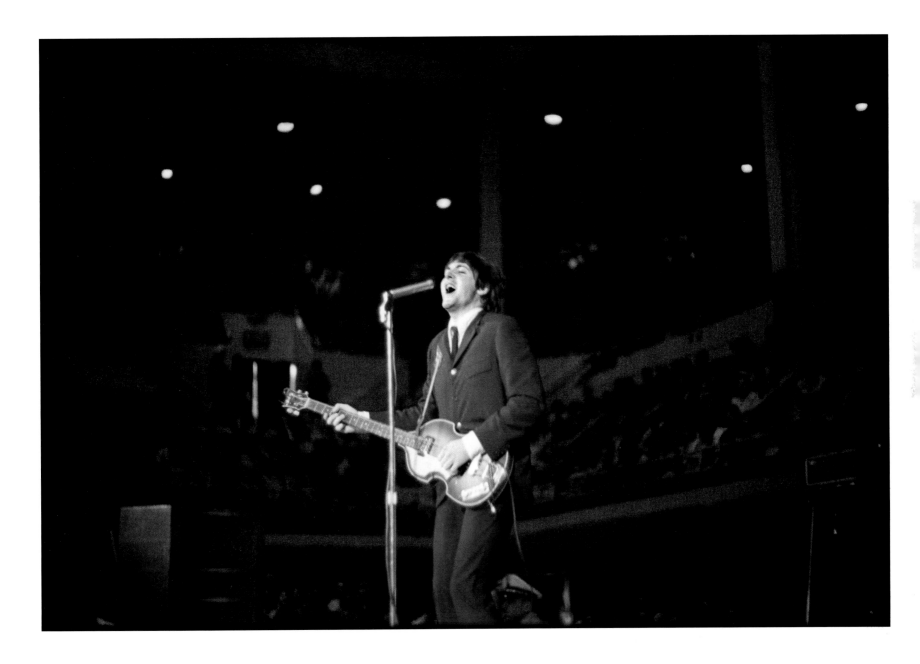

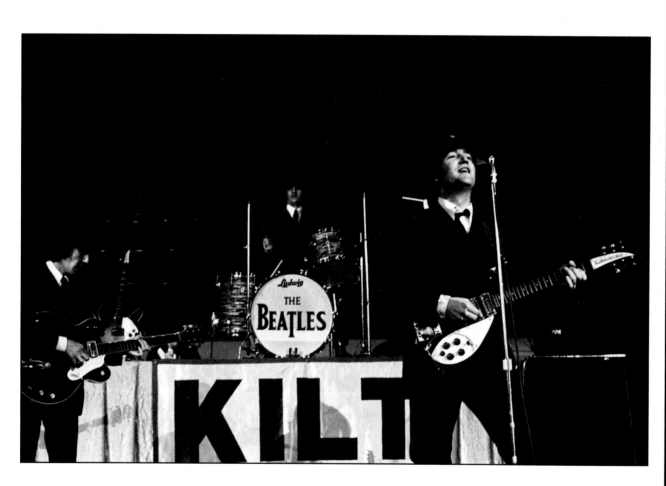
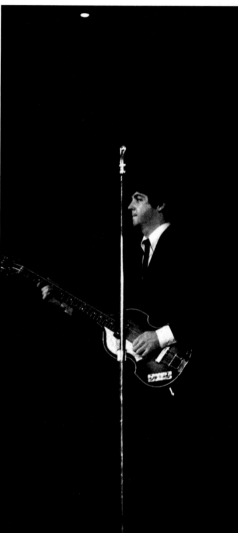

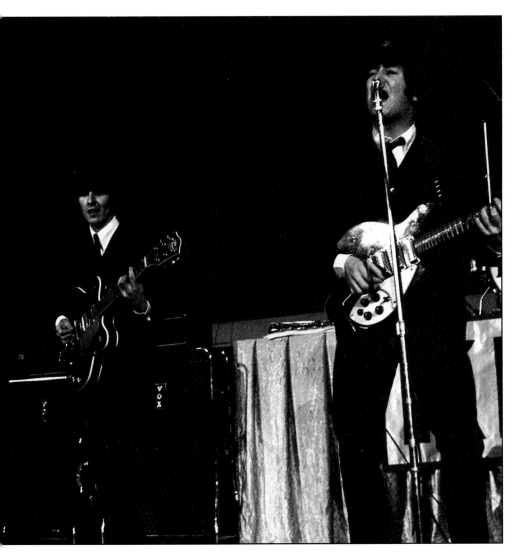
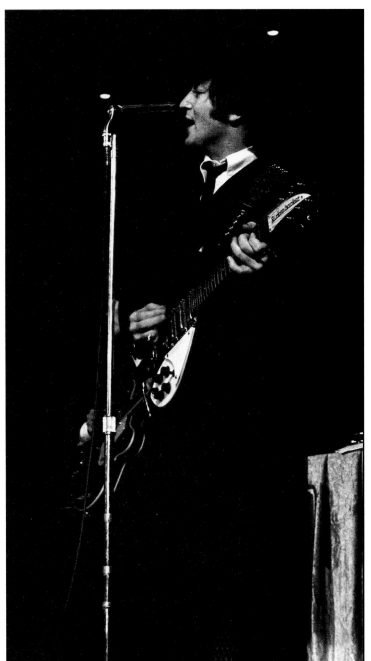

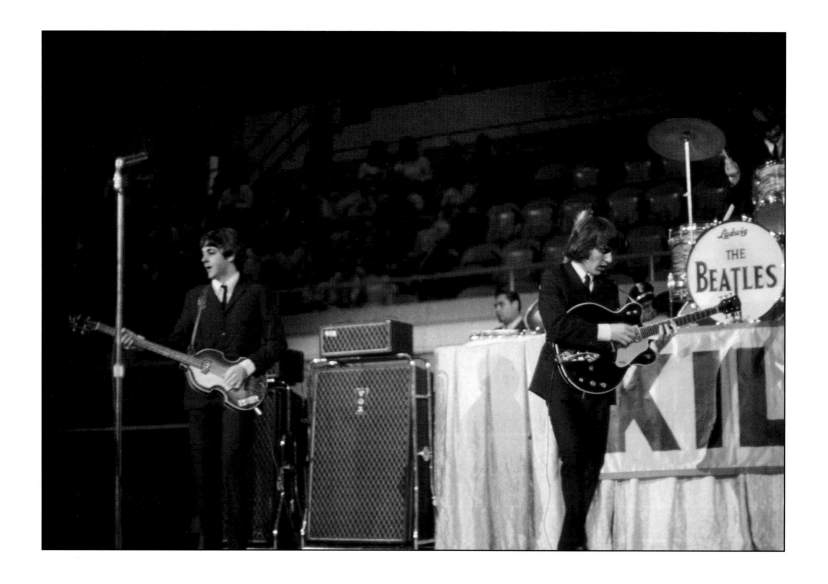

Fans in the UK began throwing a soft British candy known as jelly babies at the band after George made the mistake of mentioning in an interview that he loved them. This spread to the United States, where jelly babies were unknown, and fans began to bombard The Beatles onstage with hard U.S. jellybeans as well as everything from paper cups and makeup to other dangerous objects.

In 1963, before The Beatles first came to the United States, they were already upset by the onstage bombardment in the UK, and George, in a letter to a fifteen-year-old female fan, wrote: "We don't like jelly babies, or fruit gums for that matter, so think how we feel standing on stage trying to dodge the stuff, before you throw some more at us. Couldn't you eat them yourself? Besides, it is dangerous. I was hit in the eye once with a boiled sweet, and it's not funny!"

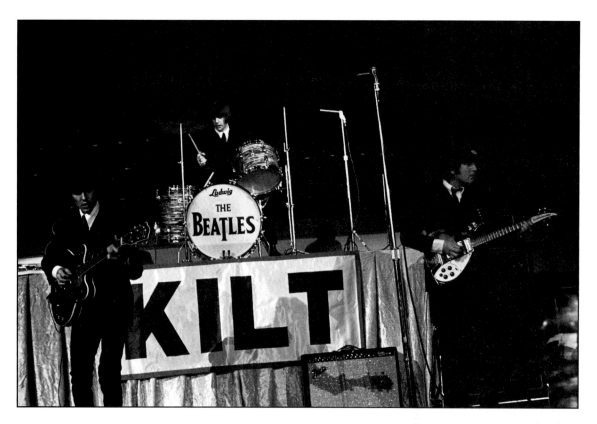

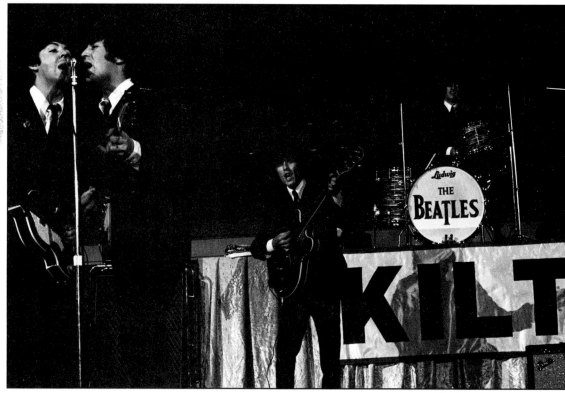

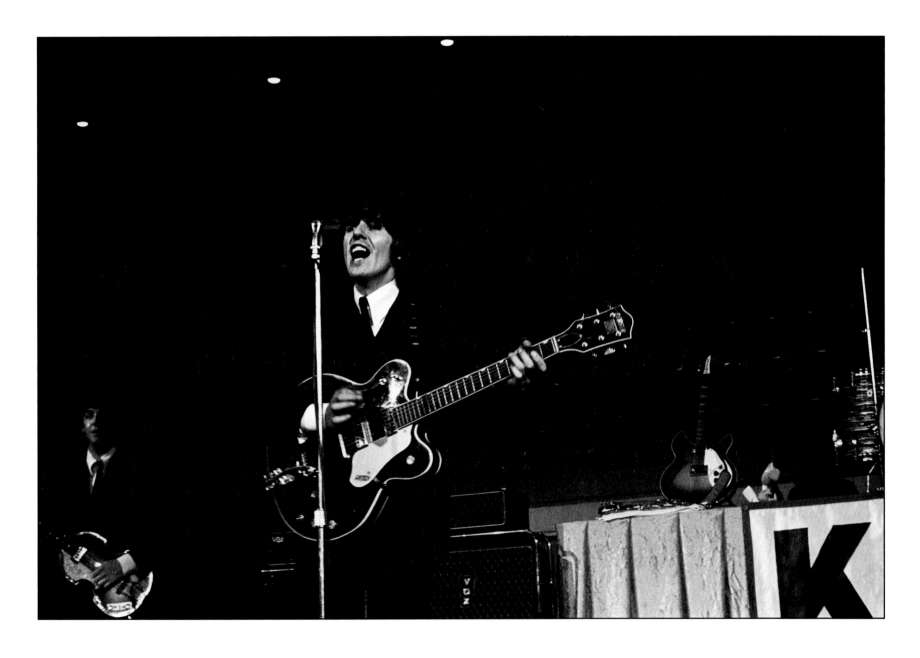

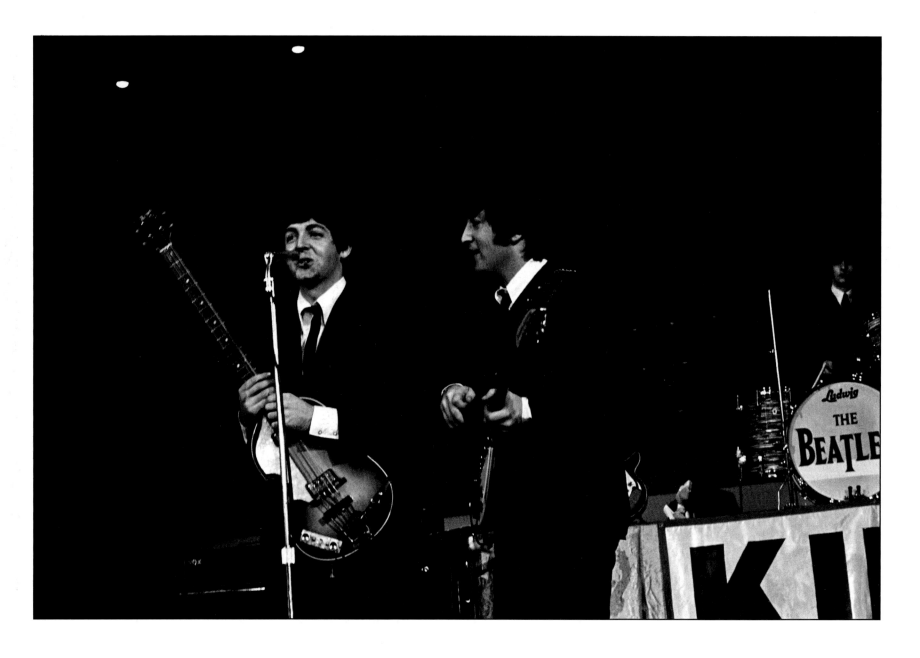

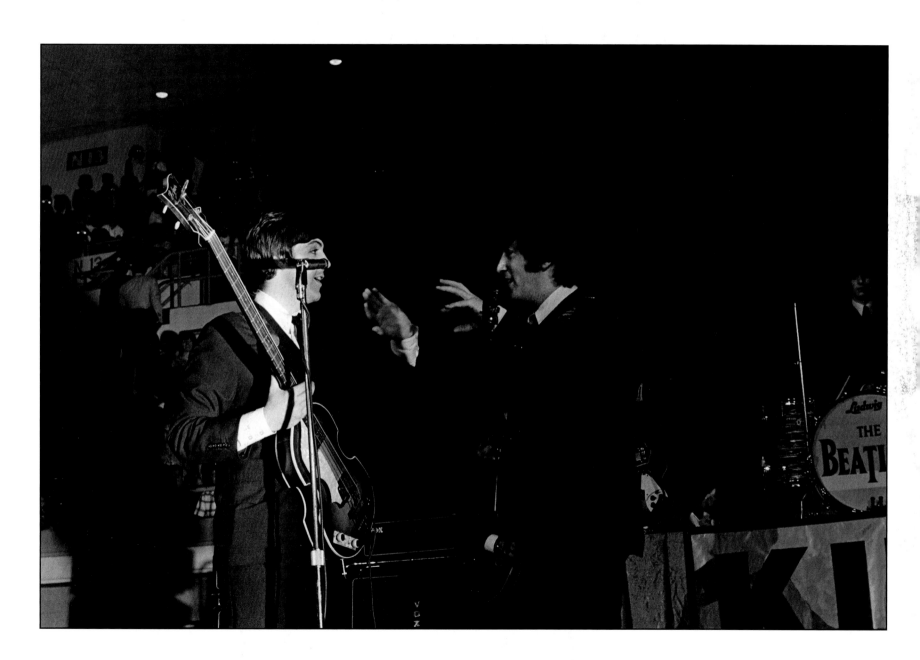

BLOOMINGTON, MINNESOTA

AUGUST 21, 1965

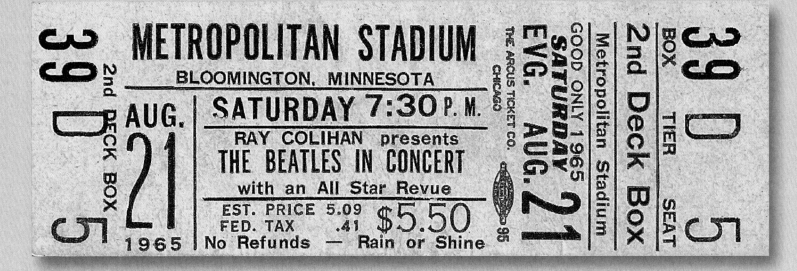

ON THE morning of August 21, 1965, The Beatles flew out of Midway Airport in Chicago en route to play Bloomington, Minnesota, south of Minneapolis. It would be their only live appearance in Minnesota of all three tours, and it was staged at Metropolitan Stadium, then the home of the Minnesota Twins baseball team and the Minnesota Vikings football team. It was also one of the few shows on the tour that was not sold out, selling only a reported 25,000 out of a capacity 45,919 tickets priced from $2.50 to $5.50.

Set list: "She's a Woman," "I Feel Fine," "Dizzy Miss Lizzy," "Ticket to Ride," "Everybody's Trying to Be My Baby," "Can't Buy Me Love," "Baby's in Black," "I Wanna Be Your Man," "A Hard Day's Night," "Help!," "I'm Down." Because John was having difficulty with his throat that night, The Beatles dropped the usual "Twist and Shout" opener.

As was the norm for their stadium shows, The Beatles' stage was set up midfield. No photographers were permitted near the stage, so the only pictures previously known of this performance are long shots taken from quite a distance. These images are the only close-up photographs taken at stage level of this historic performance.

Mal Evans with King Curtis at Chicago's Midway Airport.

Members of the entourage and the opening acts, Brenda Holloway (*third from right*) and Frankie "Cannibal" Garcia (*far right*) of Cannibal and the Headhunters, board the plane to Minnesota.

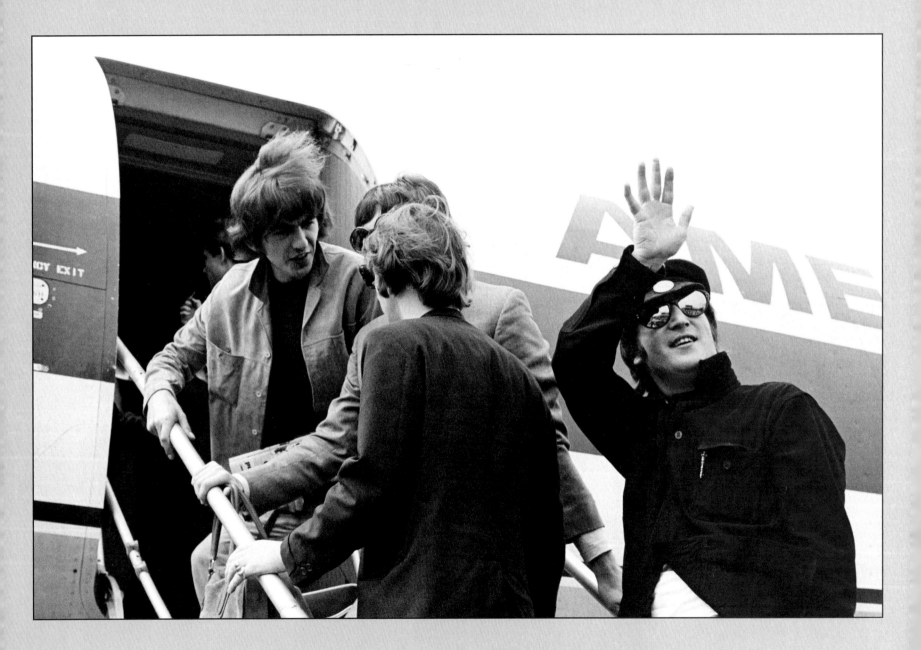

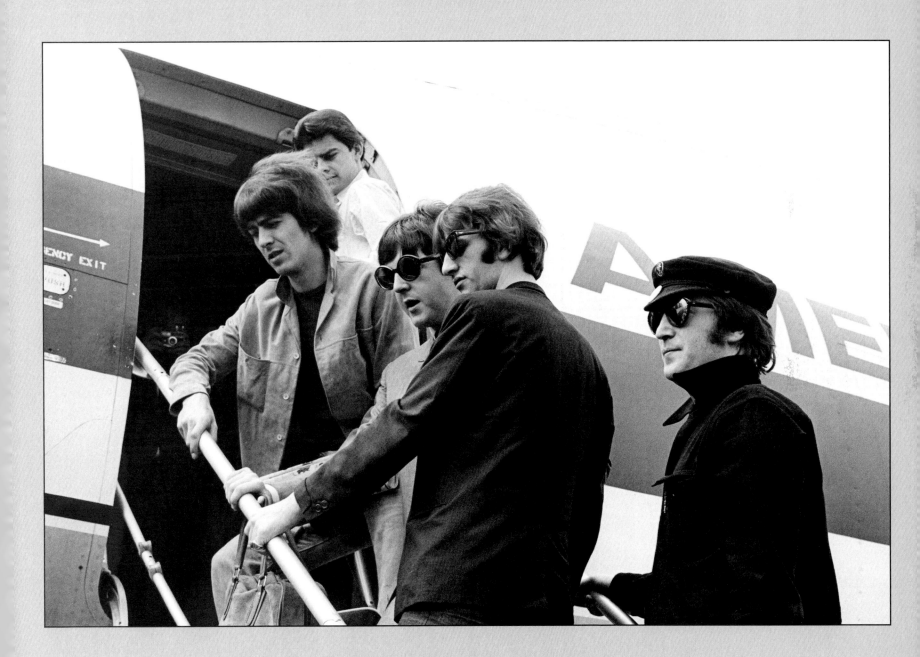

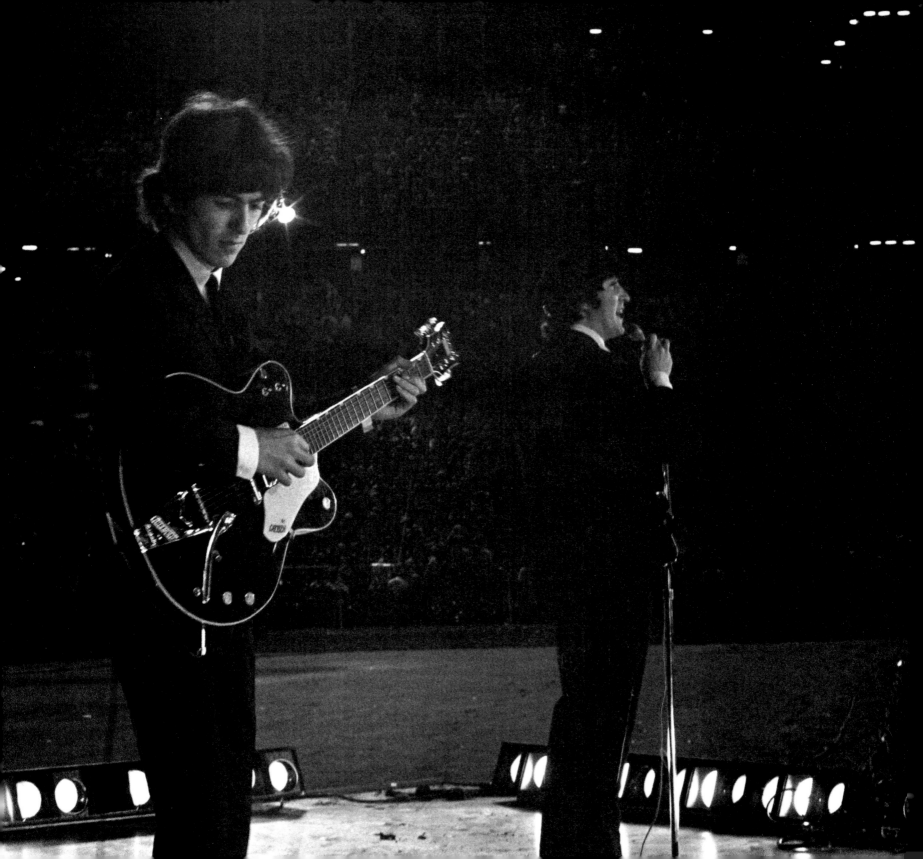

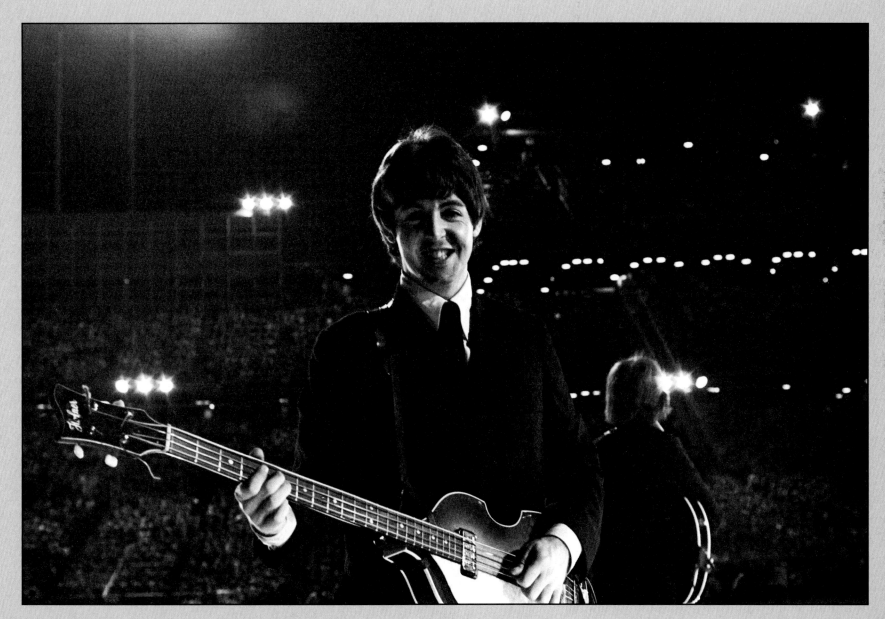

Paul, looking away from the audience, sees Bob standing there with his camera and gives him a big smile.

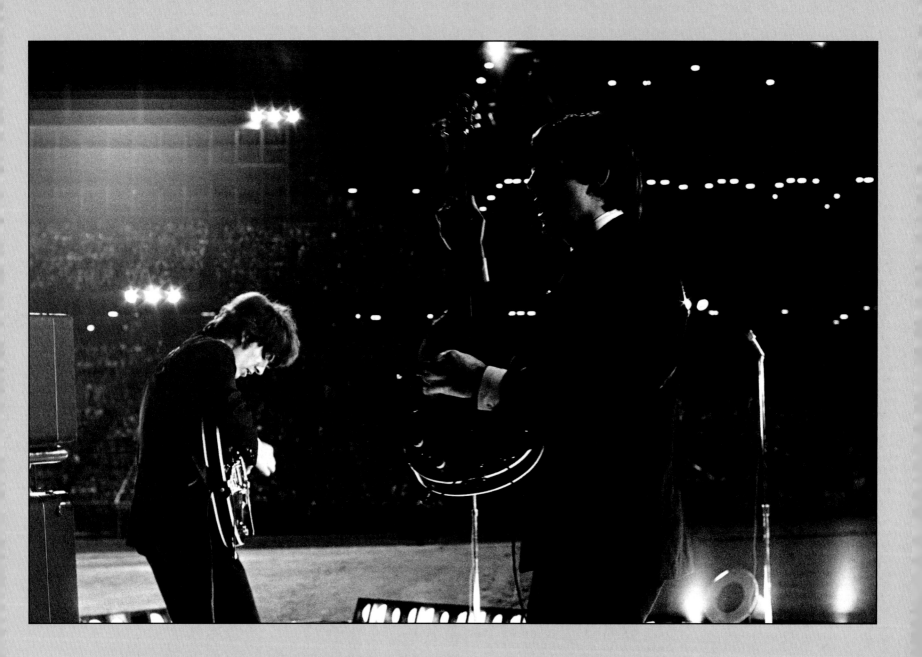

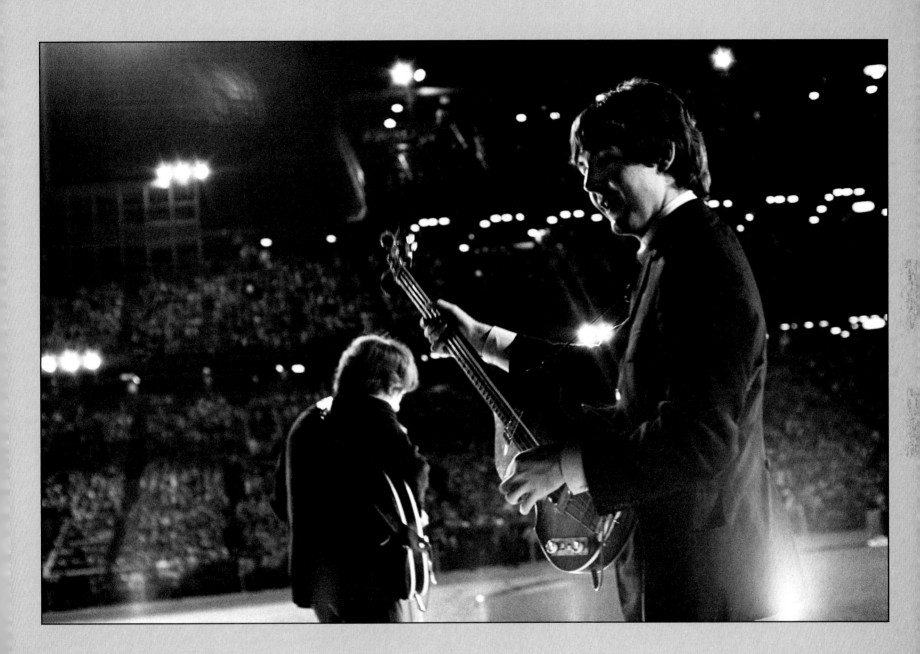

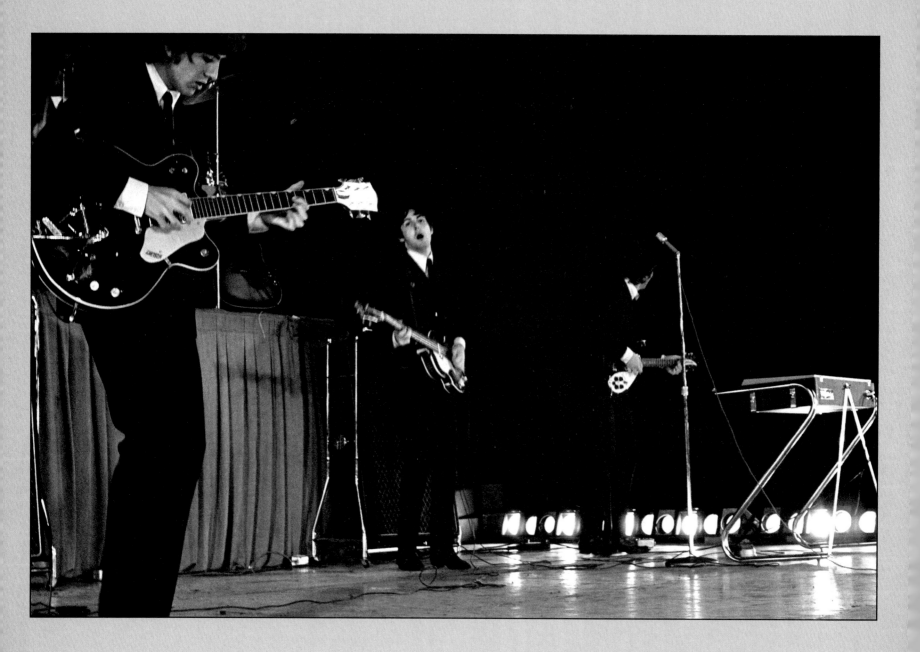

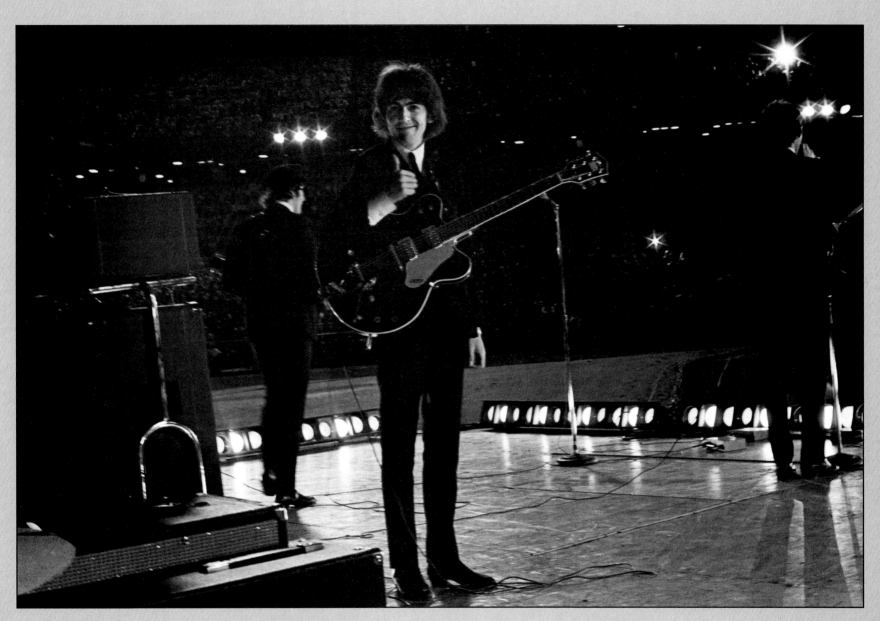

Like Paul, in an earlier photograph, George looks away from the audience and sees Bob there with his camera and gives him a thumbs-up sign.

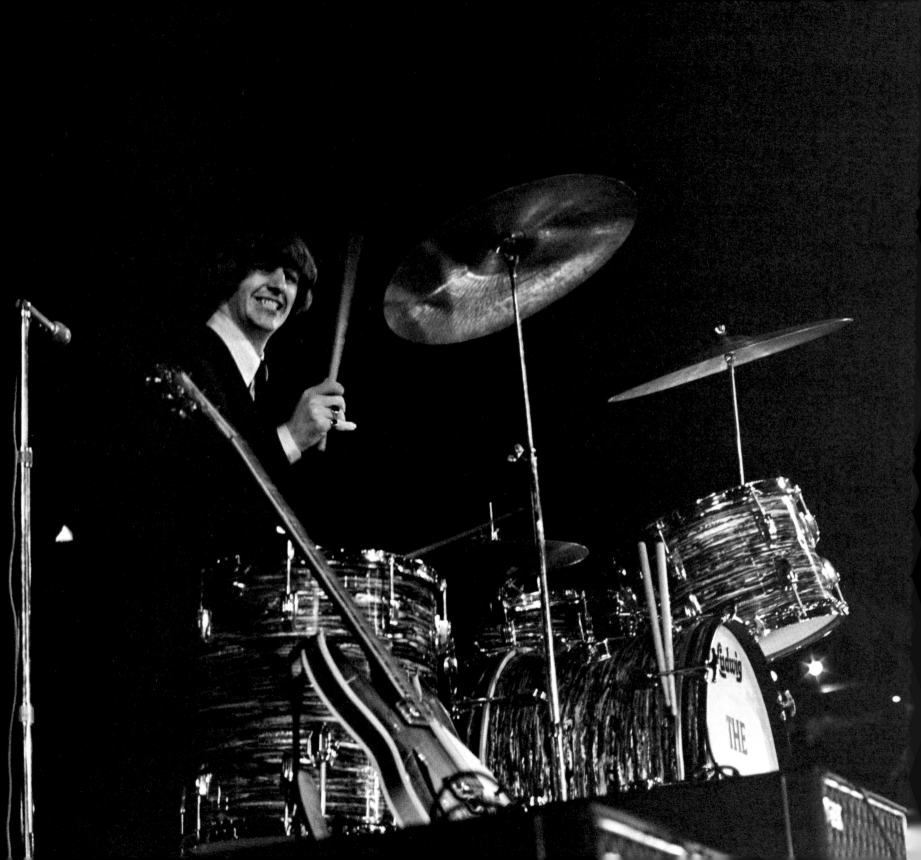

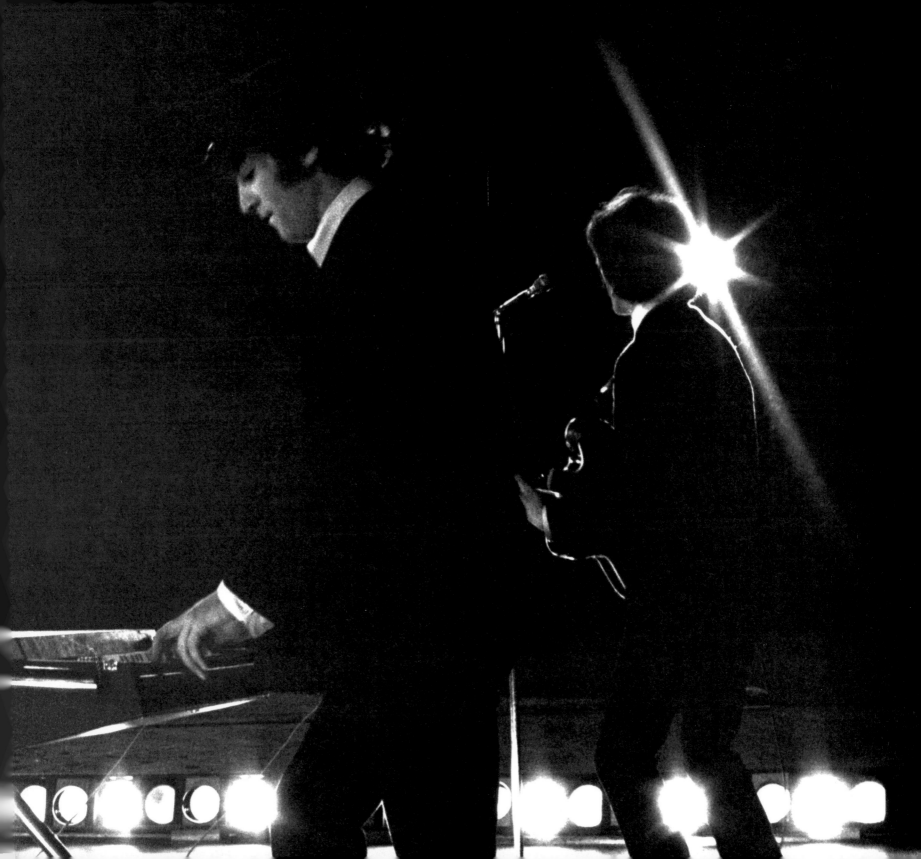

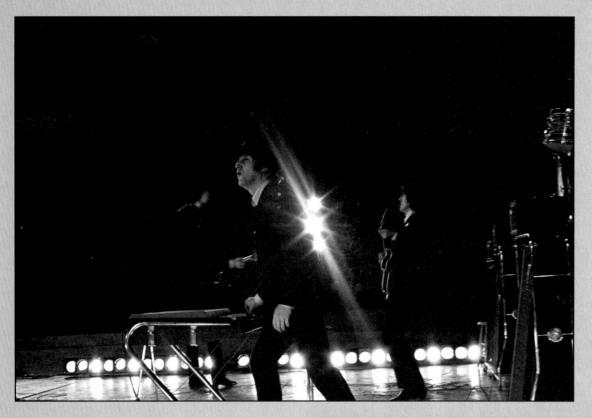
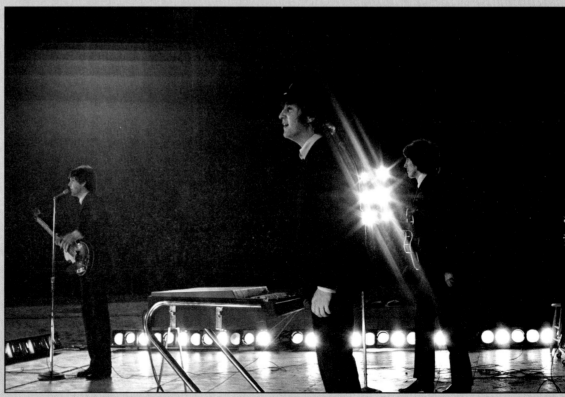

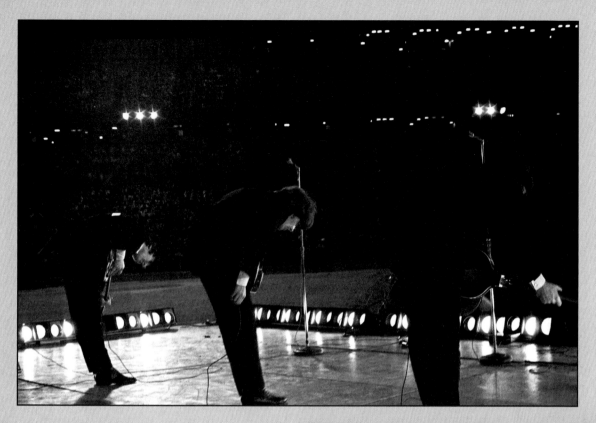
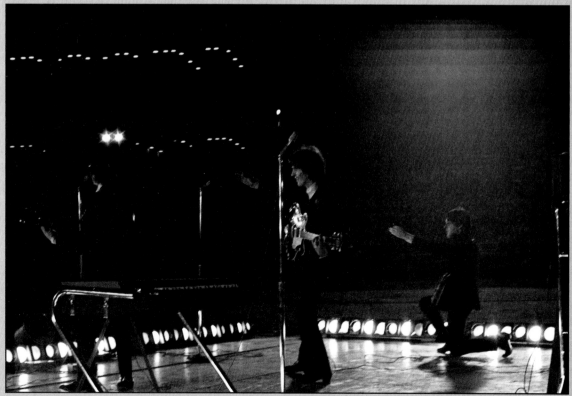

PORTLAND, OREGON

AUGUST 22, 1965

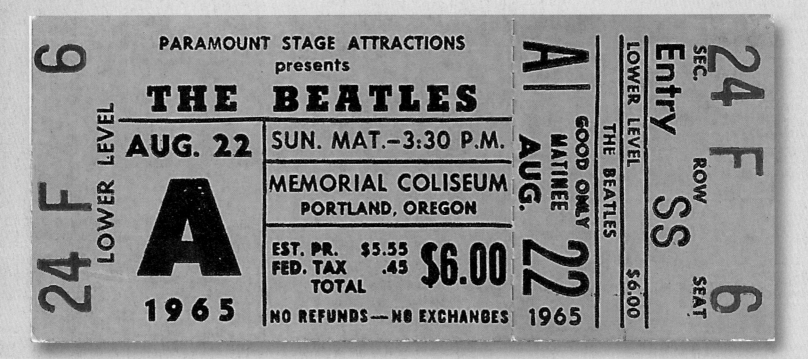

AS THE American Flyer Lockheed Electra plane chartered for this tour flew from Bloomington, Minnesota, to Portland, Oregon, one of the plane's engines caught fire and belched thick black smoke, but the plane landed safely and no one was hurt. When asked about it after they landed, Ringo said, "Beatles, women, and children first!"

The Beatles performed two shows in Portland on August 22 to a combined audience of 19,936 fans who paid between $4.00 and $6.00 for tickets.

According to the executed contract pictured on the following page, The Beatles were paid a guarantee of $50,000 versus 65 percent of the gross box office receipts after taxes were deducted. The rider that is attached to the contract reveals how modest The Beatles' demands were compared to the legendary and outrageous demands of stars today. For instance, Van Halen notoriously required a bowl of M&M'S with all the brown ones removed, Marilyn Manson required a bald hooker with no teeth, and Mötley Crüe required a twelve-foot boa constictor and a submachine gun.

Between the two shows, Mike Love, Carl Wilson, Al Jardine, and Bruce Johnston of The Beach Boys, who had flown up from California just for the occasion, went backstage and met The Beatles for the first time. They reportedly talked about girls, cars, England, and California.

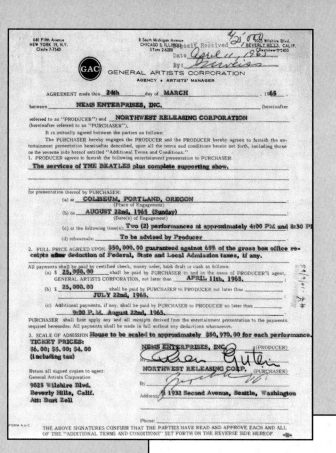

Deposit Received
Date April 11, 1965
By _____

GAC GENERAL ARTISTS CORPORATION

AGENCY • ARTISTS' MANAGER

AGREEMENT made this **24th** day of **MARCH**, 1965,

between **NEMS ENTERPRISES, INC.** (hereinafter

referred to as "PRODUCER") and **NORTHWEST RELEASING CORPORATION**
(hereinafter referred to as "PURCHASER").

It is mutually agreed between the parties as follows:

The PURCHASER hereby engages the PRODUCER and the PRODUCER hereby agrees to furnish the entertainment presentation hereinafter described, upon all the terms and conditions herein set forth, including those on the reverse side hereof entitled "Additional Terms and Conditions."

1. PRODUCER agrees to furnish the following entertainment presentation to PURCHASER:

The services of THE BEATLES plus complete supporting show.

for presentation thereof by PURCHASER

(a) at **COLISEUM, PORTLAND, OREGON**
(Place of Engagement)

(b) on **AUGUST 22nd, 1965 (Sunday)**
(Date(s) of Engagement)

(c) at the following time(s) **Two (2) performances at approximately 4:00 PM and 8:30 PM**

(d) rehearsals **To be advised by Producer**

2. FULL PRICE AGREED UPON: **$50,000.00 guaranteed against 65% of the gross box office receipts after deduction of Federal, State and Local Admission taxes, if any.**

All payments to be paid by certified check, money order, bank draft or cash as follows:

(a) $ **25,000.00** shall be paid by PURCHASER to and in the name of PRODUCER's agent, GENERAL ARTISTS CORPORATION, not later than **APRIL 11th, 1965.**

(b) $ **25,000.00** shall be paid by PURCHASER to PRODUCER not later than **JULY 22nd, 1965.**

(c) Additional payments, if any, shall be paid by PURCHASER to PRODUCER no later than **9:00 P.M. August 22nd, 1965.**

PURCHASER shall first apply any and all receipts derived from the entertainment presentation to the payments required hereunder. All payments shall be made in full without any deductions whatsoever.

3. SCALE OF ADMISSION **House to be scaled to approximately $50,970.00 for each performance.**
TICKET PRICES:
$6.00; $5.00; $4.00
(including tax)

Return all signed copies to agent:
General Artists Corporation
9025 Wilshire Blvd.
Beverly Hills, Calif.
Att: Burt Zell

NEMS ENTERPRISES, INC. (PRODUCER)

By _____

NORTHWEST RELEASING CORP. (PURCHASER)

By _____

Address **1932 Second Avenue, Seattle, Washington**

Phone: _____

FORM A.A-7

THE ABOVE SIGNATURES CONFIRM THAT THE PARTIES HAVE READ AND APPROVE EACH AND ALL OF THE "ADDITIONAL TERMS AND CONDITIONS" SET FORTH ON THE REVERSE SIDE HEREOF.

THIS RIDER IS HEREWITH ATTACHED AND MADE A PART OF THE CONTRACT BETWEEN NEMS ENTERPRISES, LTD. (HEREINAFTER CALLED PRODUCER) AND **NORTHWEST RELEASING CORPORATION** (HEREINAFTER CALLED PURCHASER.)

1. The PURCHASER agrees, at his sole expense, to supply police protection for this engagement of not less than 150 uniformed officers. Said officers will be present from the time the doors open for this engagement throughout the entire show and until the place of engagement is completely empty. If, in the opinion of the PRODUCER, and/or his authorized representative (s) additional police protection is required, PURCHASER agrees to provide for such additional police immediately and at PURCHASER's sole expense. All security arrangements including, but not limited to, police, ushers, barricades, fences, etc., shall be approved by the PRODUCER's advance agent.

2. The PURCHASER will furnish at his sole expense the following:

a) A hi-fidelity sound system with adequate number of speakers, four (4) floor stand Hi = Fi microphones, with detachable heads and forty (40) feet of cord for each microphone. If sound system and/or microphones do not meet with PRODUCER's satisfaction, PRODUCER has the right to change or augment the system in order to meet PRODUCER's sound requirements. Any costs in relation to such changes shall be borne solely by the PURCHASER. PURCHASER further agrees to provide and pay for a Monitor Speaker to be placed on stage.

b) Not less than two (2) super trouper follow spotlights with normal complement of gelatins and necessary operators.

c) A first-class sound engineer who will be present for technical rehearsals, is required by PRODUCER, and this same engineer will work the entire performance.

d) A stage, the dimensions to be not less than 25' x 25' and at least 5' high.

e) A platform for Ringo Starr and his drums. The dimensions of the platform should be 10' x 6' and 4' high.

f) In the event that there are seats behind the stage, the PURCHASER must provide a strong fence or barrier behind the stage to prevent any of the audience from climbing over.

g) In the case of an outdoor appearance, PURCHASER must provide a removable roof for the stage. In the event the weather is good this roof will not be used, but it must be kept as close to the stage as possible in the event of sudden rain. Performance (s) to go on regardless of any adverse weather conditions. It is expressly understood and agreed that PURCHASER's obligations to pay the PRODUCER shall not in any event be modified or affected because of rain or other adverse weather conditions.

continued.....

=2=
NEMS ENTERPRISES, LTD.

h) PURCHASER will make available at his sole expense, the place of performance, fully staffed for necessary music and technical rehearsal on the day of engagement. PURCHASER is to be notified of exact rehearsal time by PRODUCER.

i) The PURCHASER must furnish clean and adequate dressing room facilities for the entire cast. In the case of OUTDOOR ENGAGEMENTS, PURCHASER must furnish a portable dressing room, preferably a house trailer, immediately behind the stage for THE BEATLES only. This trailer is to have electricity and water. In all dressing rooms for THE BEATLES, the PURCHASER must provide four cots, mirrors, an ice cooler, portable TV set and clean towels.

3. The PURCHASER must submit to PRODUCER for PRODUCER'S Approval, a list of people PURCHASER wishes to include on his complimentary ticket list. In no case will the number of complimentary tickets exceed fifty (50).

4. The PURCHASER will arrange for one general press conference the day of the engagement. The exact time and place of the press conference to be approved by the PRODUCER. In the event this conference is held away from the place of the engagement, PURCHASER agrees to provide the location of the press conference at no cost to the PRODUCER. No interviews of THE BEATLES and/or any other artists appearing on the show, will be scheduled by the PURCHASER without the written consent of the PRODUCER. The PURCHASER agrees to exclude from the premises and particularly from the immediate vicinity of the stage and the backstage areas all TV cameras, and/or photographers with motion picture cameras and/or tape recorders unless specifically authorized by the PRODUCER and/or his authorized representatives.

5. Artists will not be required to perform before a segregated audience.

6. The PURCHASER will comply with exact billing requirements as furnished by PRODUCER. It is further understood and agreed that PURCHASER will take and pay for newspaper ads, listing the complete supporting show. These ads shall be taken not later than seven (7) days prior to the performance date and copies of these ads are to be furnished to the PRODUCER.

7. It is understood and agreed that tickets for this performance are not to go on sale prior to April 12, 1965.

8. The PURCHASER agrees to furnish the following at no expense to the PRODUCER.

a) One (1) one-ton enclosed truck with a driver and one (1) assistant.
b) One (1) 30-passenger bus with driver.
c) Two (2) seven-passenger Cadillac limousines (air-conditioned if possible), with chauffeurs.

continued.....

=3=
NEMS ENTERPRISES, INC.

These vehicles and drivers are to meet the party and equipment at the local airport upon arrival, and are to be at the disposal of the PRODUCER and/or his authorized representative at all times during the engagement and while THE BEATLES are in PURCHASER's city, as well as to bring the entire party and equipment back to the airport for their departure.

9. The attached contract together with this rider must be signed in all places designated by the PURCHASER and returned to General Artists Corporation, accompanied by the deposit as outlined in the contract, not later than April 11, 1965.

10. Upon return of the contract to General Artists Corporation, it is understood and agreed that PURCHASER must also provide a letter of agreement between himself and the building management and/or the concessionaire of the place of engagement, stating that the concessionaires will not be permitted to sell any souvenir merchandise in connection with this engagement, other than the official BEATLES' Souvenir Program Book. This book must be sold and distributed by the Souvenir Publishing and Distributing Company and their representatives will contact the building management directly to make necessary arrangements for the sale of this official Program Book. No other merchandise, including but not limited to, photographs, dolls, pins, games, program books, and any other novelty merchandise, is to be sold at this engagement.

11. It is understood and agreed that the PURCHASER will be required to furnish the Master Of Ceremonies for this engagement.

ACCEPTED AND AGREED TO:

NEMS ENTERPRISES, LTD.

BY: _____

BY: _____

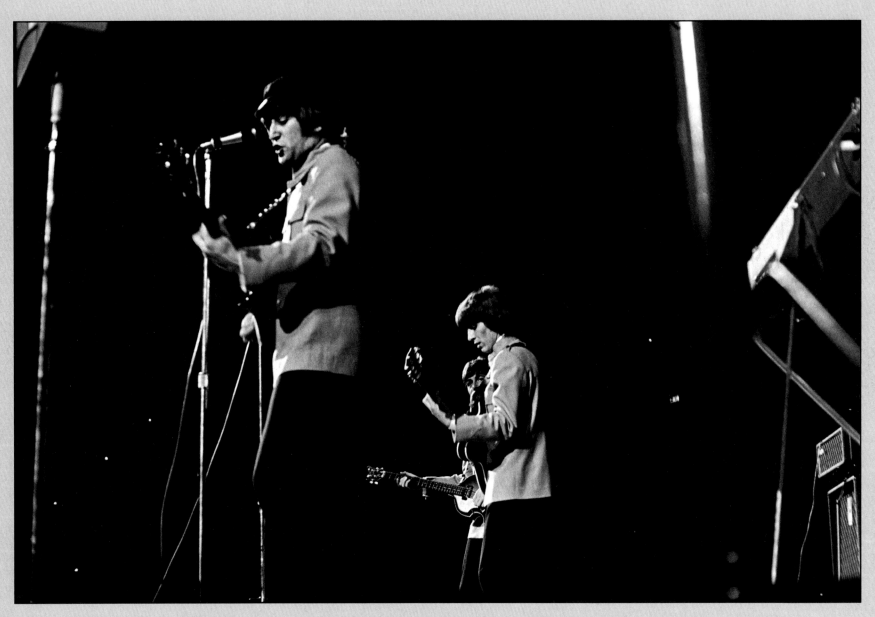

The Beatles followed the tradition of wearing matching outfits and rotated several different ones on each tour. Here they don the jackets that were so famously worn at their 1965 concert at Shea Stadium. The jackets would come to be refered to as the "Shea jackets," even though that was not the only concert where they were seen.

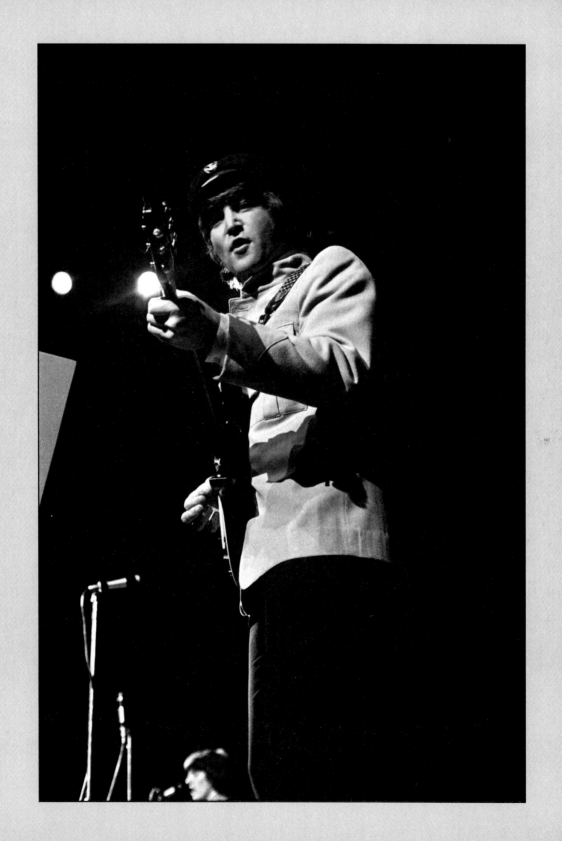

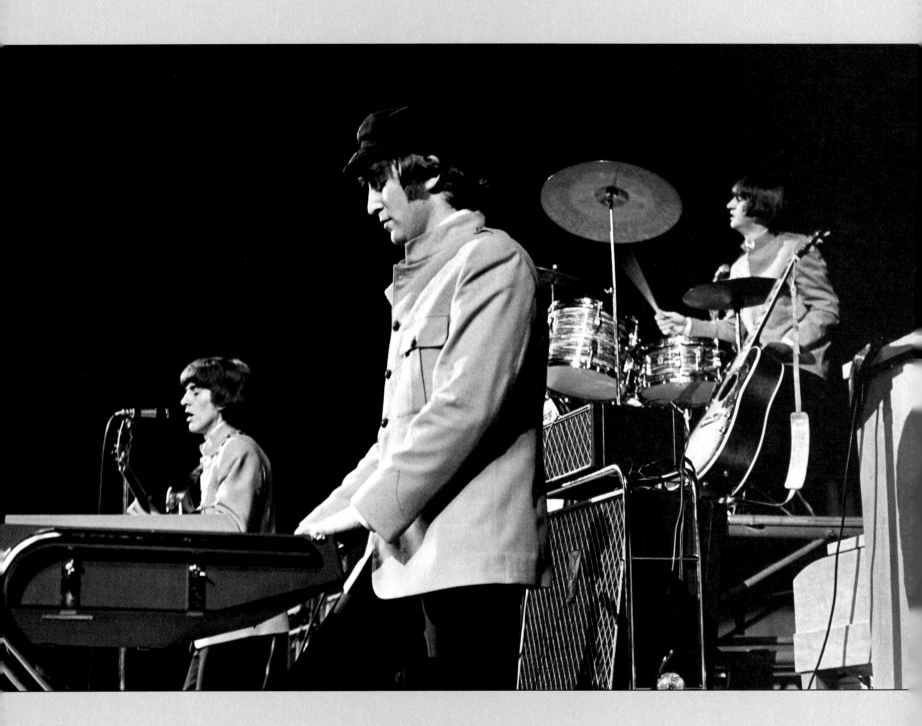

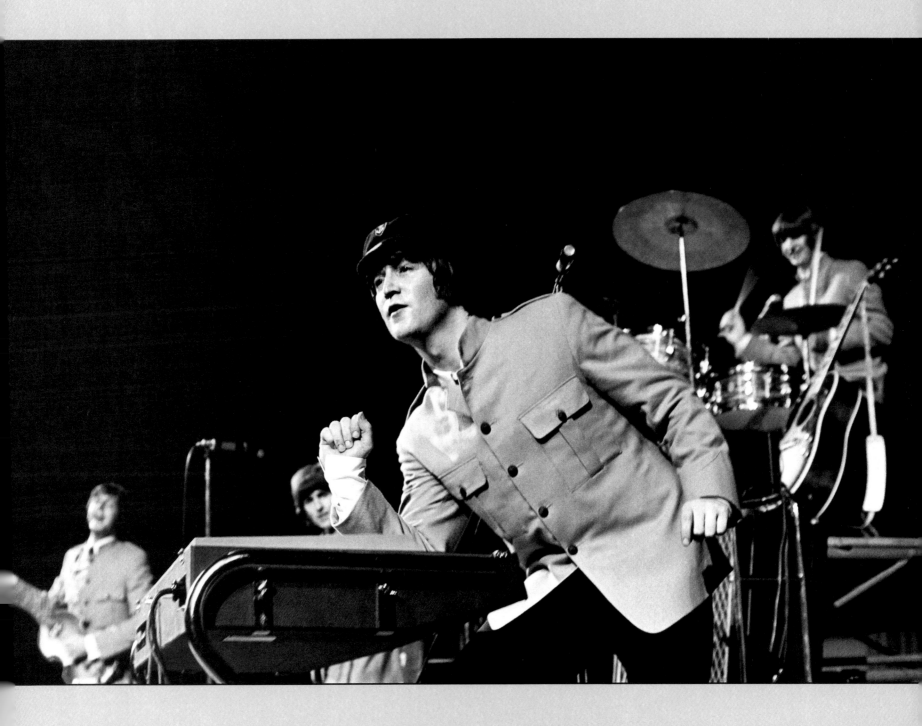

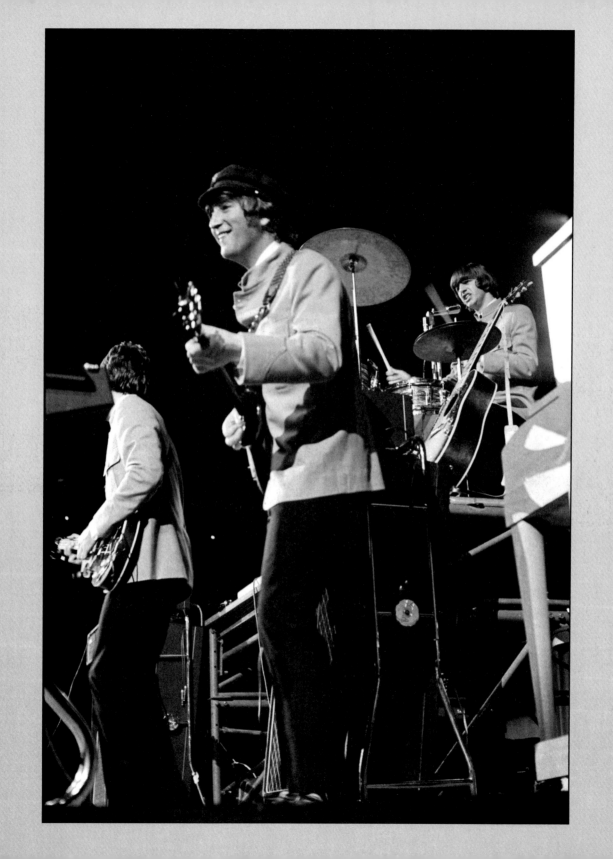

EN ROUTE TO COW PALACE, SAN FRANCISCO, CALIFORNIA

AUGUST 30, 1965

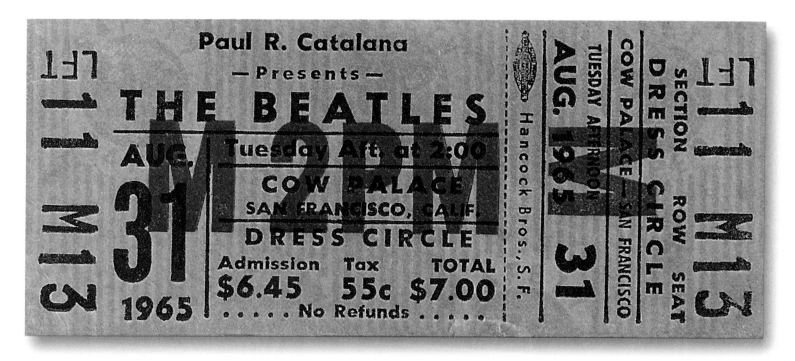

THE BEATLES closed out their second tour of America with a return to Cow Palace near San Francisco, California, where they had opened their first full tour of America in August 1964.

After they had performed two sold-out shows at the Hollywood Bowl, they flew from Los Angeles accompanied by Joan Baez. Later, Johnny Cash would visit them backstage.

Before the two shows at Cow Palace, they had performed sixteen times in nine different cities—including their third *Ed Sullivan* appearance—in front of more than 300,000 screaming fans over the span of sixteen days.

They had one more show to go before taking a much-earned six-week break, then getting back together again to record the LP *Rubber Soul.*

They performed two shows at Cow Palace. The afternoon show drew 11,700 fans, and the evening performance drew 17,000 more, who paid from $4.00 to $7.00 for their tickets.

The crowds at these shows were especially wild, and at one point the show had to be stopped for ten minutes to restore order after fans rushed the stage and broke through the barricades.

Paul R. Catalana

again presents . . .

The BEATLES

RINGO

AUGUST 31, 1965

COW PALACE

SAN FRANCISCO

GEORGE

Choice Seats Still Available

FOR 2 P.M. MATINEE ONLY

(evening performance sold out)

JOHN

PAUL

- -

ORDER FORM

BEATLES CONCERT — 2 p.m. AUGUST 31, 1965
COW PALACE ● SAN FRANCISCO

Mail To: **BEATLES TICKETS**
30 South First St.
San Jose, Calif. 95113
(THIS ADDRESS ACCEPTS
MAIL ORDERS ONLY.)

**SEATS ARE RESERVED FOR
YOUR AREA**

*(Note: Tickets for your area's
section cannot be reserved
after August 11)*

NAME ...

ADDRESS ...

CITY .. STATE

PLEASE RUSH ME TICKETS @ $6.50 Each (includes handling and postage)

PLEASE RUSH ME TICKETS @ $7.50 Each (includes handling and postage)

MY CHECK IN THE AMOUNT OF $.......................... **IS ENCLOSED**

TICKETS ARE FOR MATINEE ONLY . . . AUG. 31, 1965, 2 p.m.

(Note: Evening Performance tickets are all sold)

*Please enclose a
self-addressed
envelope!*

TUCKER PRINTING SAN JOSE

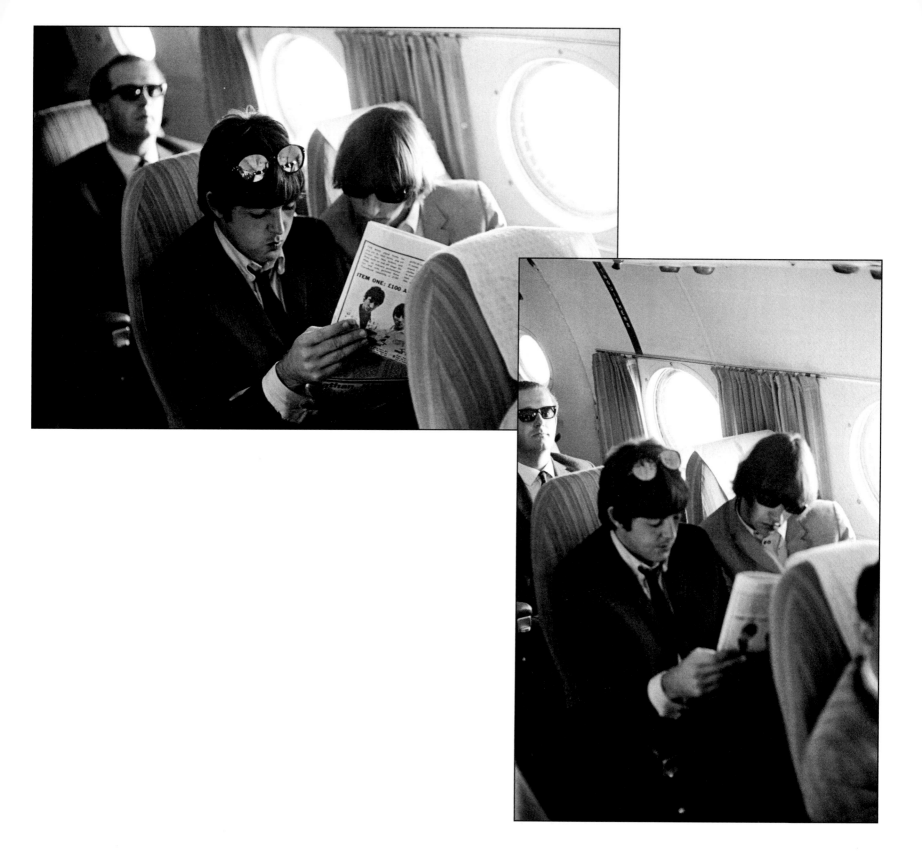

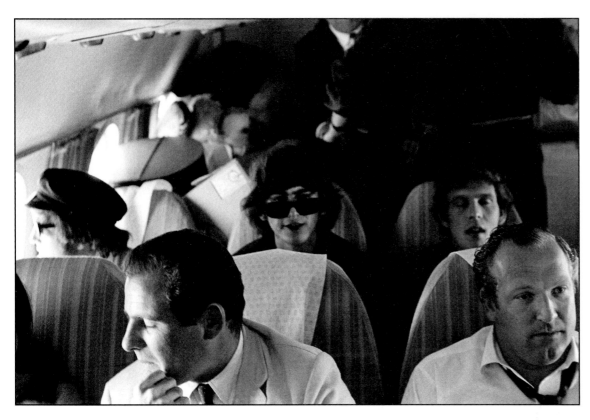

Neil Aspinall en route to San Francisco with
John and George.

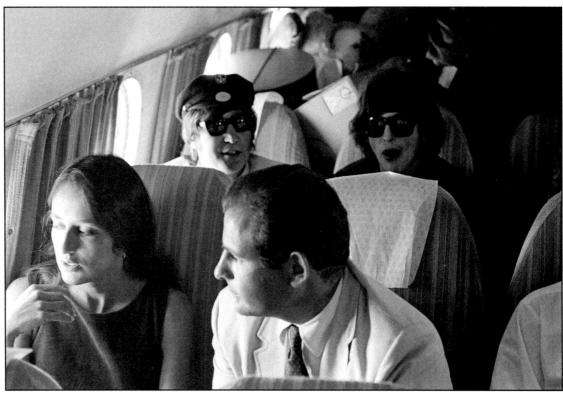

Joan Baez on the plane with John and George.

THIS WAS the last tour The Beatles would ever do. It would take place under the cloud of controversy created by John Lennon's quote about The Beatles being "more popular than Jesus."

On March 4, 1966, London's *Evening Standard* published an interview with John Lennon and his friend, journalist Maureen Cleave. In this interview, John made the following statement: "Christianity will go. It will vanish and shrink. I needn't argue with that; I'm right and I will be proved right. We're more popular than Jesus now; I don't know which will go first—rock 'n' roll or Christianity. Jesus was all right but his disciples were thick and ordinary. It's them twisting it that ruins it for me." John had been reading extensively about religion at the time, and his statement was a small part of a much larger article. In Britain it barely raised an eyebrow.

But on July 29, 1966, the American magazine *Datebook* published an excerpt of the interview, highlighting the "We're more popular than Jesus" quote out of context and using it as part of its cover story. The reaction was severe: Radio stations in the South banned The Beatles' music and sponsored rallies where parents and teens smashed Beatles records and bonfires where they burned Beatles memorabilia. John Lennon received death threats.

Preceding their first concert of the tour, in Chicago, The Beatles met with the press to try and move past the controversy, and John apologized.

Q—Could you tell us what you really meant by that statement?

John—I wasn't saying whatever they were saying I was saying . . . That's the main thing about it. I was just talking to a reporter—but she also happens to be a friend of mine and the rest of us—at home. It was a sort of in-depth series she was doing. And so I wasn't really thinking in terms of PR or translating what I was saying. It was going on for a couple of hours, and I just said it as—just to cover the subject . . . I didn't mean it the way they said it. It's amazing. It's just so complicated. It's got out of hand . . . I wasn't saying The Beatles are better than Jesus or God or Christianity. I was using the name Beatles because I can use them easier, 'cause I can talk about Beatles as a separate thing and use them as an example, especially to a close friend. But I could have said TV, or cinema, or anything else that's popular . . . or motorcars are bigger than Jesus. But I just said Beatles because, you know, that's the easiest one for me. I just never thought of repercussions. I never really thought of it . . . I wasn't even thinking, even though I knew she was interviewing me, you know, that it meant anything.

Q—What's your reaction to the repercussions?

John—Well when I first heard it, I thought "It can't be true." It's just like one of those things like "Bad Eggs in Adelaide" and things.

And then when I realized it was serious, I was worried stiff, you know, because I knew sort of how it'd go on. And the more things that'd get said about it, and all those miserable-looking pictures of me looking like a cynic, and that. And they'd go on and on and it'd get out of hand, and I couldn't control it, you know. I can't answer for it when it gets that big 'cause it's nothing to do with me then.

Q—A disc jockey in Birmingham, Alabama, who really started most of the repercussions, has demanded an apology from you.

John—He can have it . . . I apologize to him if he's upset and he really means it . . . I'm sorry. I'm sorry I said it for the mess it's made. But I never meant it as a lousy or antireligious thing, or anything . . . I can't say anymore than that. There's nothing else to say really . . . no more words. But if an apology—if he wants one . . . he can have it. I apologize to him.

After two tour-opening shows in Chicago, The Beatles traveled to Detroit, where they played two shows to a combined audience of 30,800 fans, 14,000 at the afternoon show and 16,800 at the evening show, who paid $3.50 to $5.50 for their tickets.

The set list for this concert was: "Rock and Roll Music," "She's a Woman," "If I Needed Someone," "Baby's in Black," "Day Tripper," "I Feel Fine," "Yesterday," "I Wanna Be Your Man," "Nowhere Man," "Paperback Writer," "Long Tall Sally."

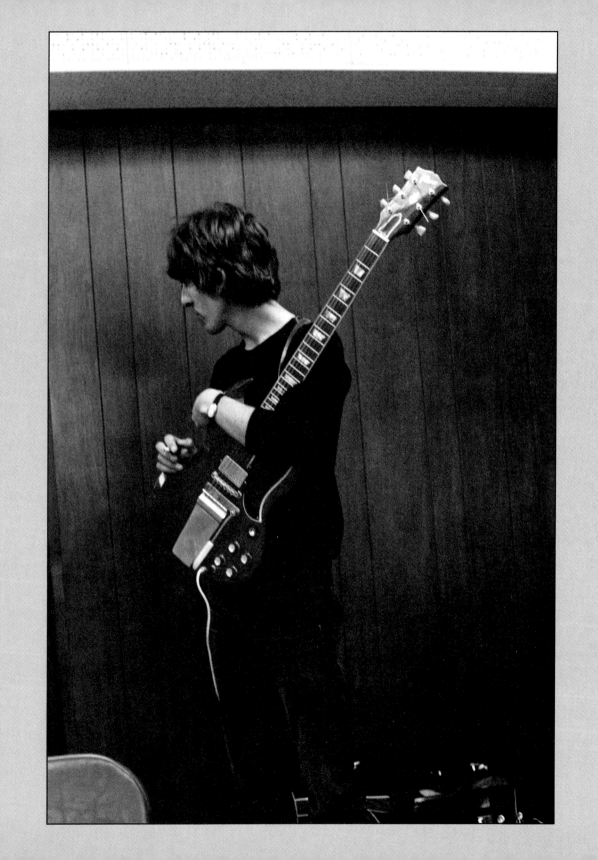

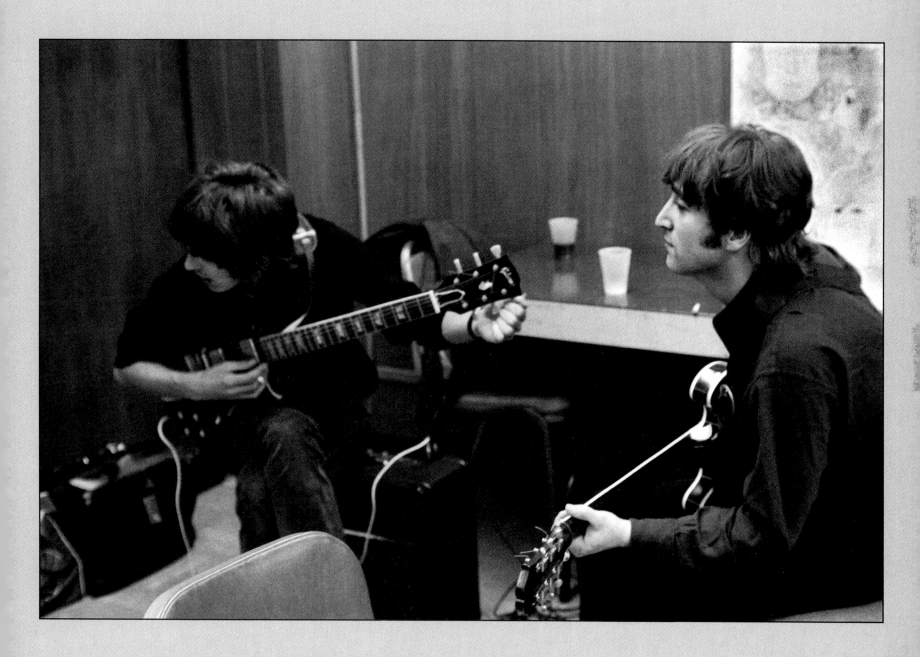

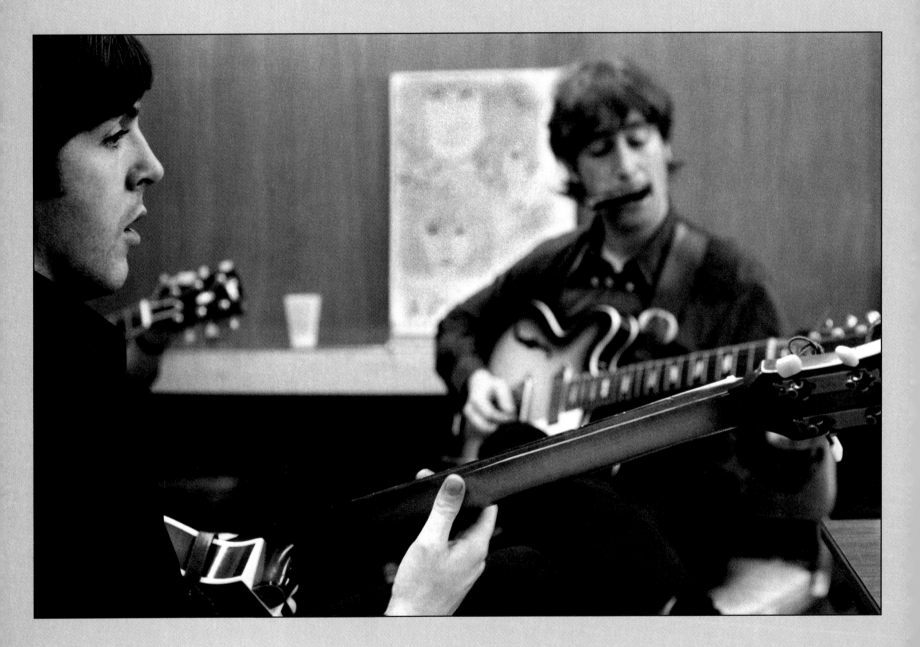

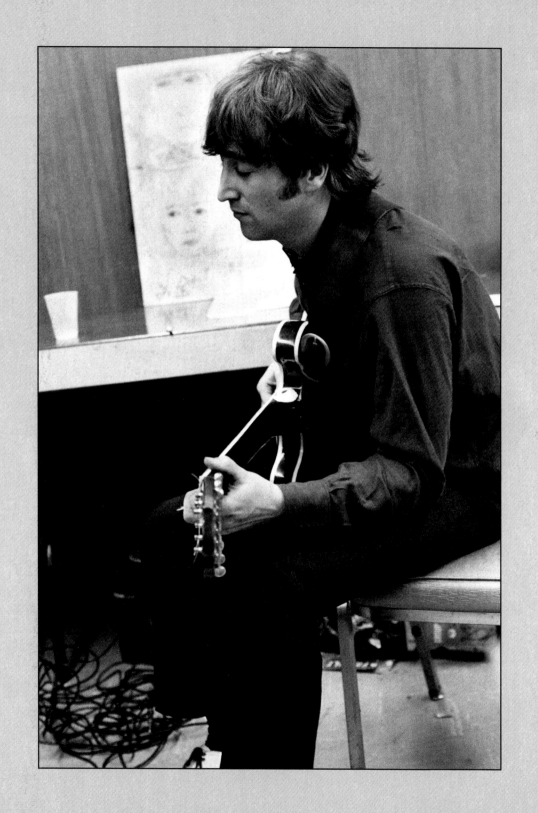

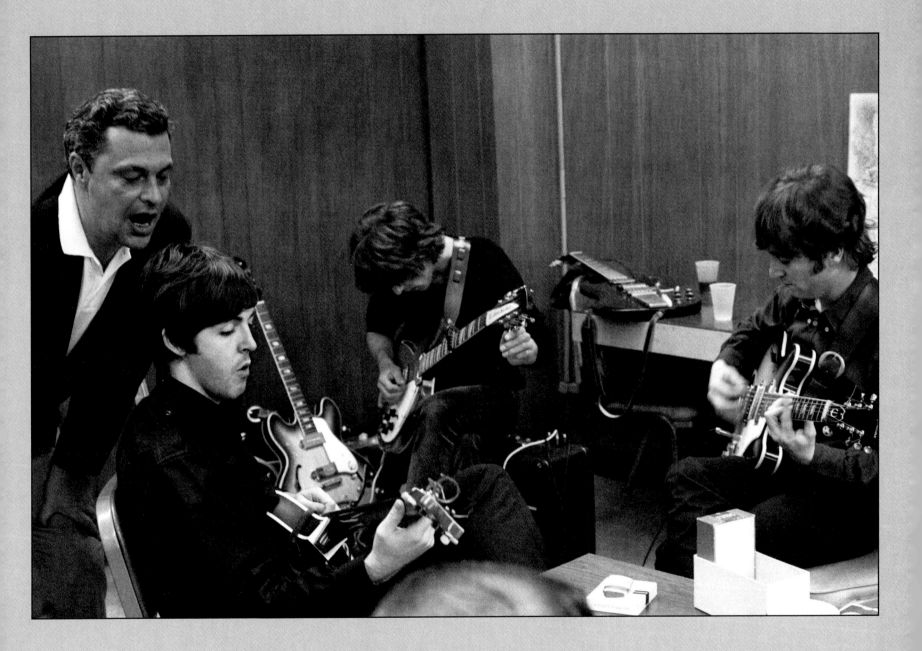

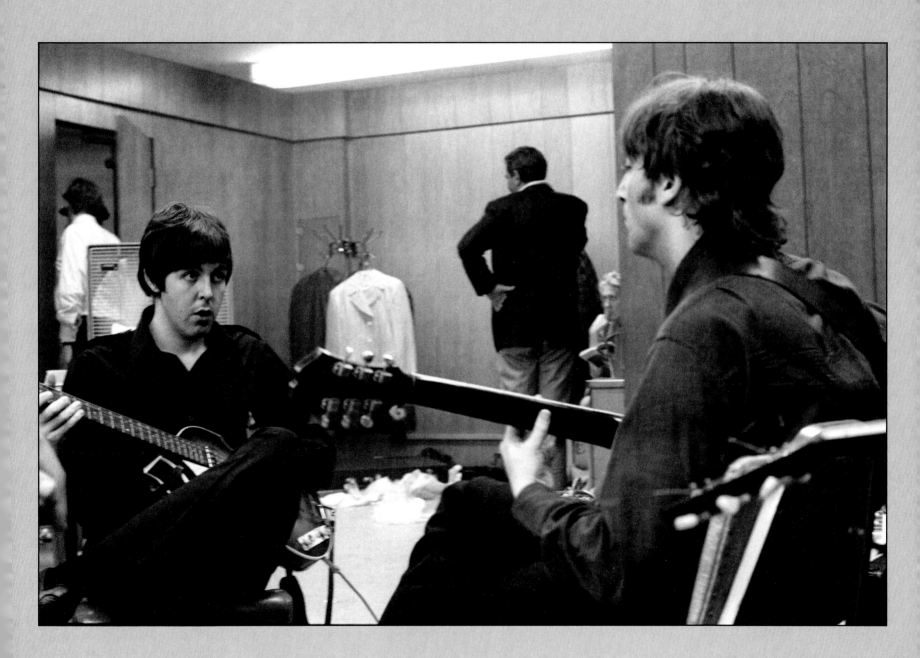

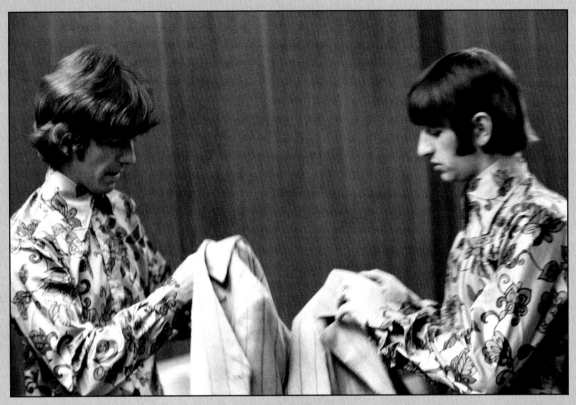

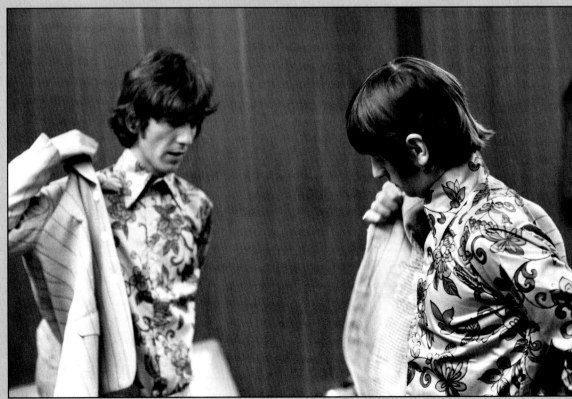

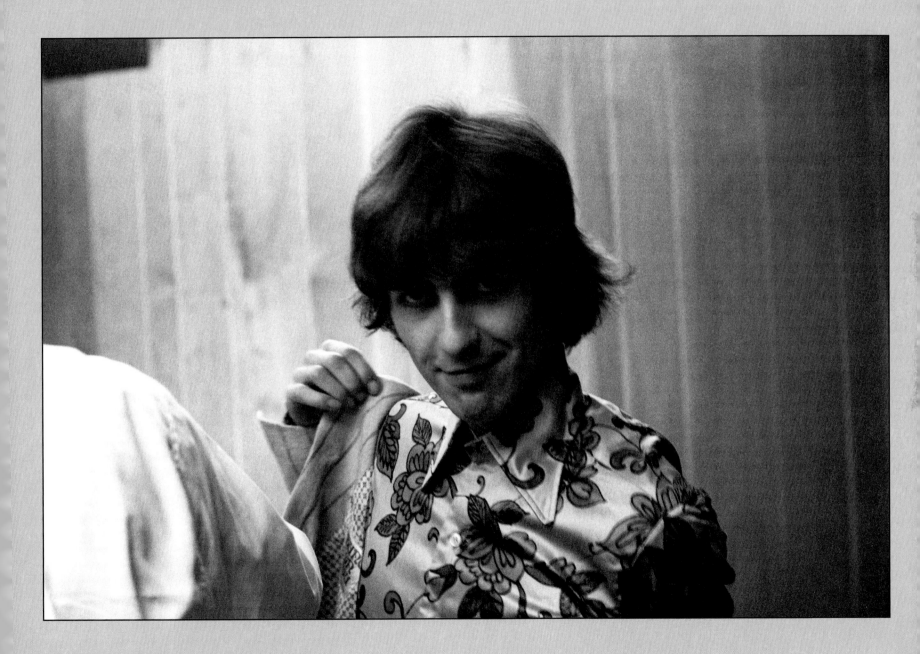

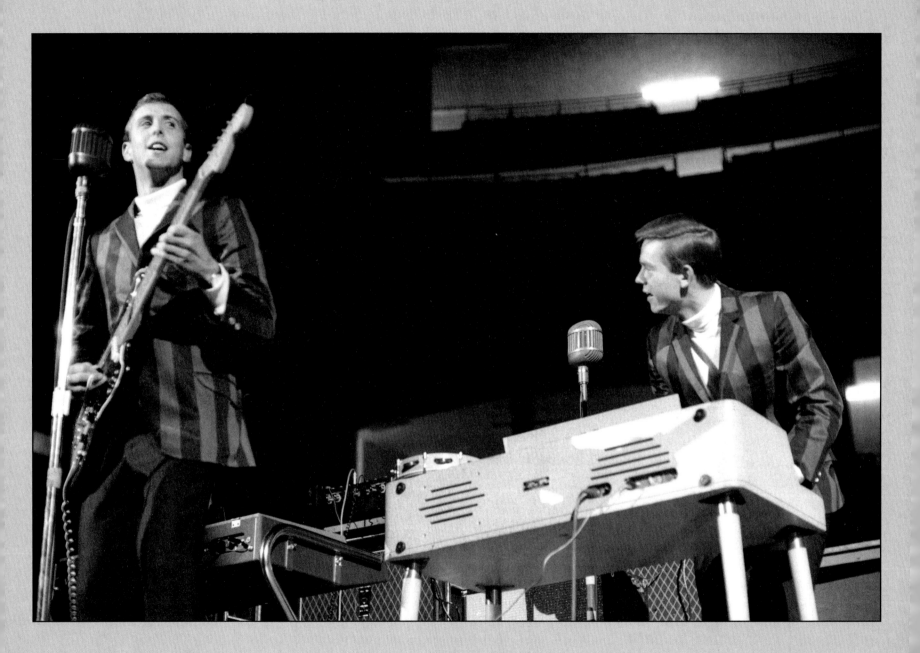

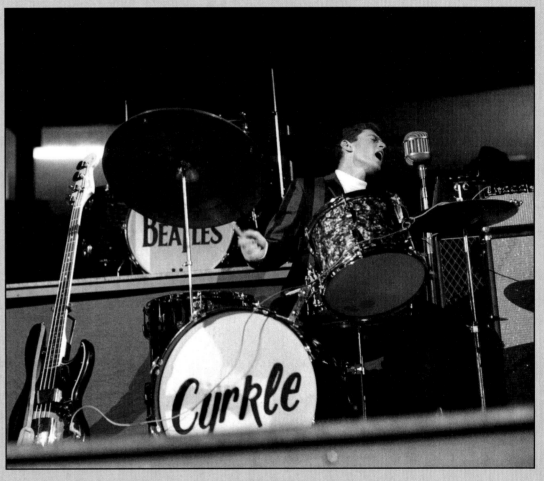

The Cyrkle was one of four acts that opened for The Beatles' 1966 U.S. tour. The other acts were Bobby Hebb, The Remains, and The Ronettes. The Cyrkle consisted of Don Dannemann, Tom Dawes, Earl Pickens, and Marty Fried. They were a "frat rock" band playing in Atlantic City when Nat Weiss came upon them and recommended them to Brian Epstein, who signed on to manage them. He helped them secure a recording contract with Columbia Records and renamed them The Cyrkle, after the term for a roundabout in their hometown of Easton, Pennsylvania. John Lennon suggested the spelling change from "Circle" to "Cyrkle." They had a big hit with the Paul Simon–Bruce Woodley–penned "Red Rubber Ball" and followed that with "Turn Down Day." Dawes and Dannemann went on to become successful jingle writers. Dawes created the famous "Plop, Plop, Fizz, Fizz" jingle for Alka Seltzer.

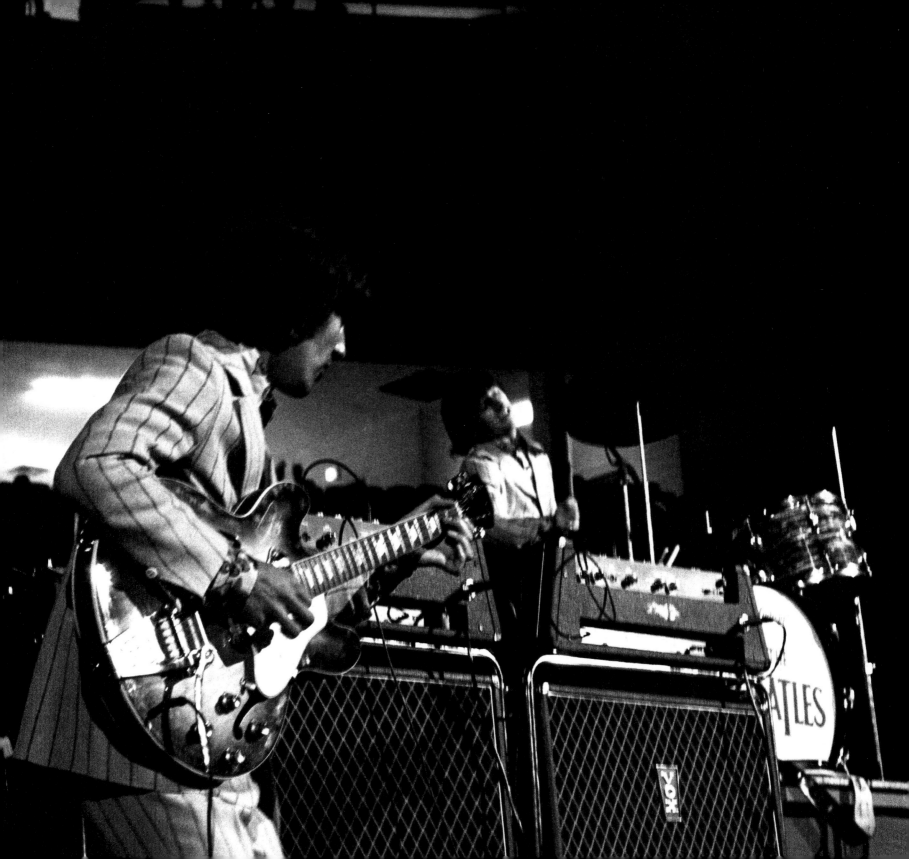

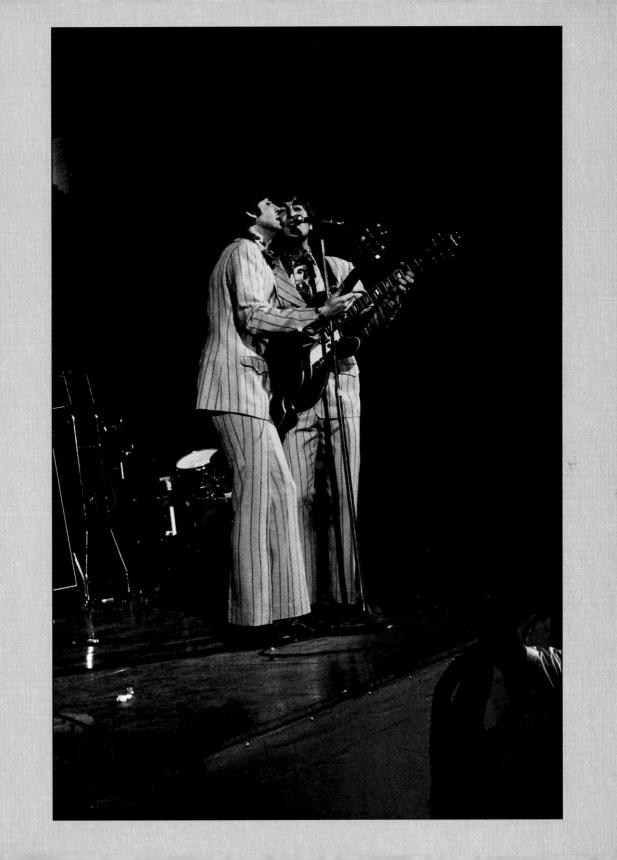

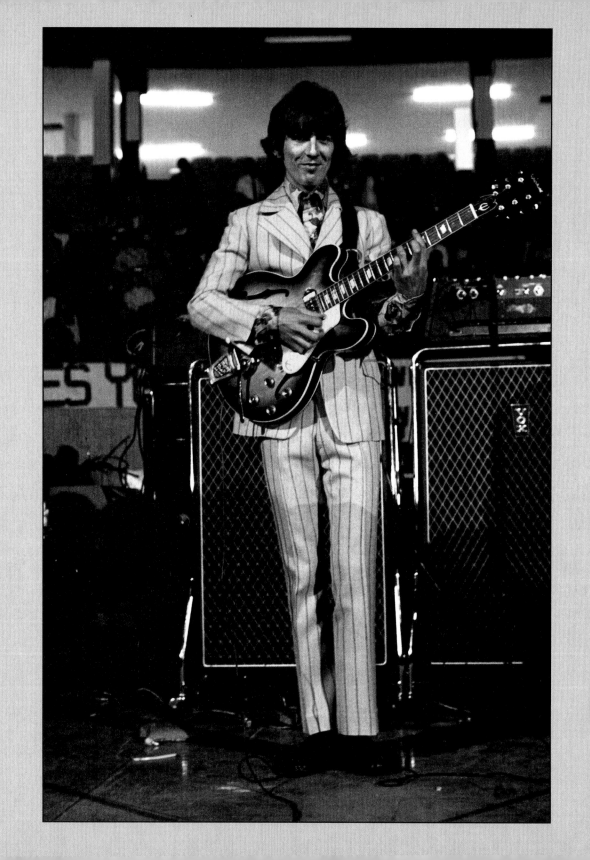

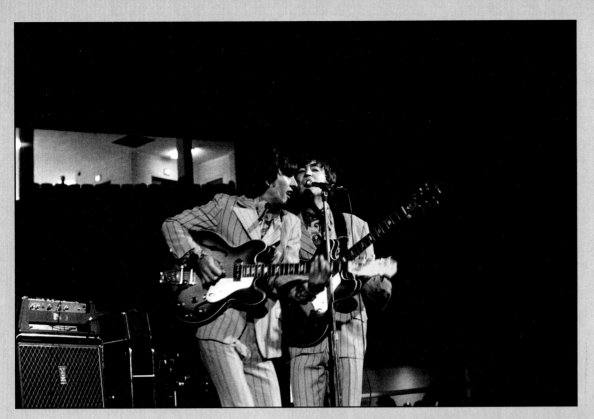
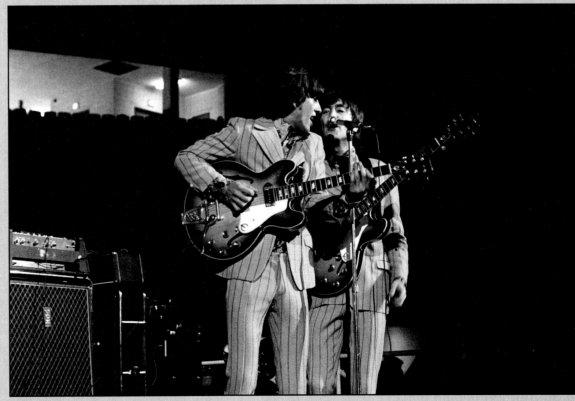

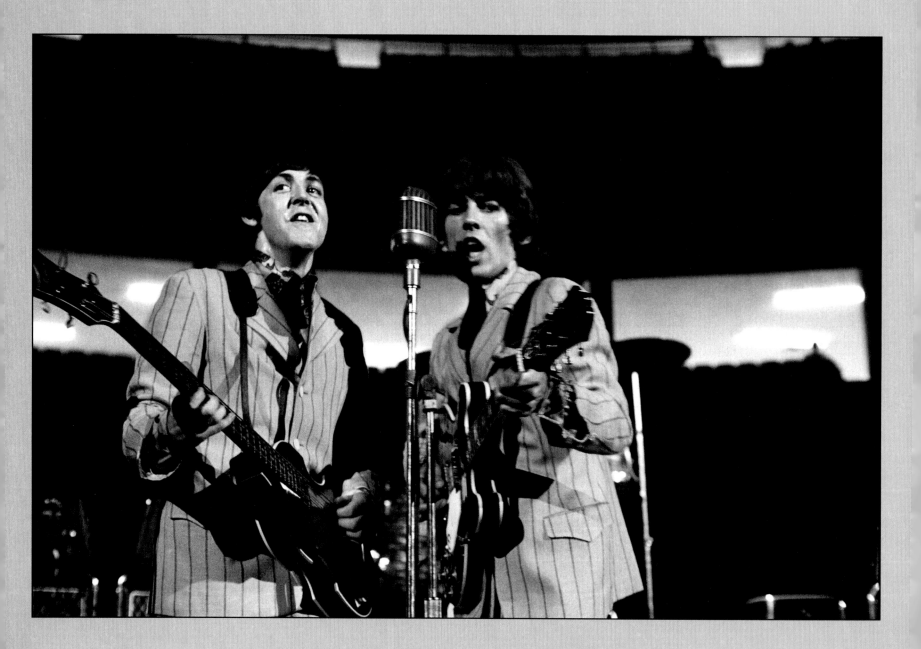

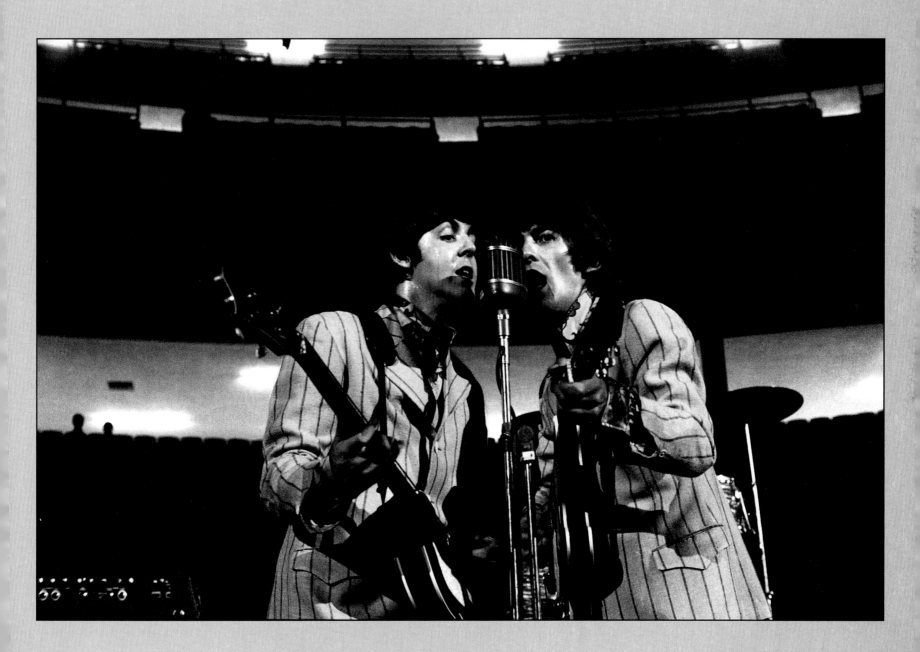

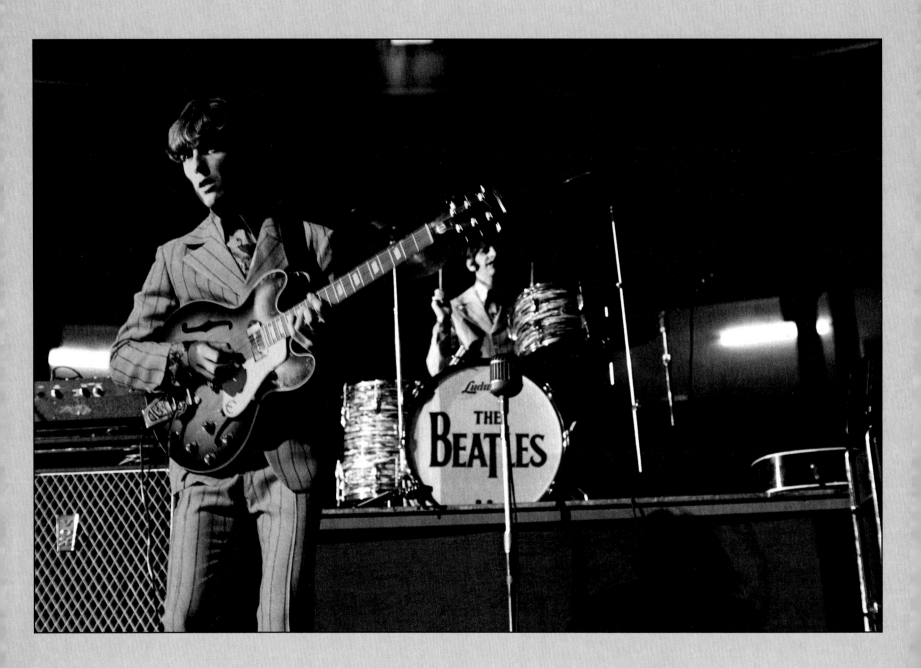

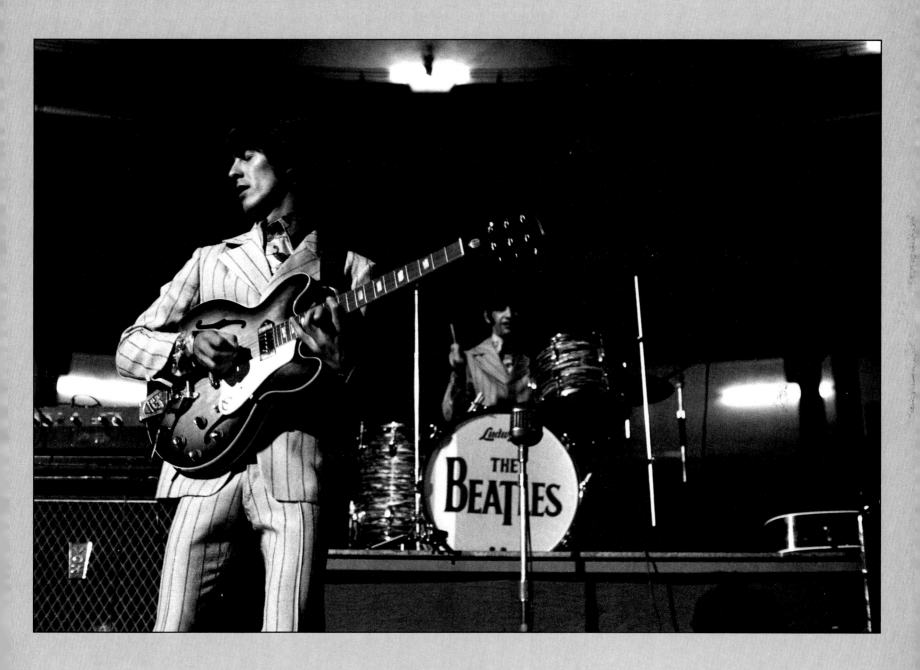

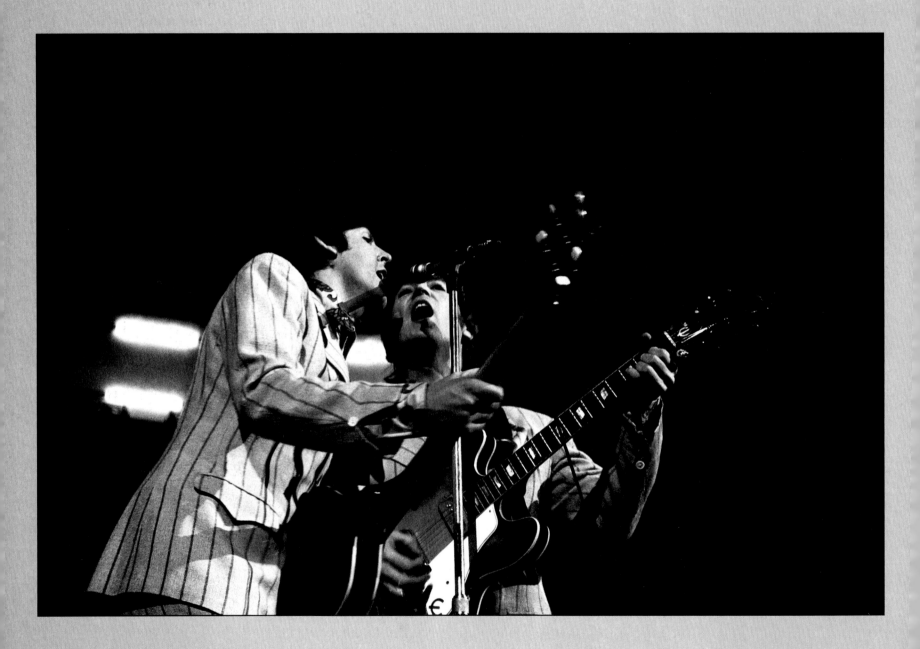

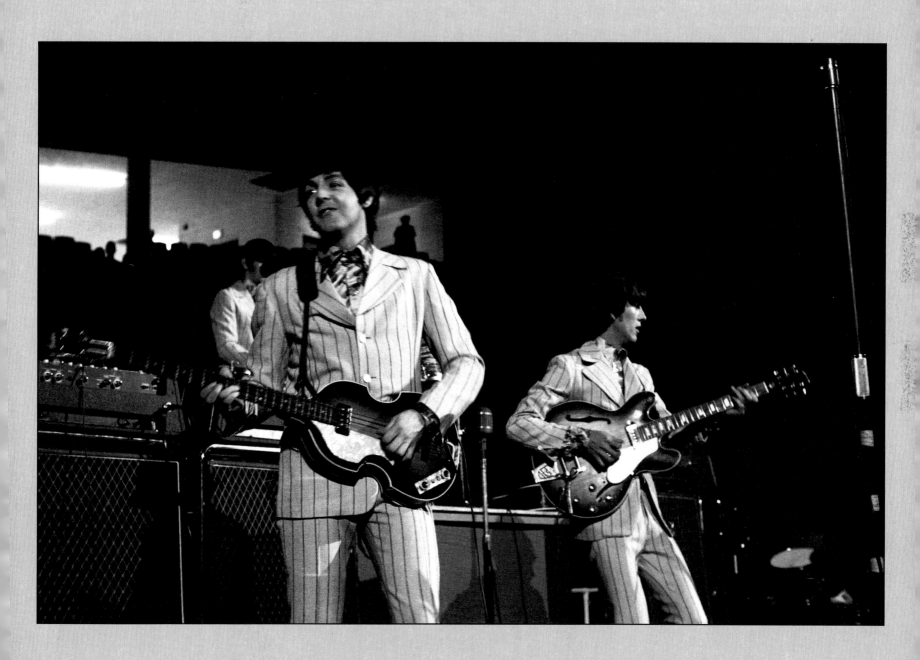

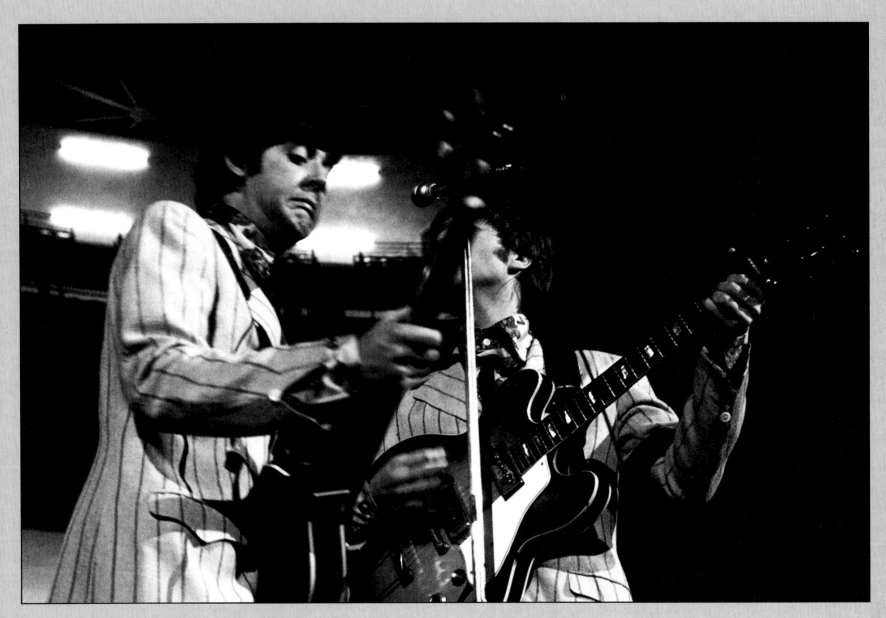

Paul reacts to playing a wrong note.

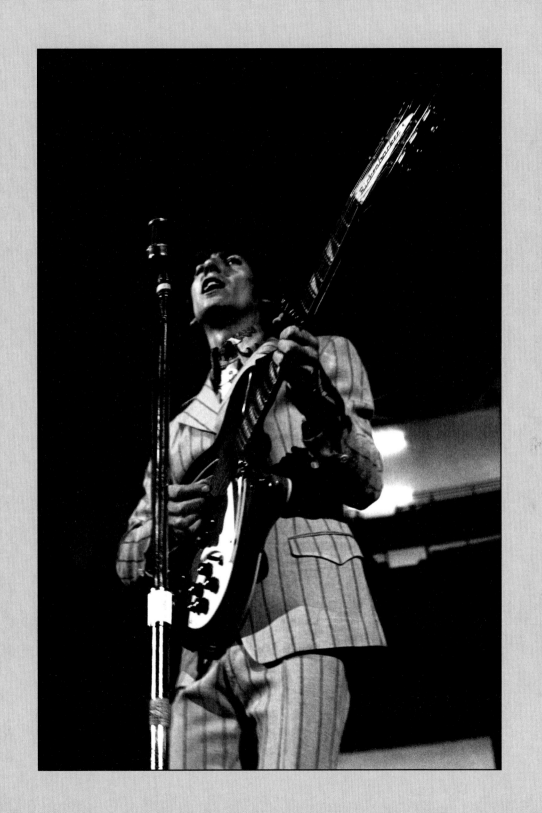

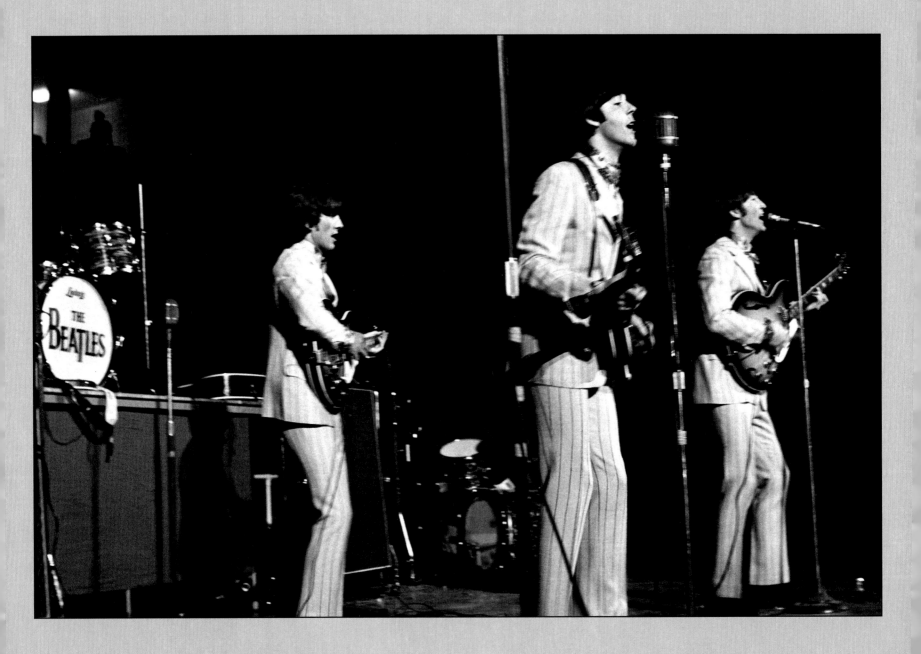

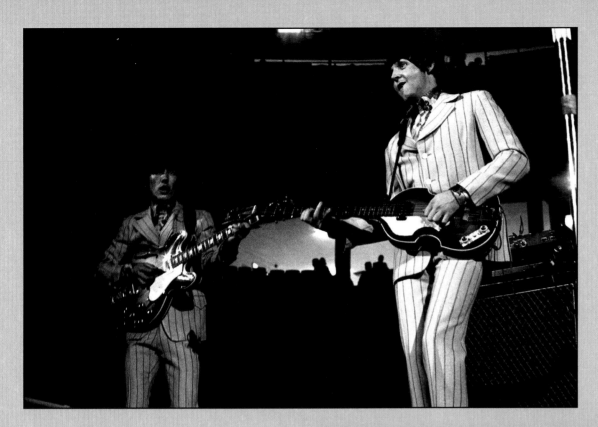
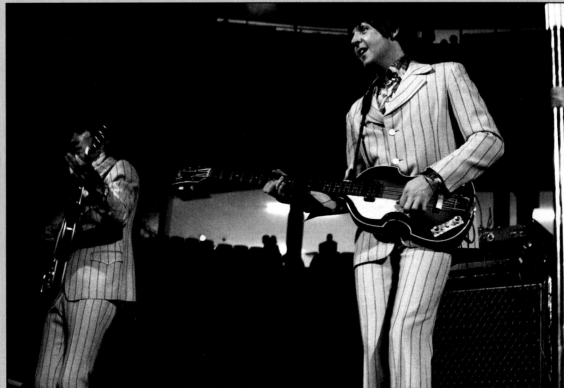

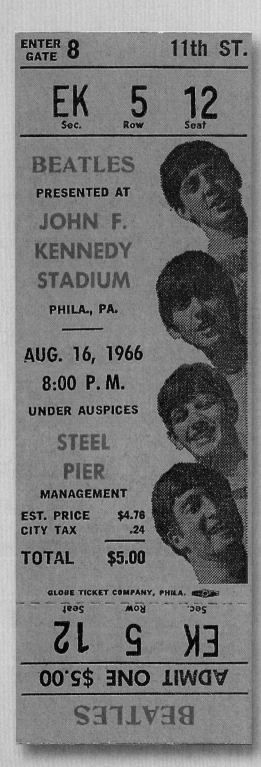

PHILADELPHIA, PENNSYLVANIA

AUGUST 16, 1966

THE OPENING acts on the 1966 tour were Bobby Hebb, The Cyrkle, The Ronettes, and The Remains.

The Beatles' concert was the first concert ever at JFK Stadium, but it was certainly not the largest concert ever held there. A little over 21,000 fans attended the show (far from a sellout), compared with 99,000 who attended Live Aid in 1993. (Tickets for The Beatles were $3.00 for general admission and $5.00 for reserved seats.)

The show was sponsored by George A. Hamid, the owner and promoter of the world-famous Steel Pier in Atlantic City, New Jersey. The back of the tickets advertised acts appearing at the Steel Pier that summer, including The Rolling Stones, The Dave Clark Five, and The Animals. The British Invasion dominated entertainment that season.

The set list was: "Rock and Roll Music," "She's a Woman," "If I Needed Someone," "Baby's in Black," "Day Tripper," "I Feel Fine," "Yesterday," "I Wanna Be Your Man," "Nowhere Man," "Paperback Writer," "I'm Down."

Instead of the usual press conference, The Beatles allowed six newsmen to interview them in the dressing room before the show. The next seven photos are of The Beatles backstage at JFK Stadium, tuning up and relaxing.

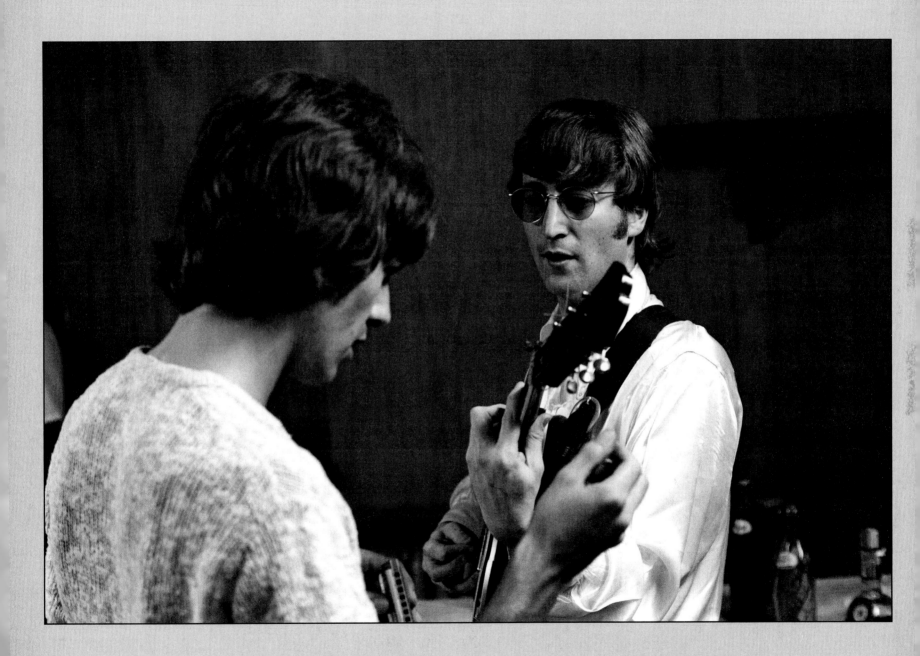

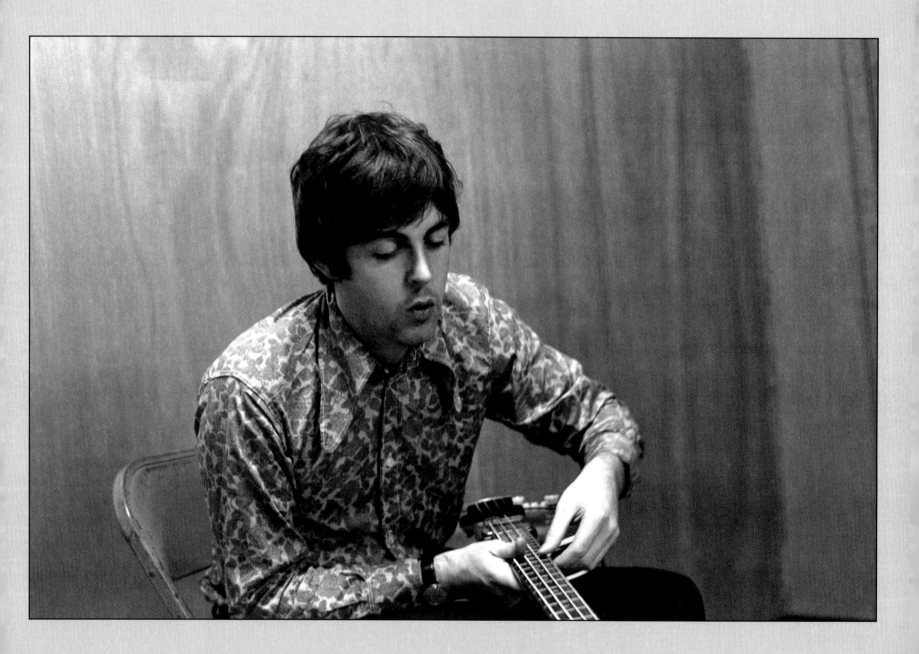

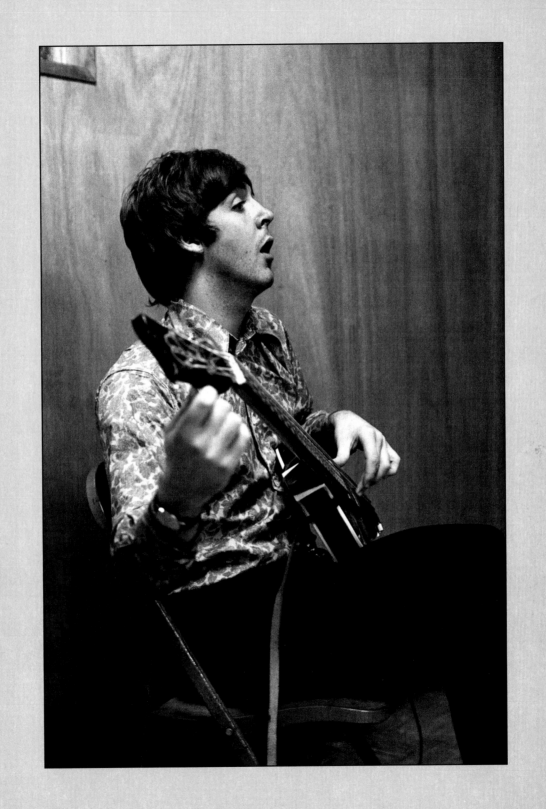

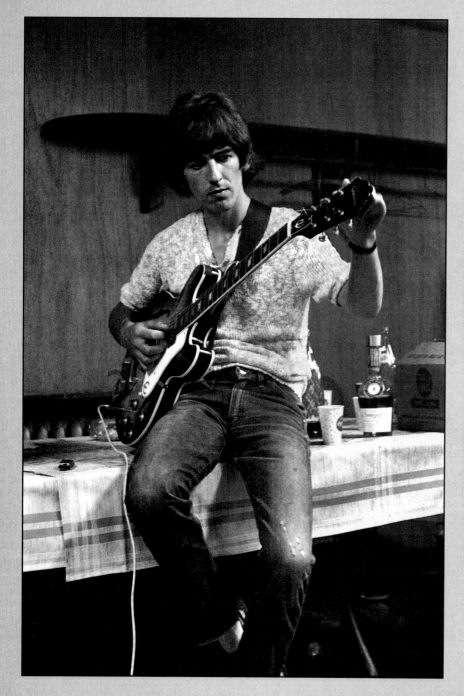
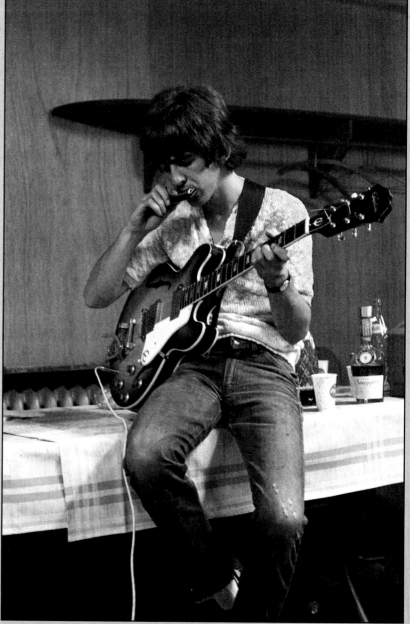

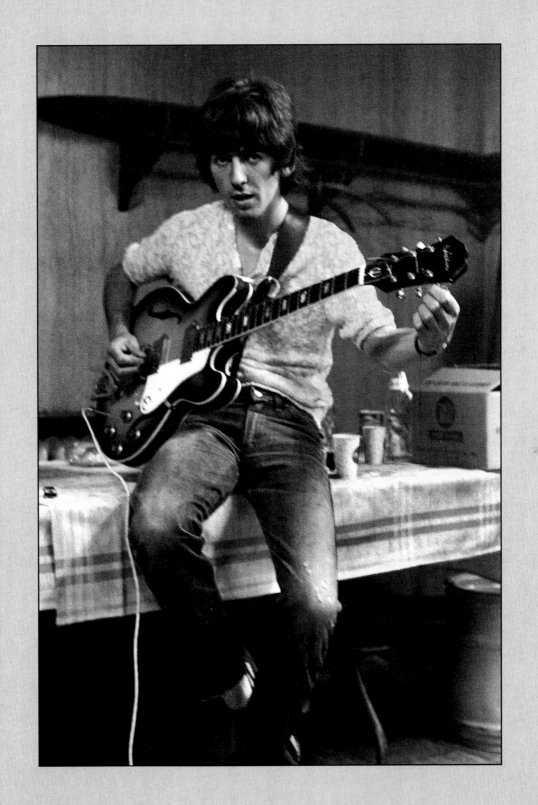

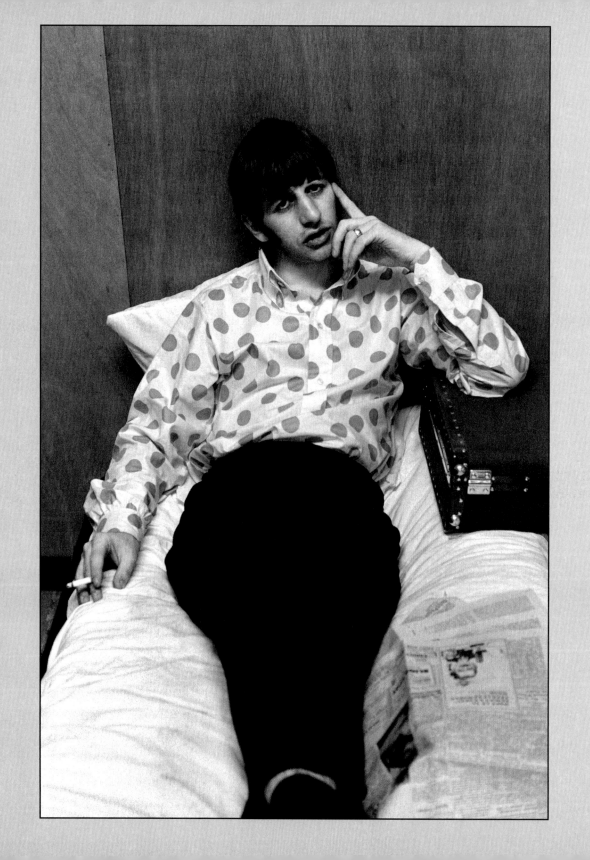

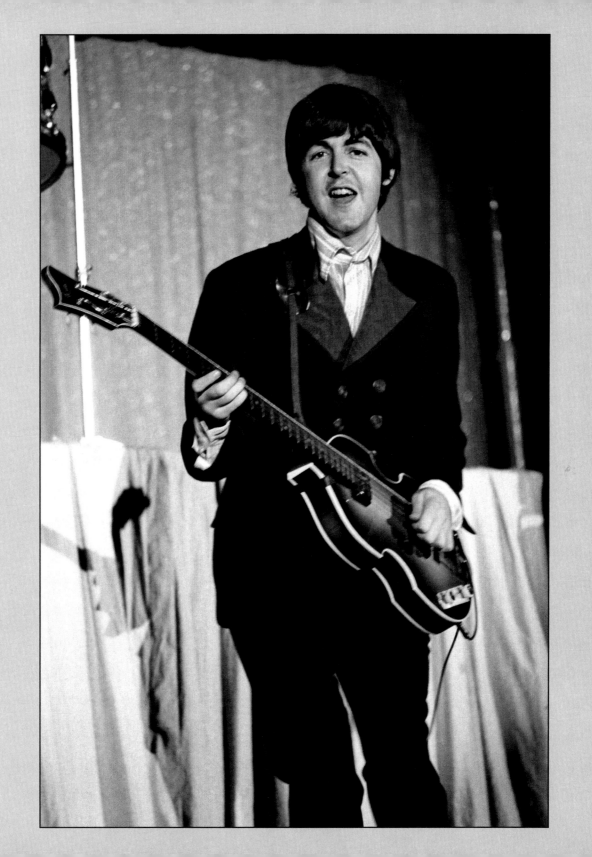

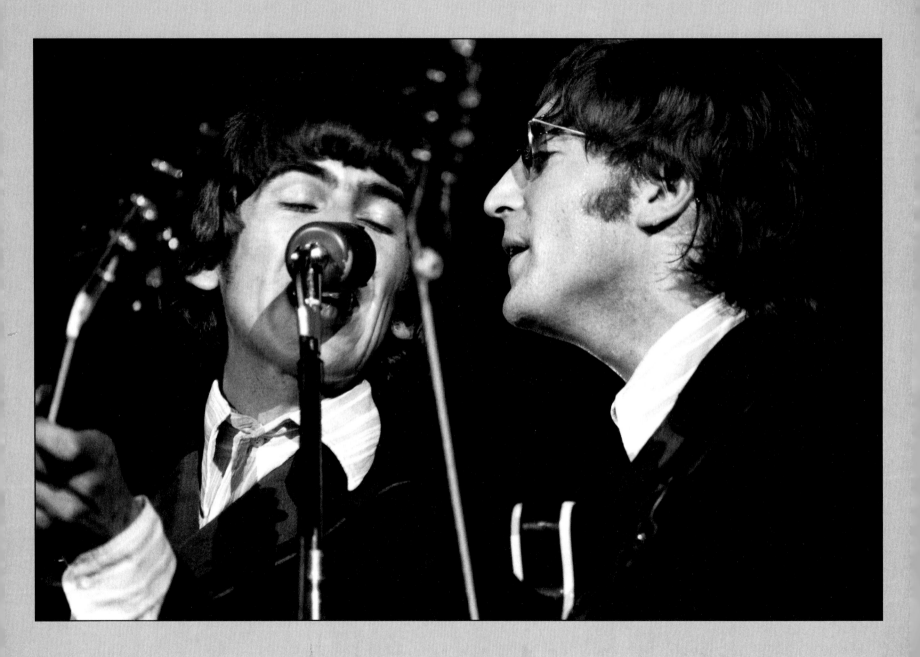

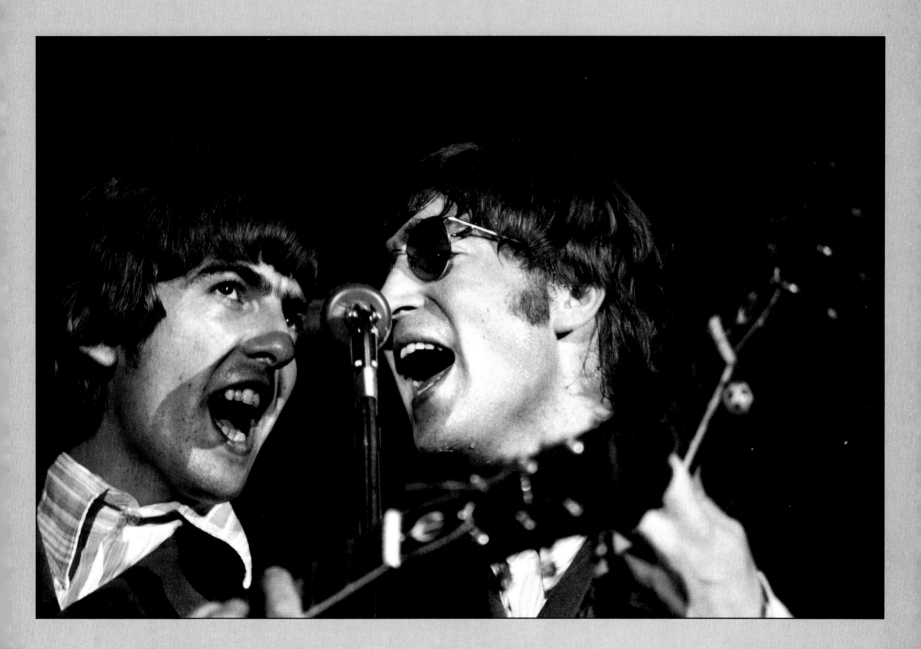

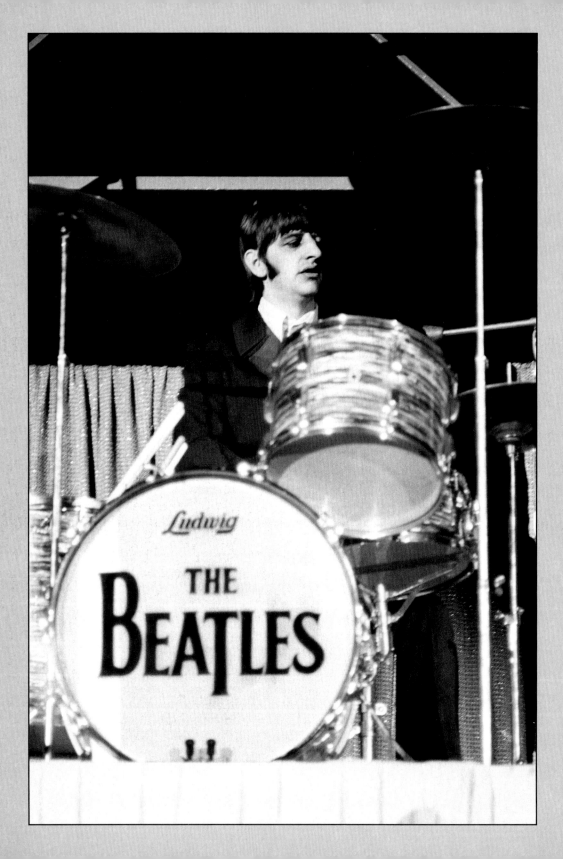

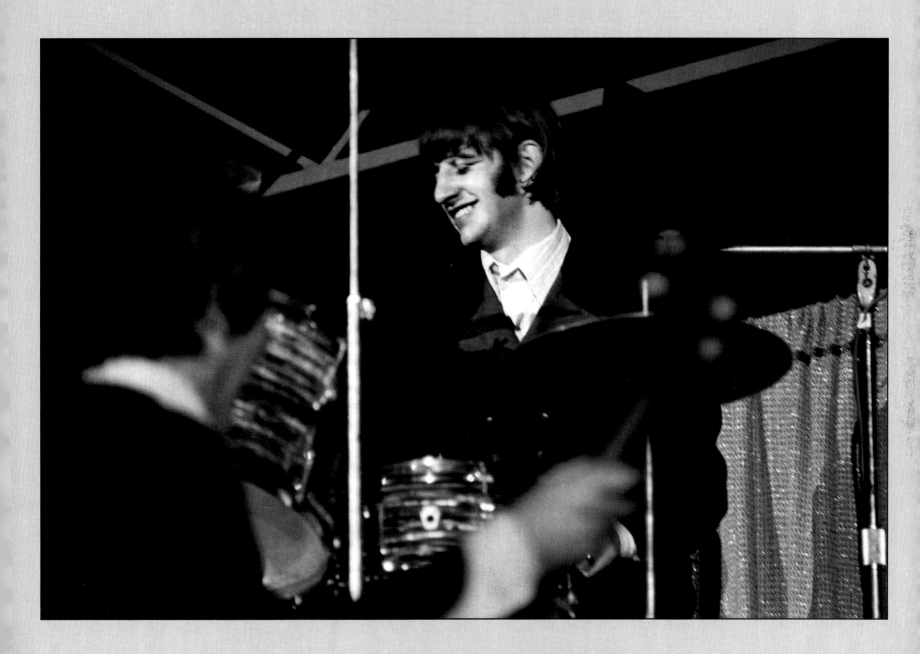

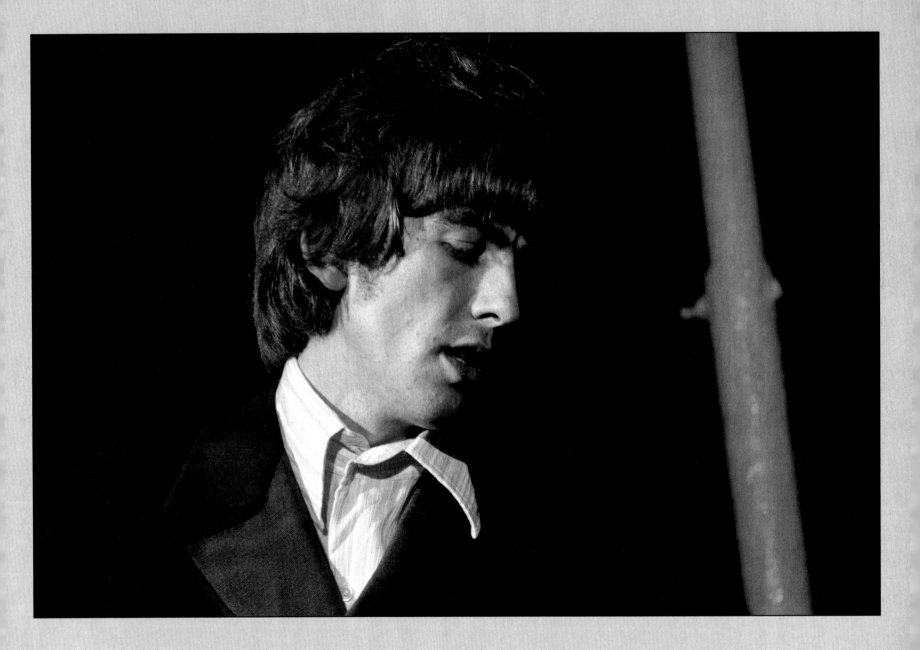

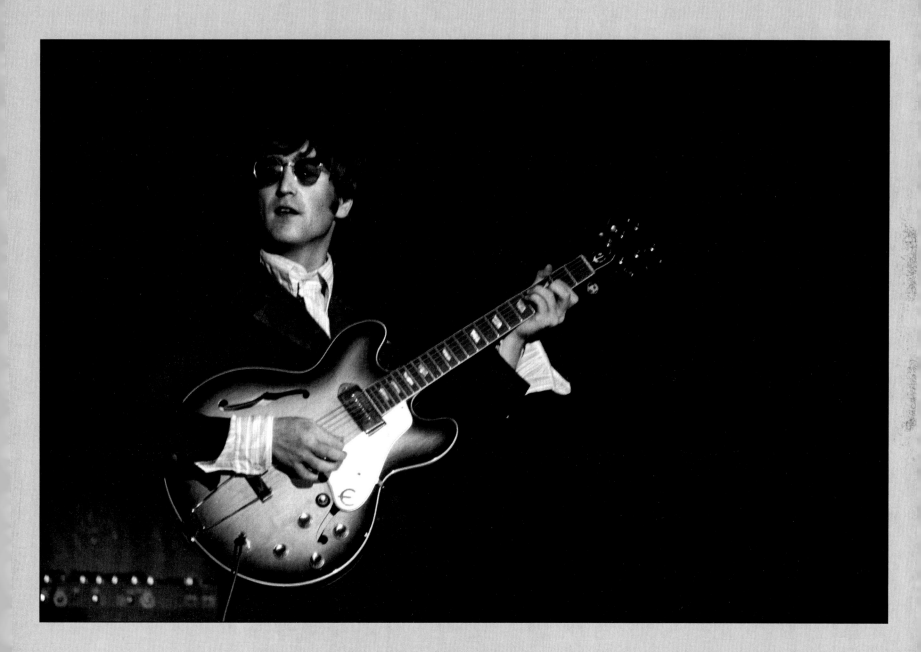

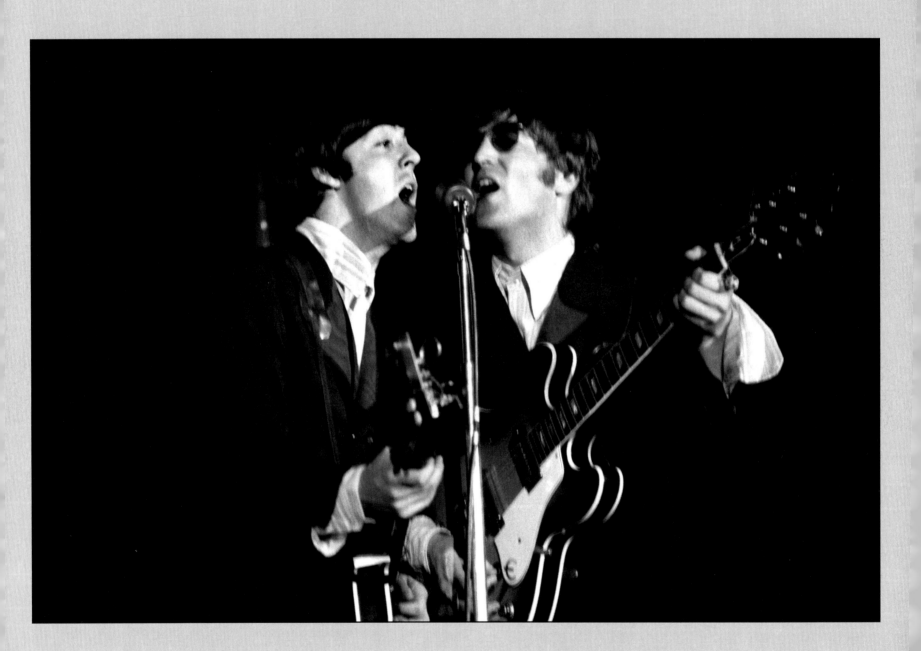

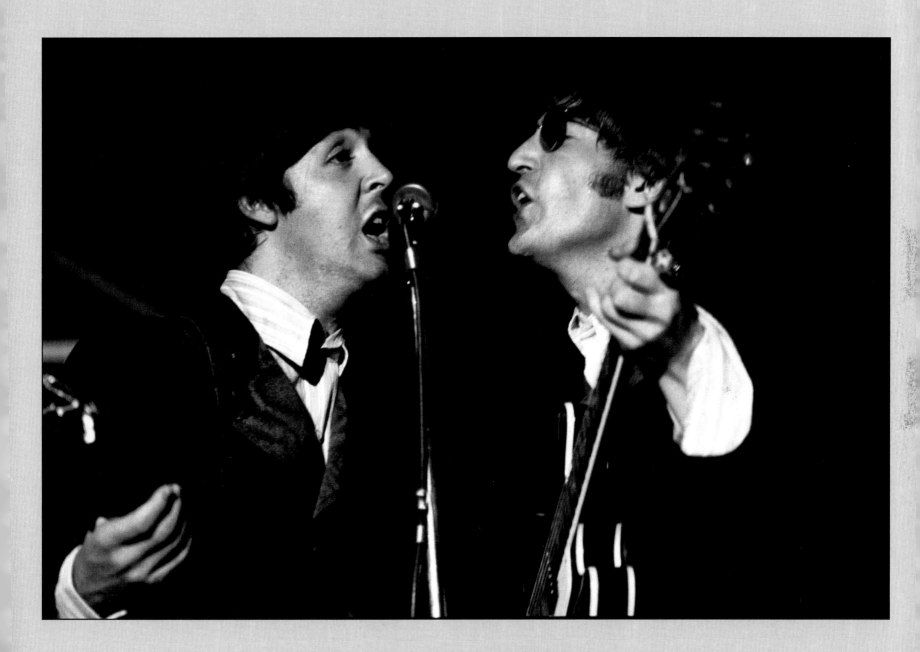

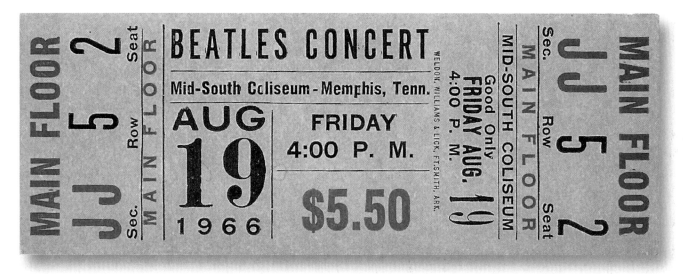

ON THE morning of August 19, The Beatles and their entourage woke up early for a flight to Memphis. The flight was unusually quiet, and Barry Tashian of The Remains sat across from John for a few minutes and asked how he was doing. John replied, "Ask me after Memphis."

The harshest response to John's Jesus remarks came from the Bible Belt in the southern United States, and the Memphis show was their first stop on the tour in the South. Because of death threats, security was tripled. The city commission had tried unsuccessfully to cancel the concerts, and the Ku Klux Klan was even picketing one of the gates to the Coliseum.

The Beatles' plane landed at a military air strip, where everyone boarded a city bus to go to Mid-South Coliseum in Memphis. Protesters lined the bus route from the airport to the Coliseum, carrying signs that read "Go Home Beatles!" There were two shows that day in Memphis. The afternoon show was delayed one hour because of a bomb threat.

A member of the KKK was interviewed on TV with the Coliseum in the background and promised "a few surprises" for The Beatles. While there were no problems at the afternoon performance, during the evening performance someone threw a cherry bomb onstage. It sounded like a gunshot and everyone immediately looked to see if John had been shot.

Beatles press officer Tony Barrow later recalled, "All of us at the side of the stage, including the three Beatles onstage, all looked immediately at John Lennon. We would not at that moment have been surprised to see that guy go down."

Two teenagers were found with a number of cherry bombs and firecrackers. But in truth Memphis received The Beatles warmly and, other than the cherry bomb, everything went smoothly.

The afternoon show sold 7,589 tickets and the evening show was a near sellout with 12,538 seats sold. Ticket prices were $5.50. The Beatles received $71,957.60 as their share of the $110,704 total take for the two shows.

A newspaper advertisment for the concert the day before read "Go to Church on Sunday, but SEE THE BEATLES Friday!"

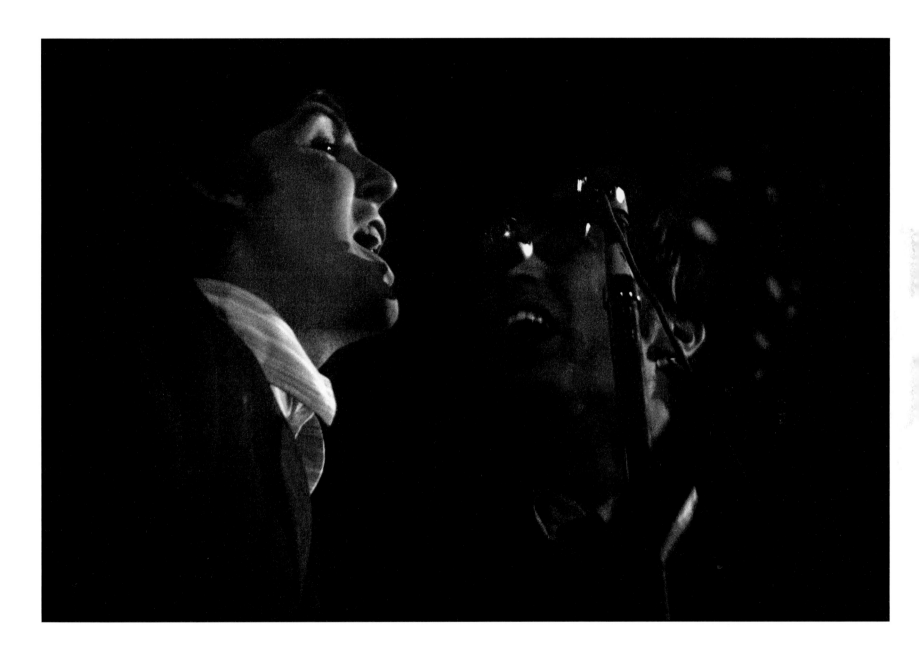

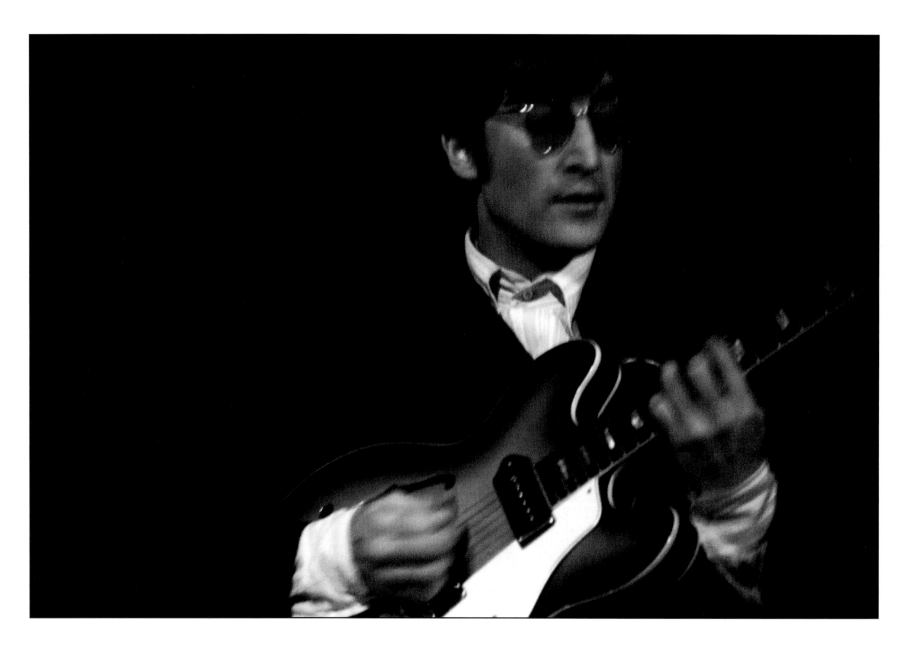

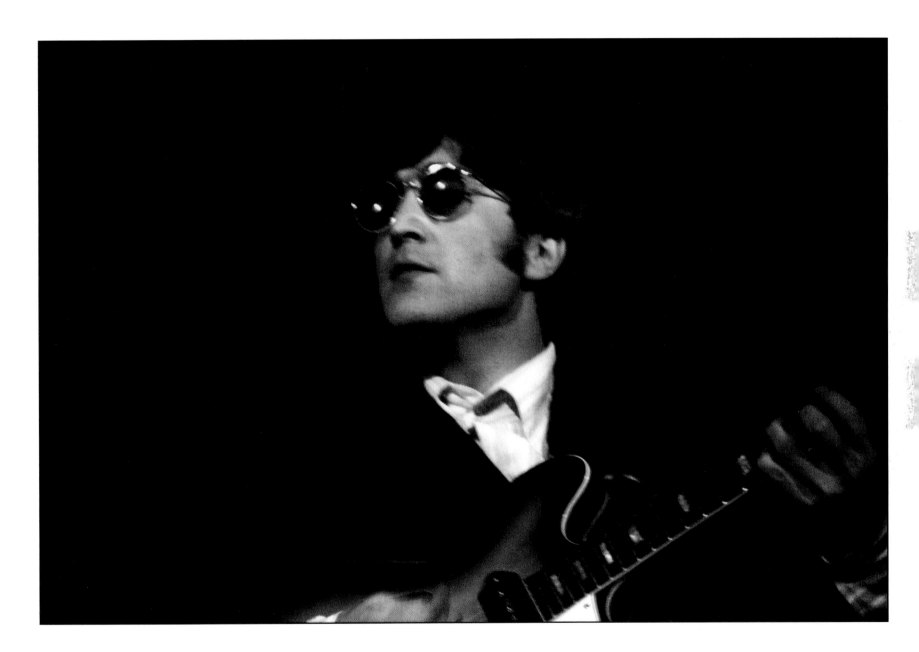

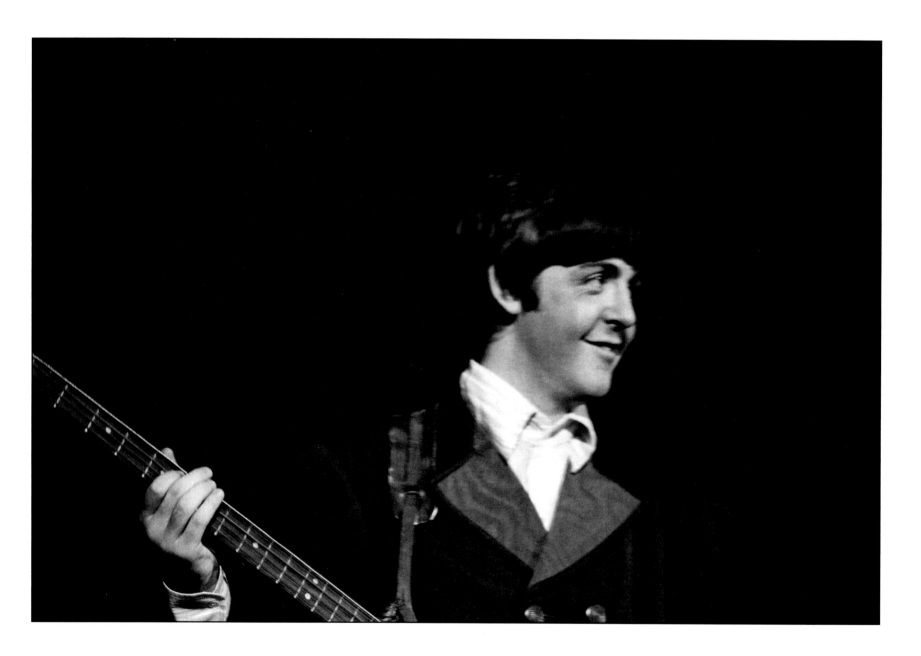

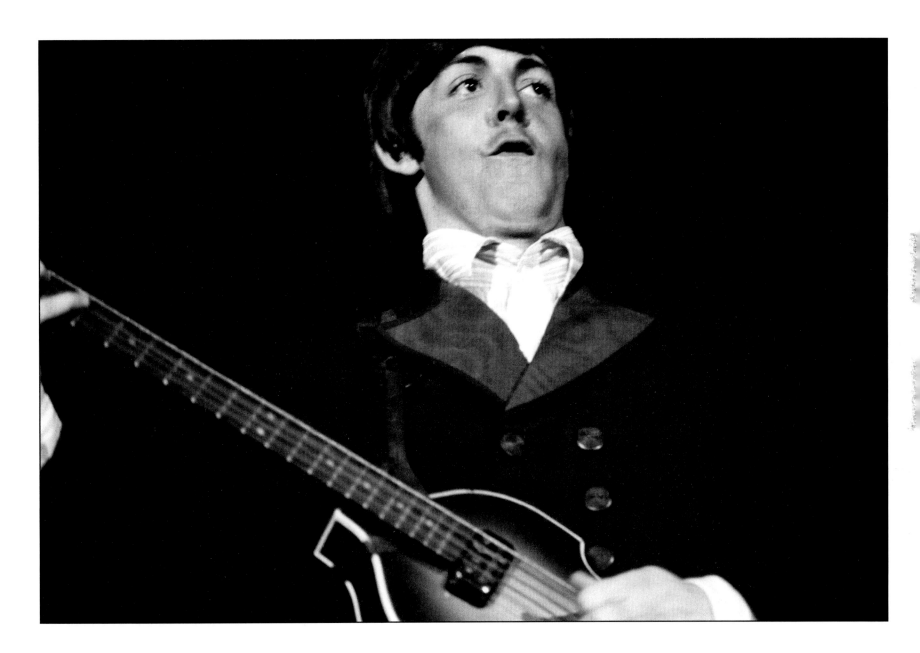

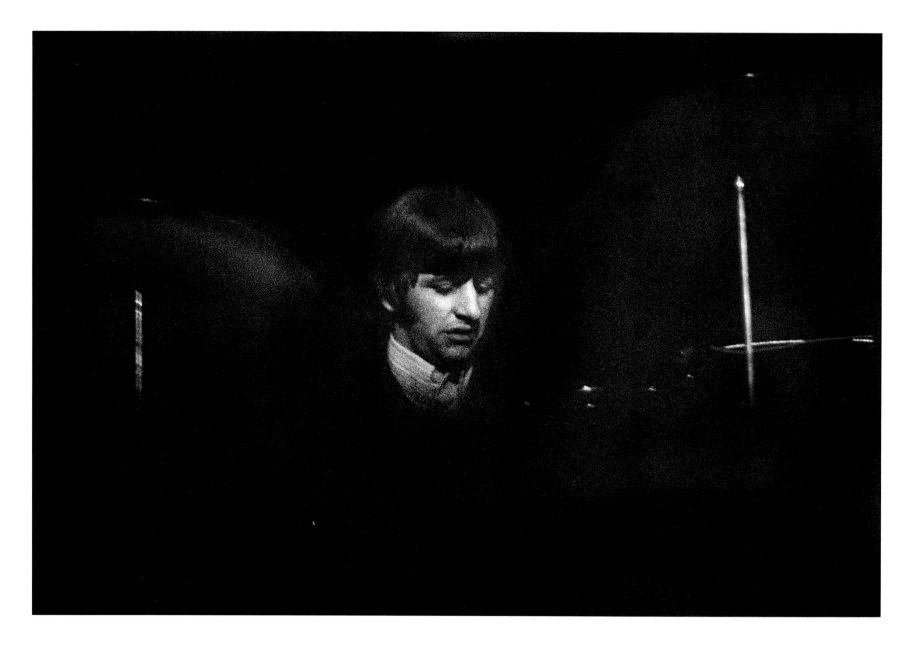

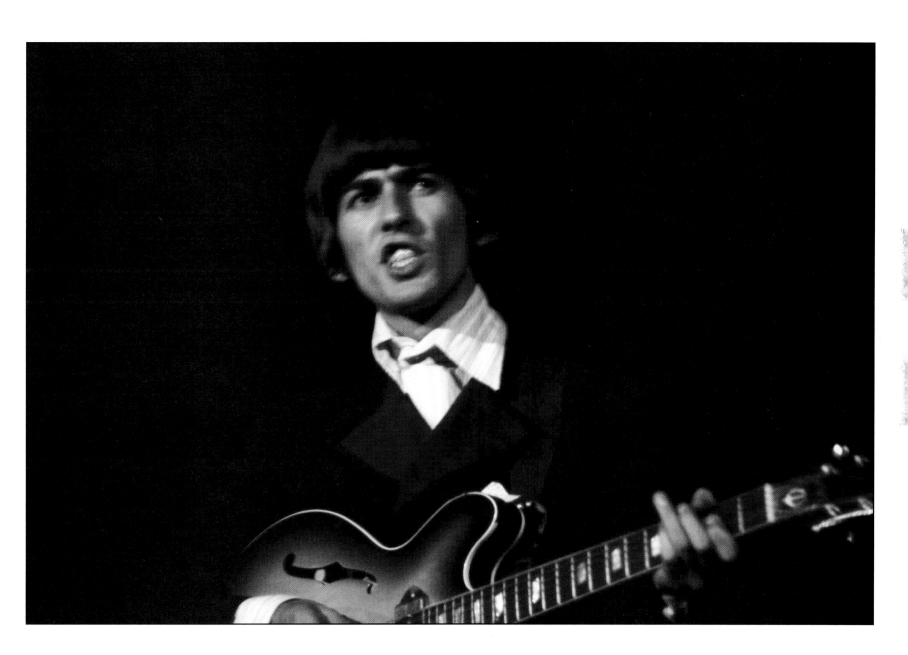

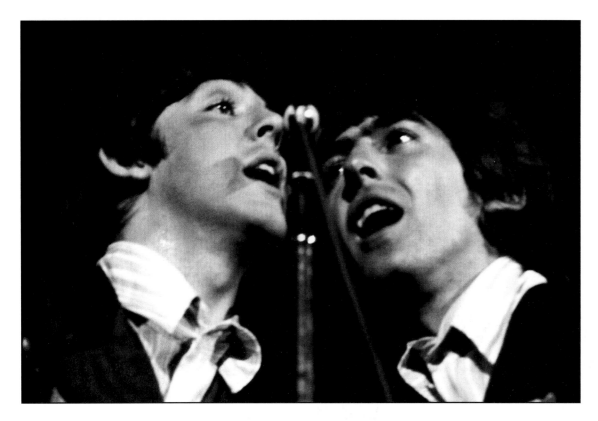
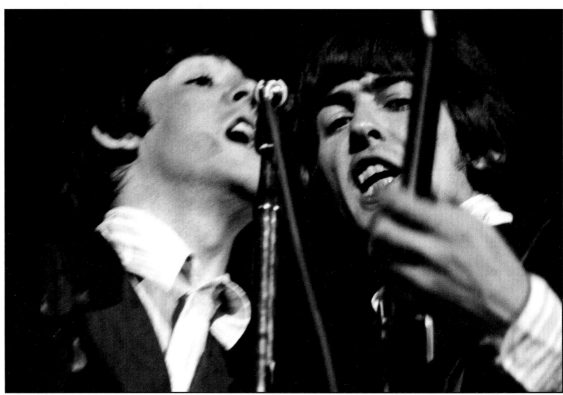

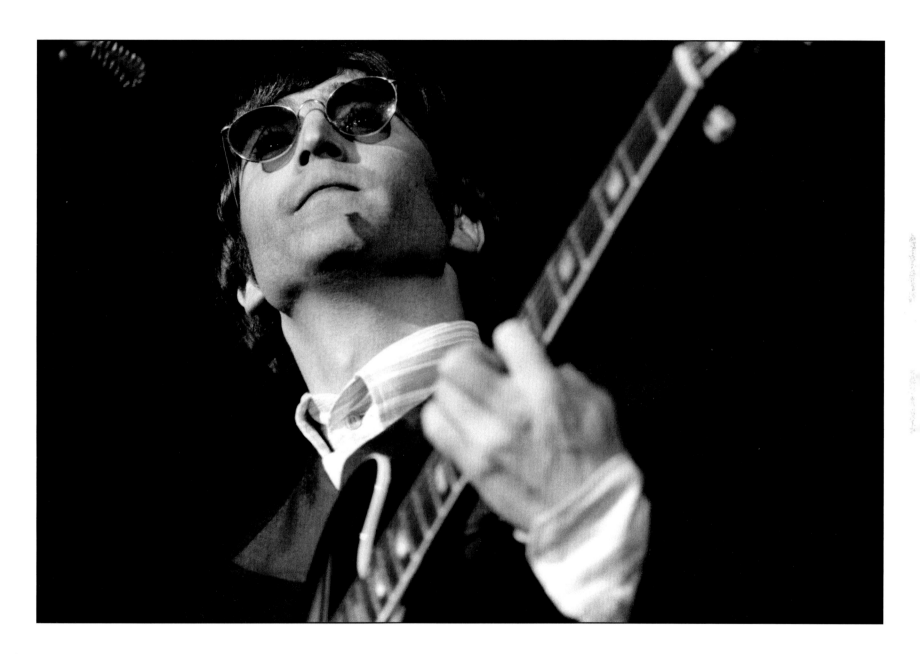

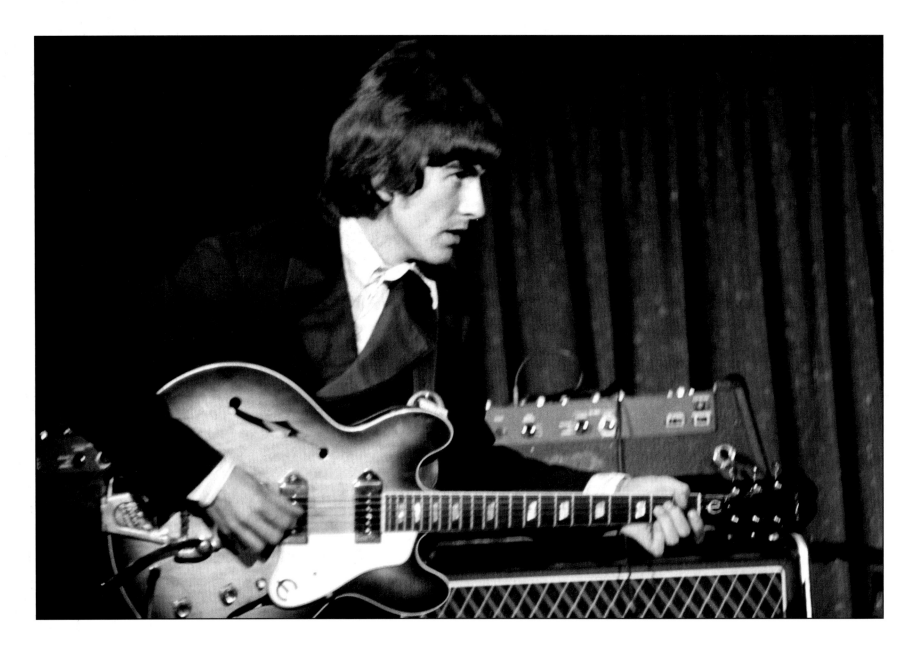

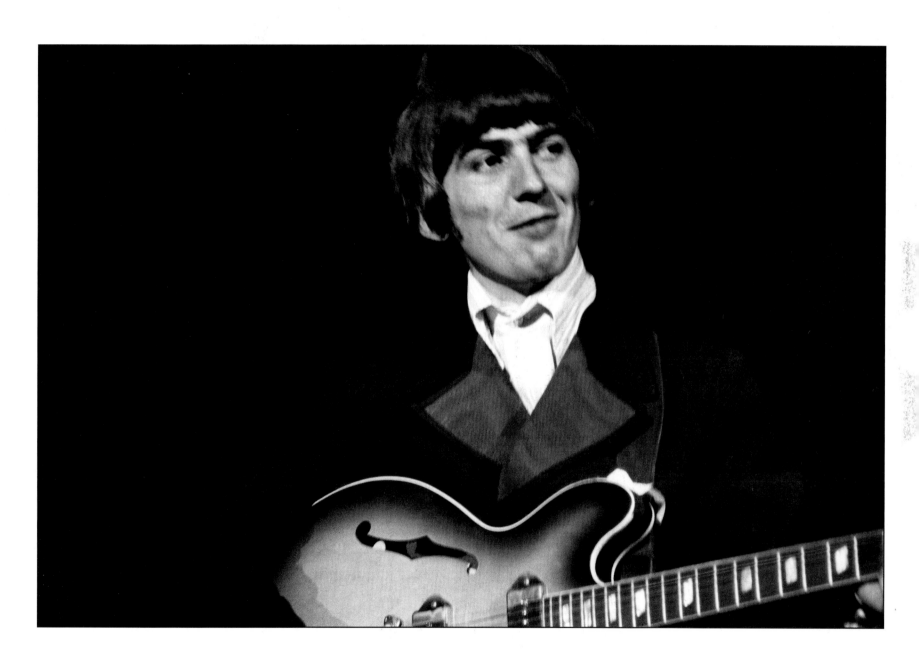

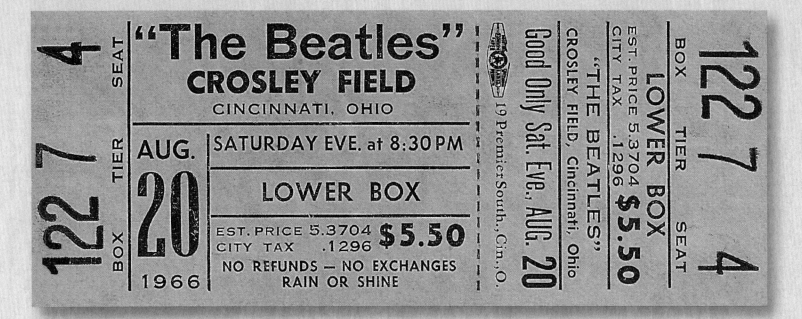

THE BEATLES were scheduled to perform at Crosley Field, an outdoor baseball park in Cincinnati, on Saturday, August 20, 1966. A few minutes before the first opening act took the stage, it started to rain heavily.

While the stage did have a canopy to protect the performers from rain, it failed to do so. There was a real fear that one of The Beatles could be electrocuted when he plugged in his amp, though the local promoter argued with Brian Epstein that he wanted the show to go on, as the seats were filled with fifteen thousand fans. But Paul McCartney was so nervous that he threw up backstage and The Beatles decided that they would refuse to perform. The promoter relented and the concert was postponed.

The Beatles were scheduled to appear at Busch Memorial Stadium in St. Louis the following evening, almost 350 miles away, so they agreed to reschedule Cincinnati for noon on August 21. The fans (albeit three thousand less than the night before) were allowed to use their stubs for admission the next day, and the show came off without any problems.

Black-and-white photographs of this concert surfaced a few years ago, but these are the only color photographs of this show that have come to light.

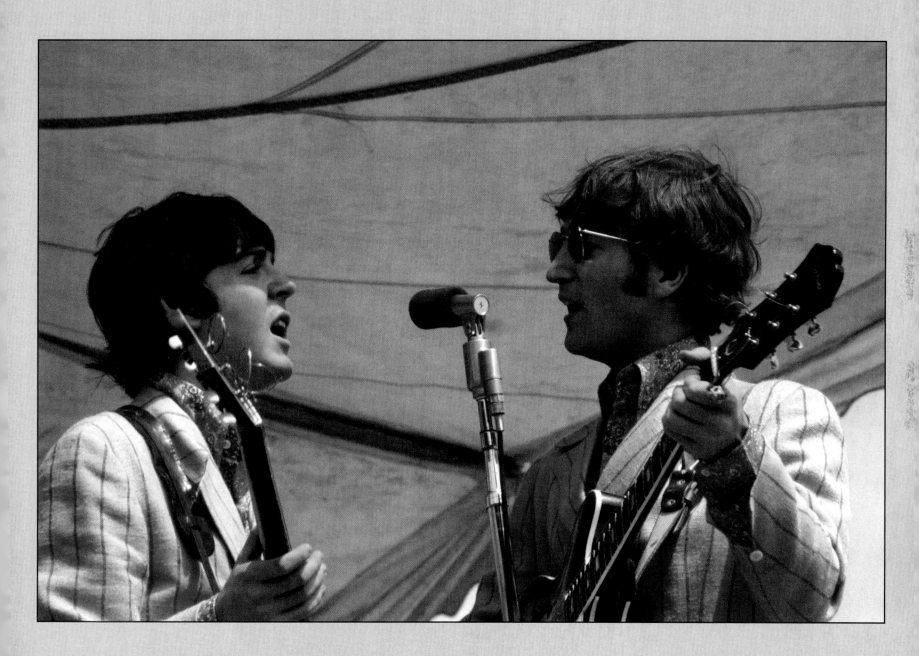

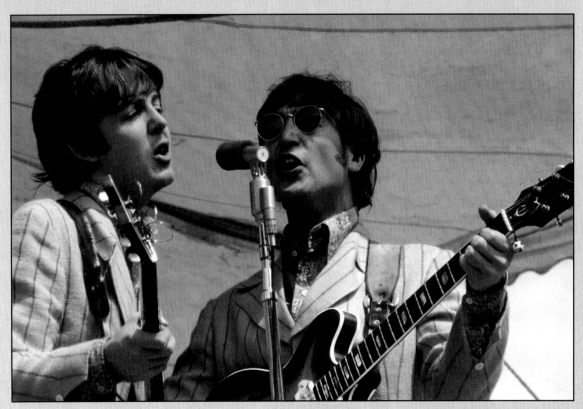
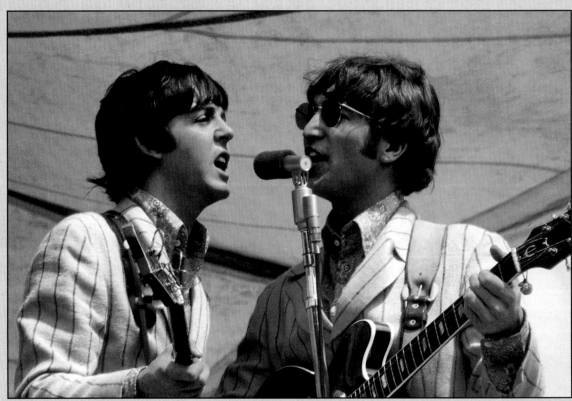

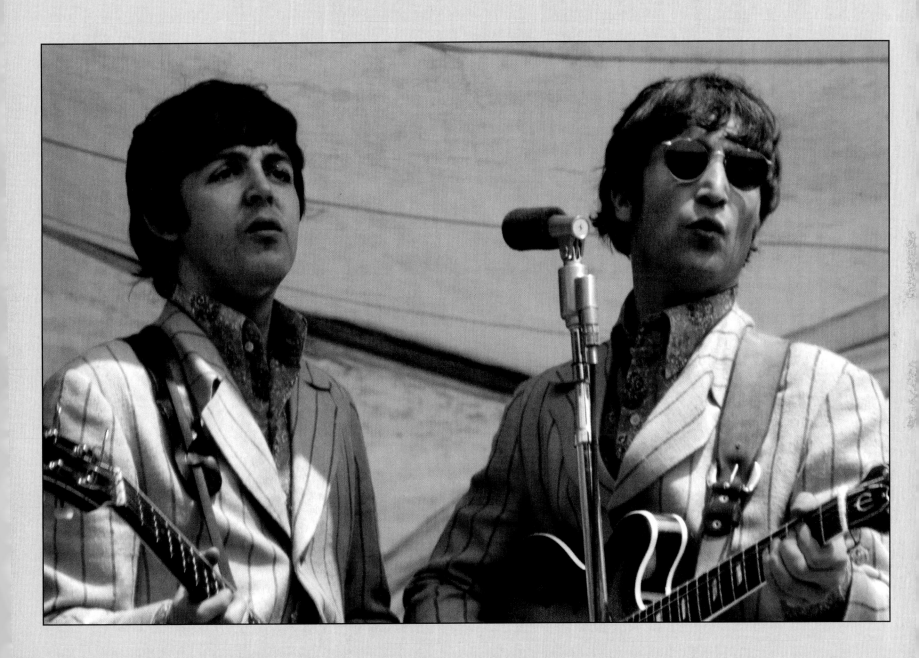

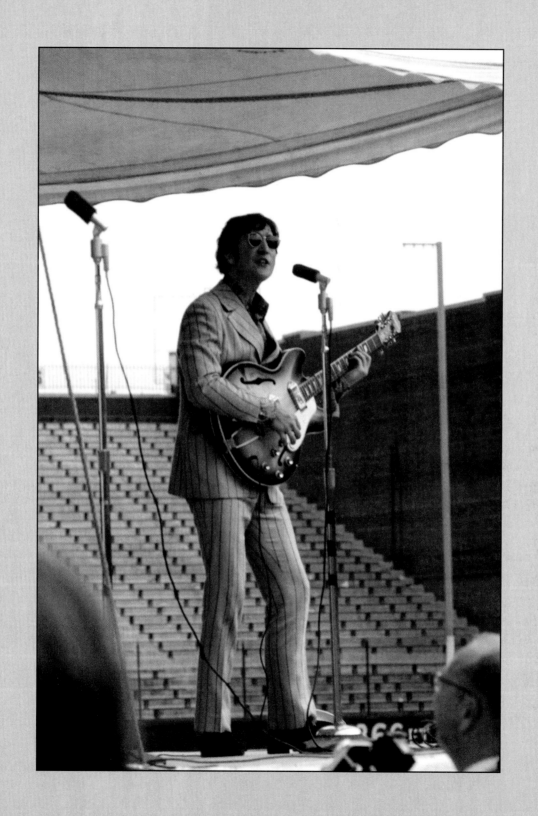

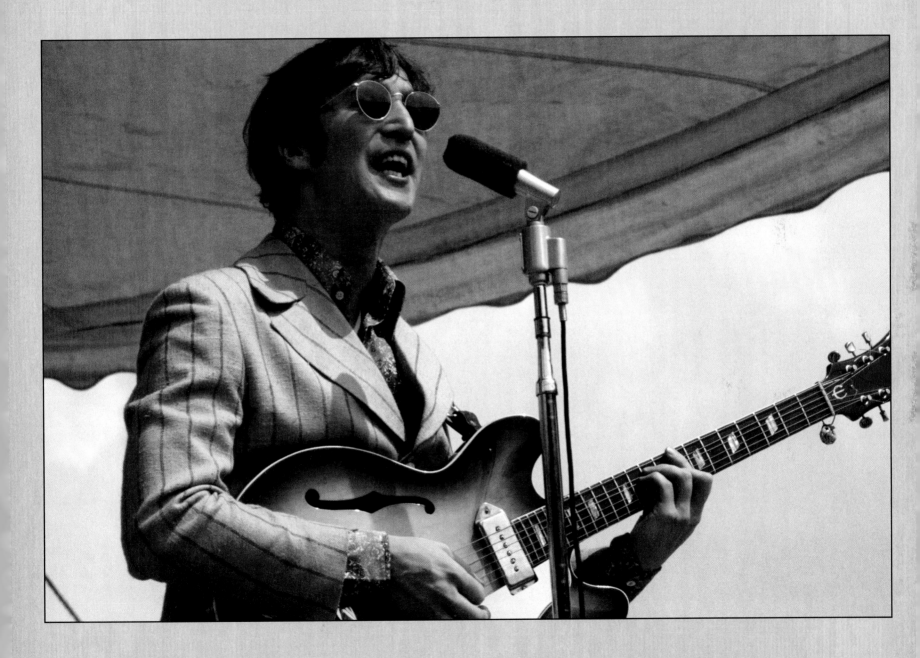

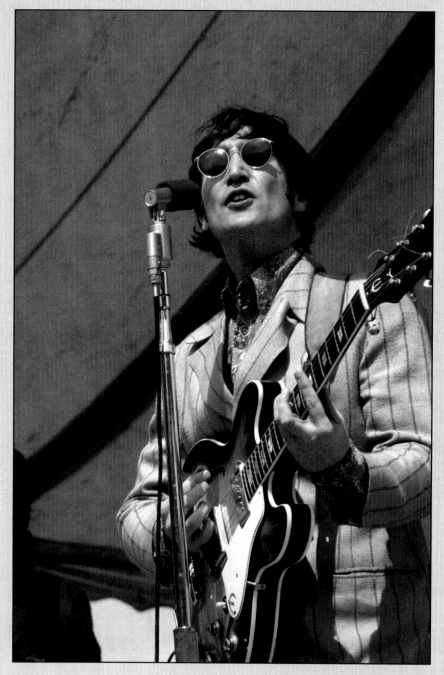
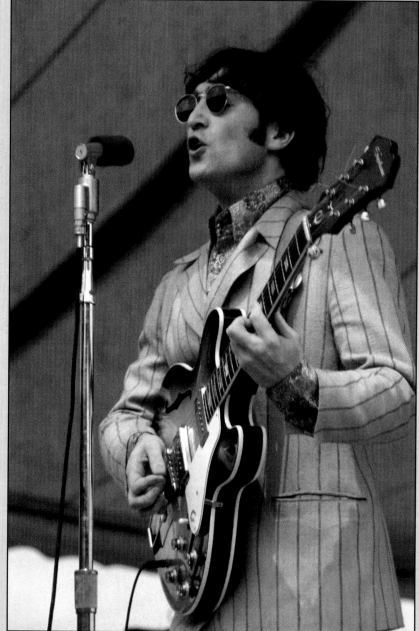

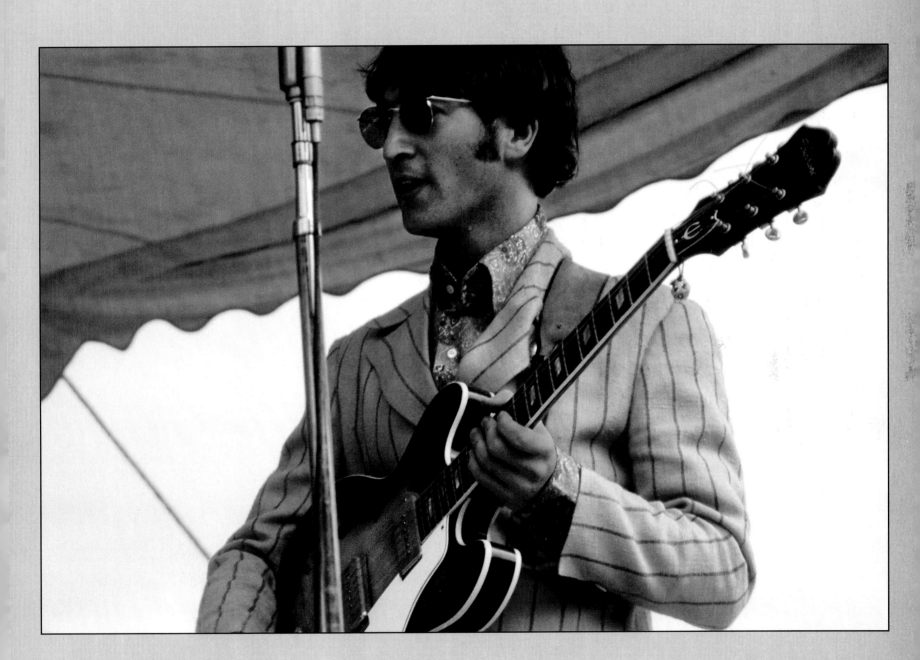

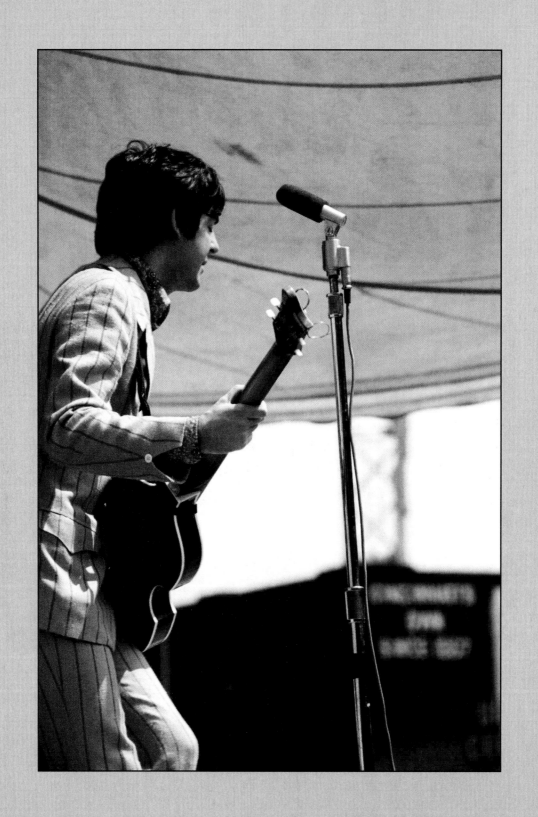

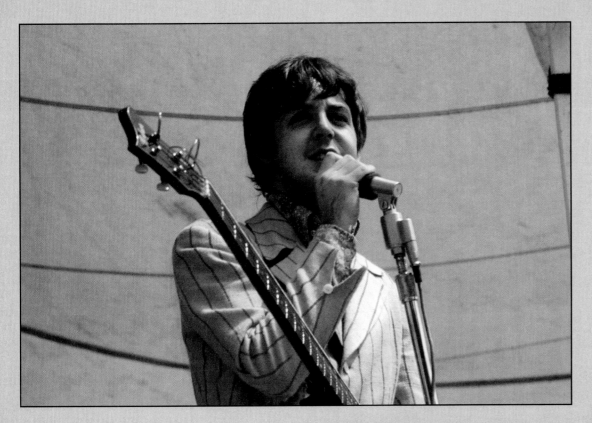
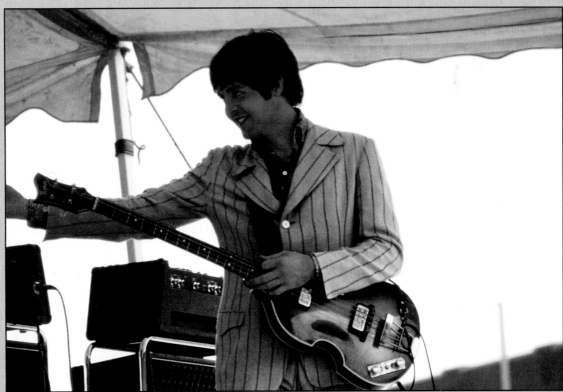

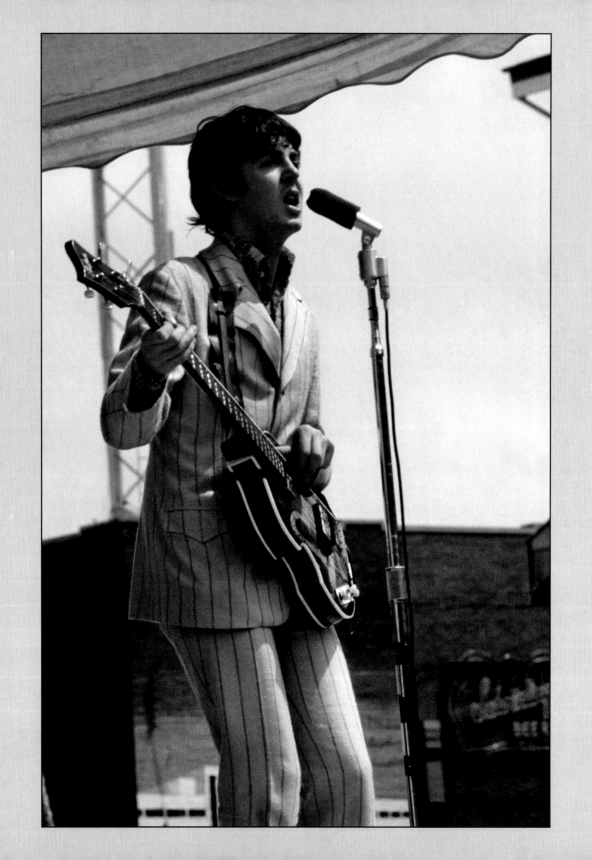

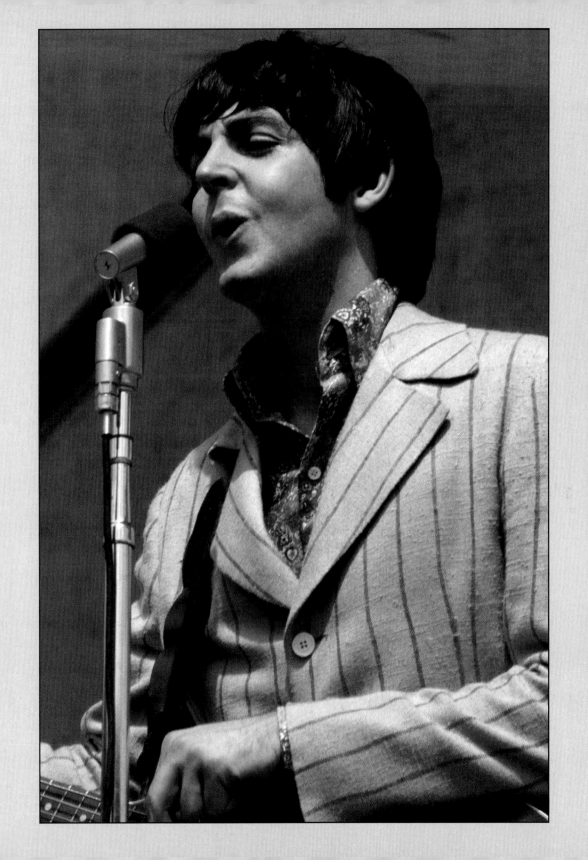

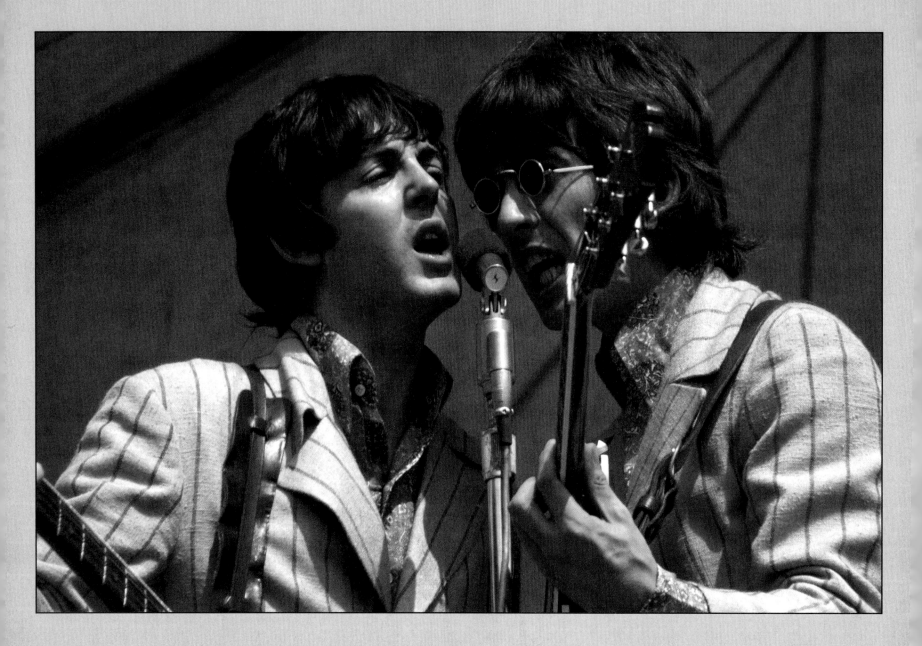

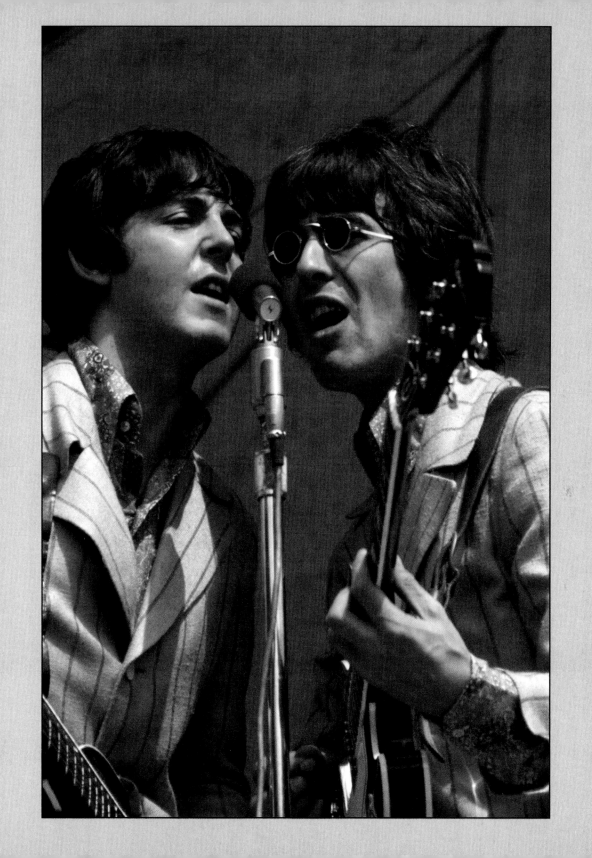

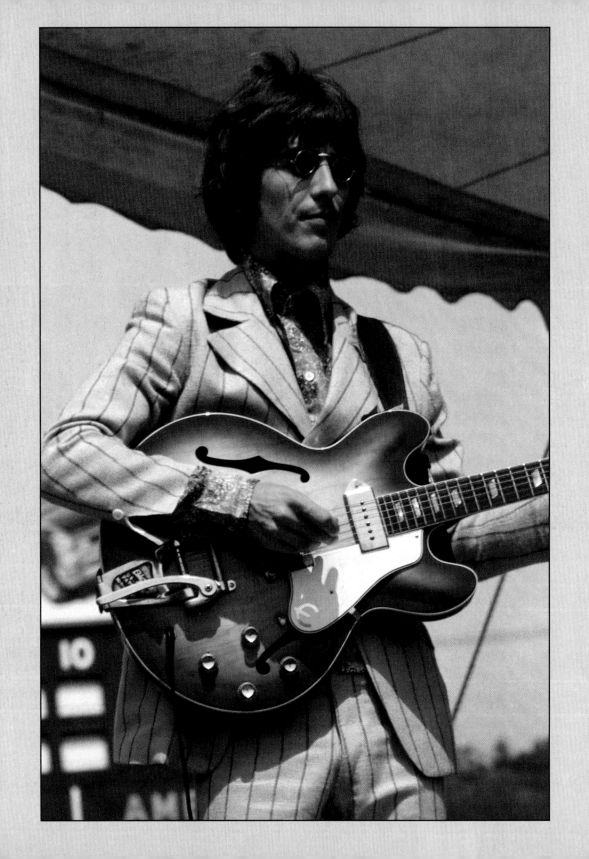

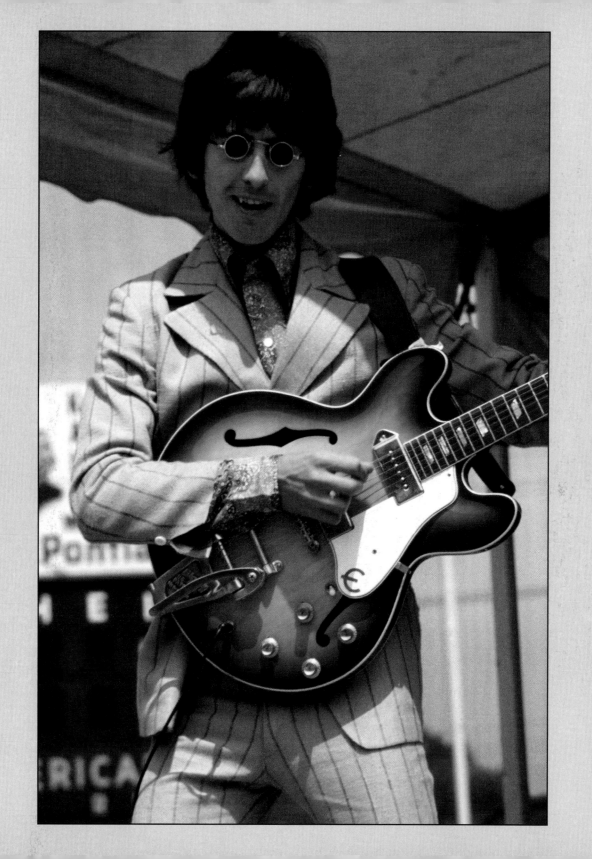

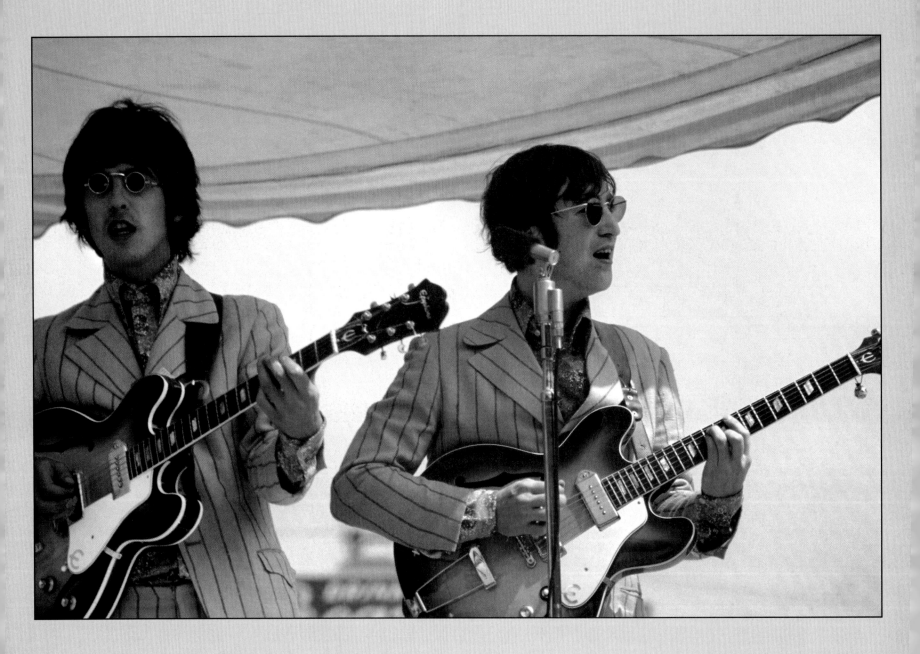

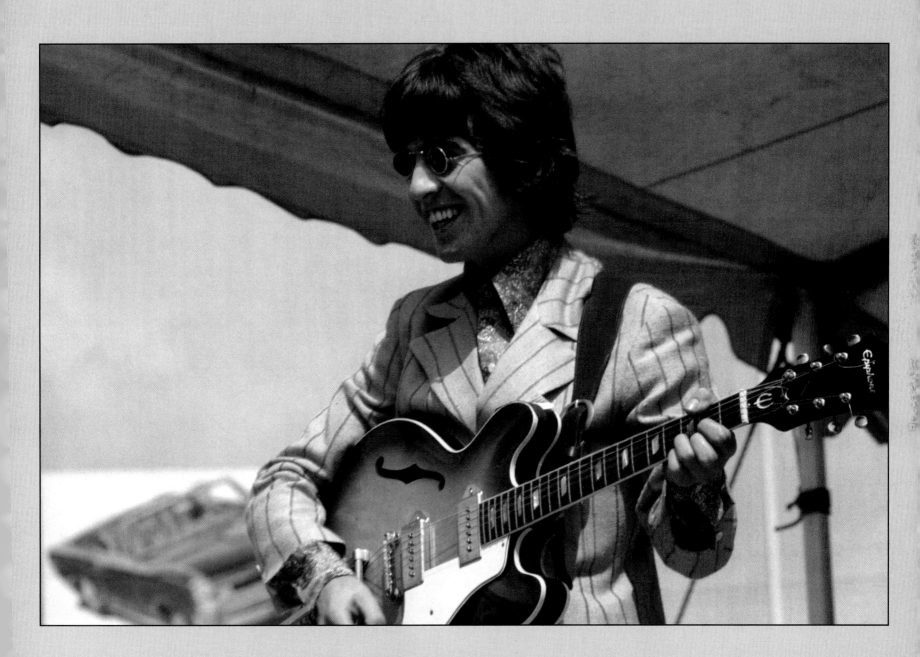

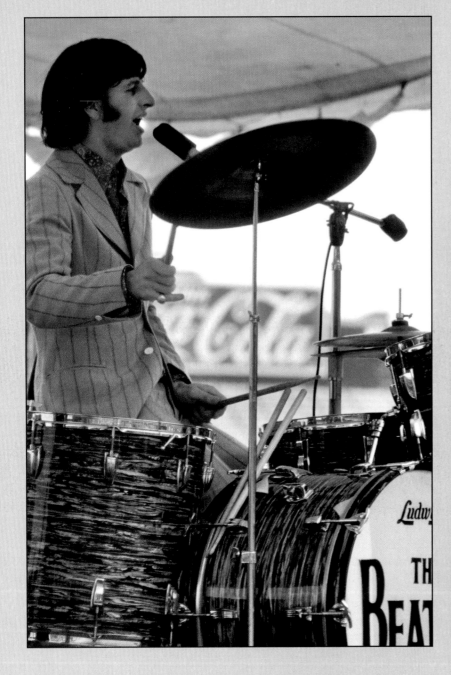
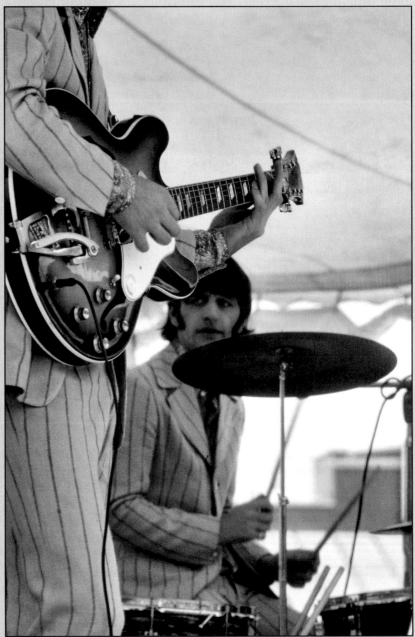

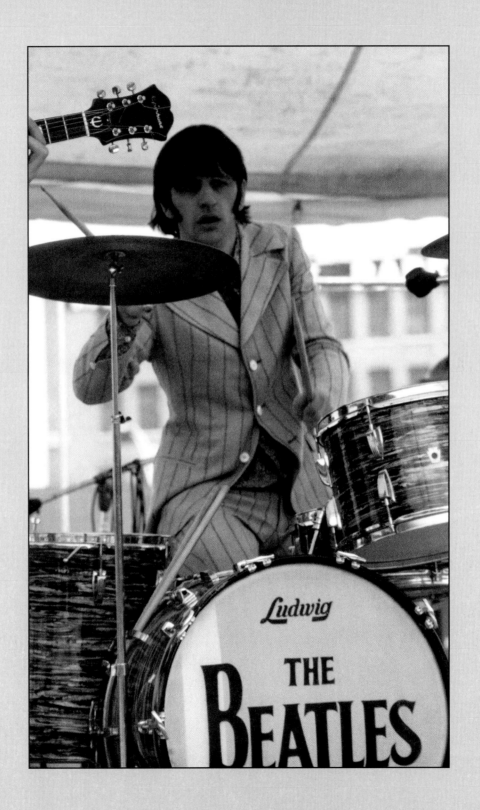

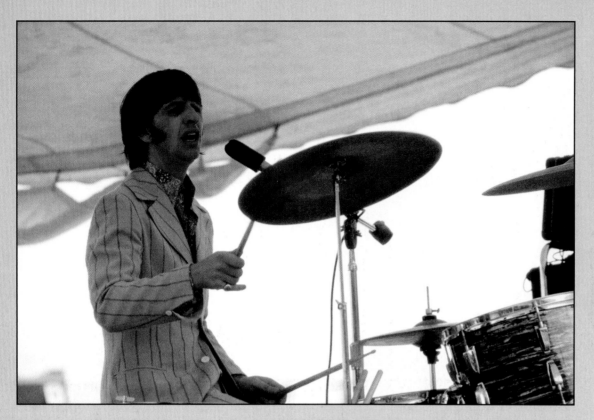
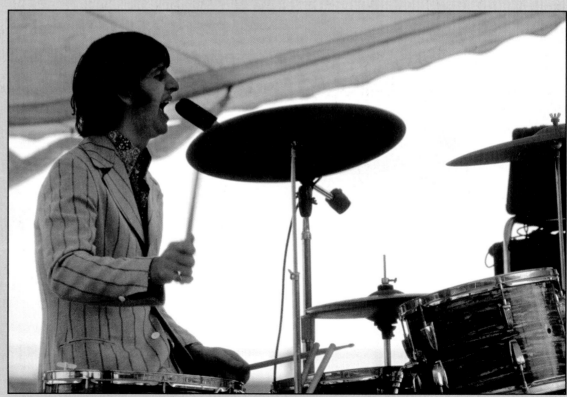

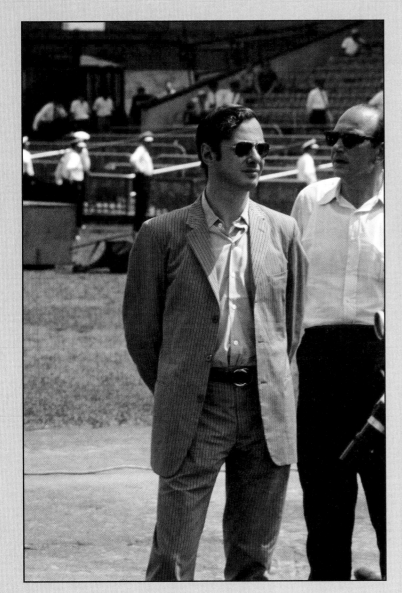

Brian Epstein, The Beatles' manager.

"If anyone was the fifth Beatle,
it was Brian."

—Paul McCartney

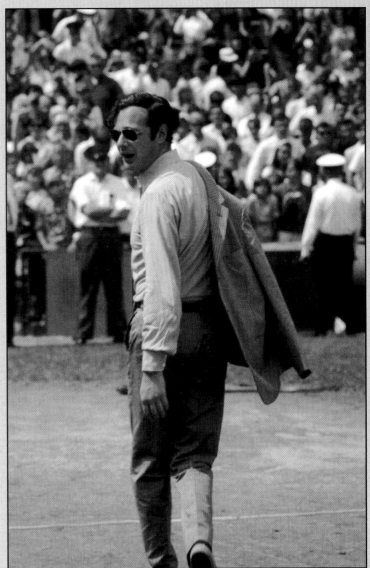

ST. LOUIS, MISSOURI

En Route and in the Dressing Room, Busch Memorial Stadium

AUGUST 21, 1966

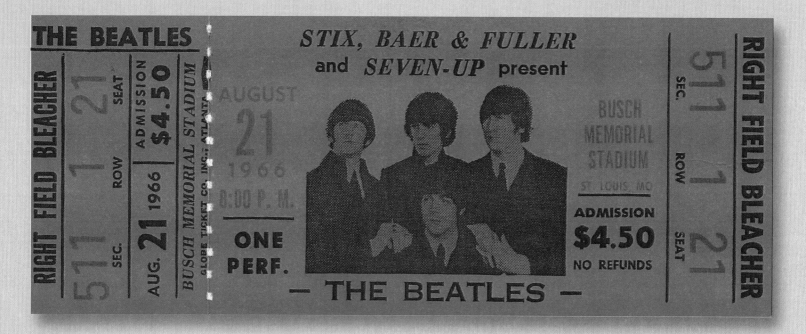

AFTER THE rescheduled afternoon concert at Crosley Field, The Beatles, the other acts, and the entire entourage headed directly to Boone County Airport in Kentucky for a quick flight to St. Louis, Missouri, for the evening concert at Busch Memorial Stadium. It was the only time in all three of The Beatles' U.S. tours that they would play in two different cities on the same day.

These are the last photographs that Bob Bonis shot of The Beatles. After the photos were taken, the band played the concert in St. Louis. The next day they flew to New York and played at Shea Stadium on August 23, followed by Seattle on August 25, Dodger Stadium in Los Angeles on August 28, and then their last-ever offical concert on August 29 at Candlestick Park in San Francisco.

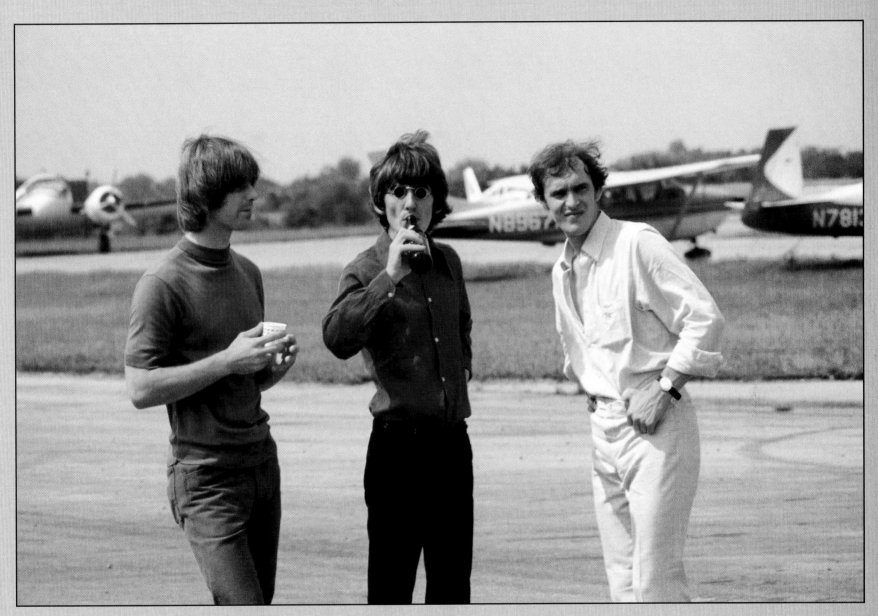

Bill Briggs (of The Remains), George Harrison, and Neil Aspinall grab a drink on the tarmac before boarding their plane to St. Louis.

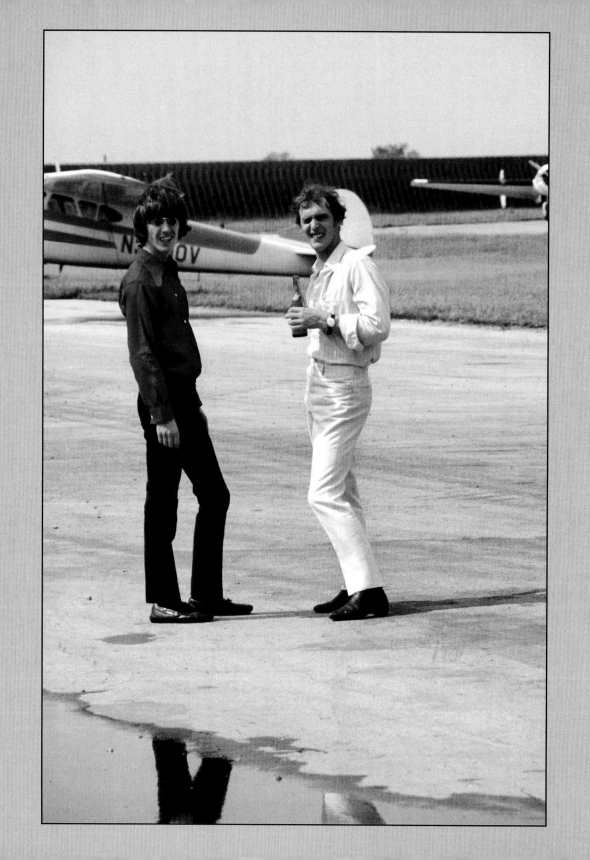

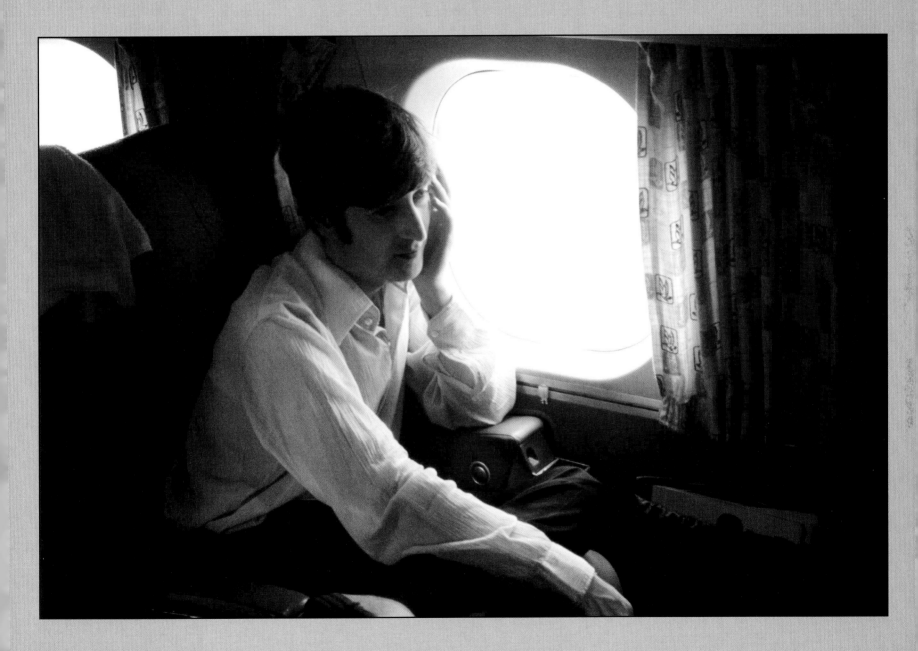

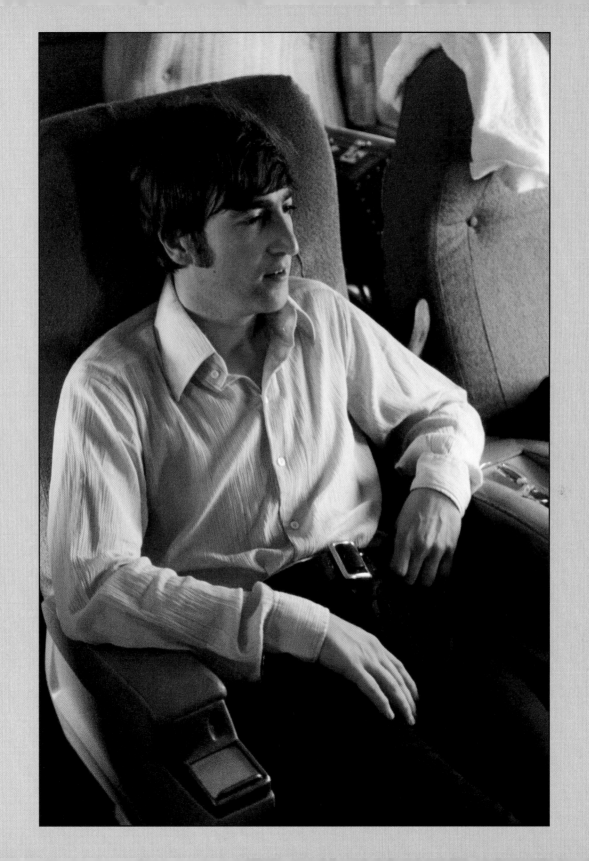

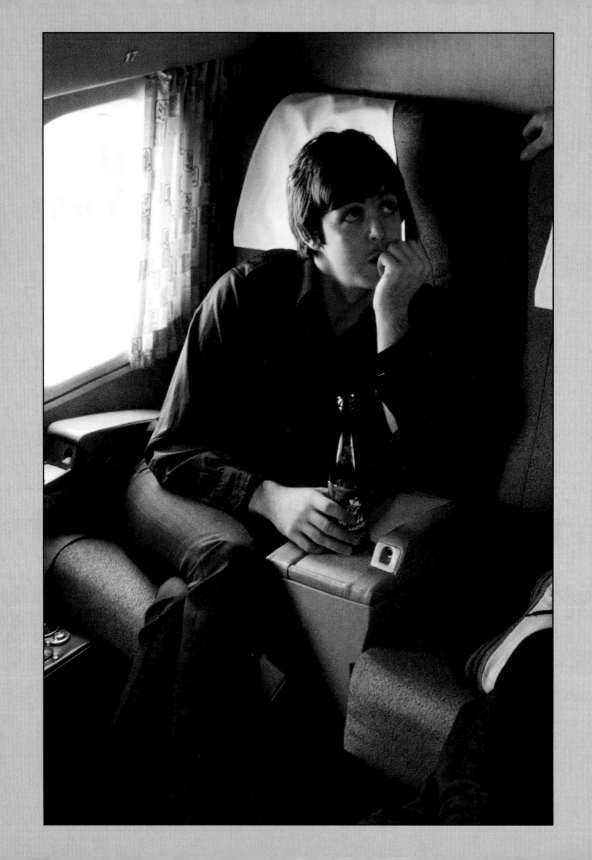

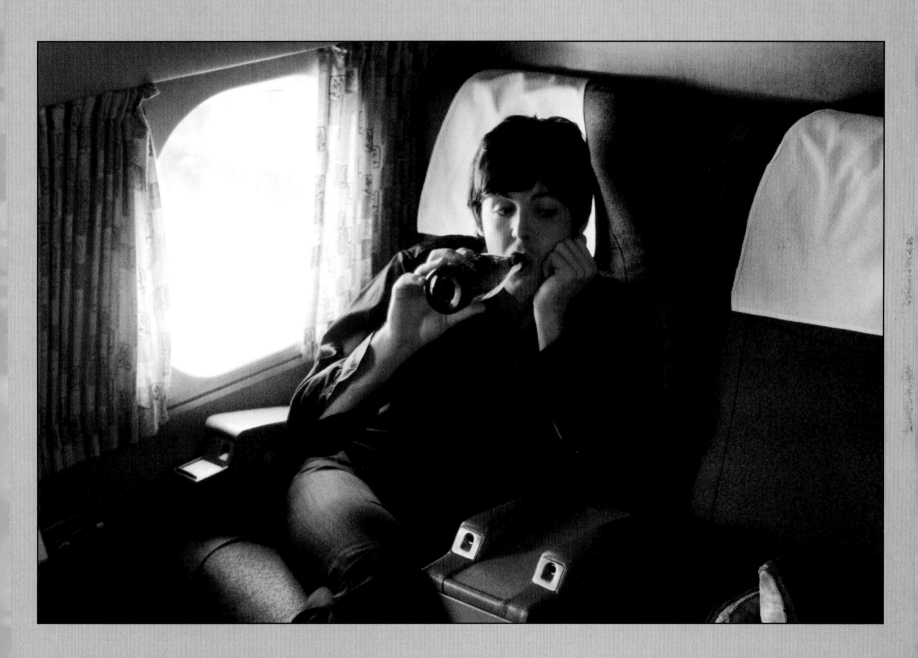

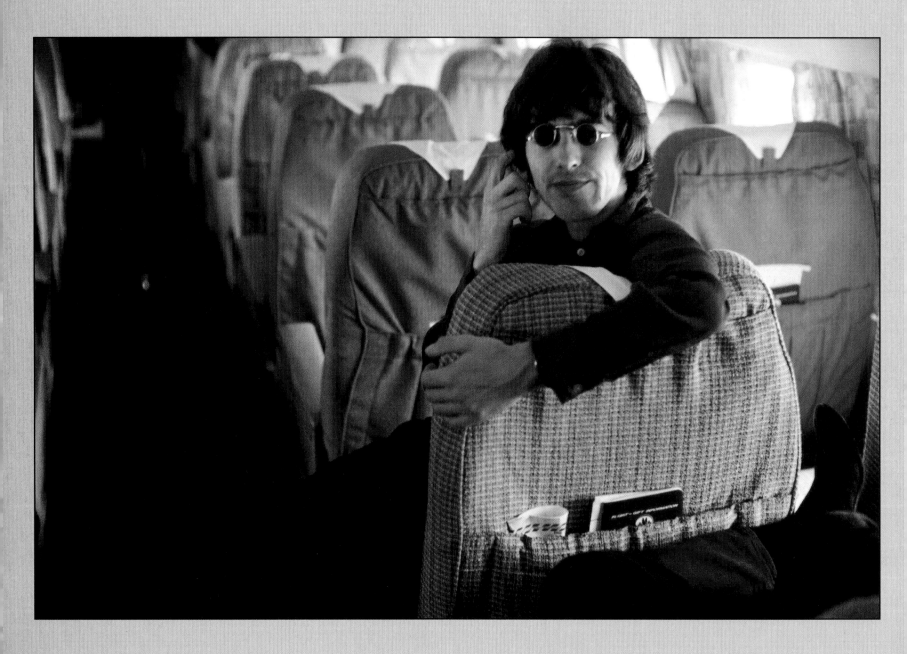

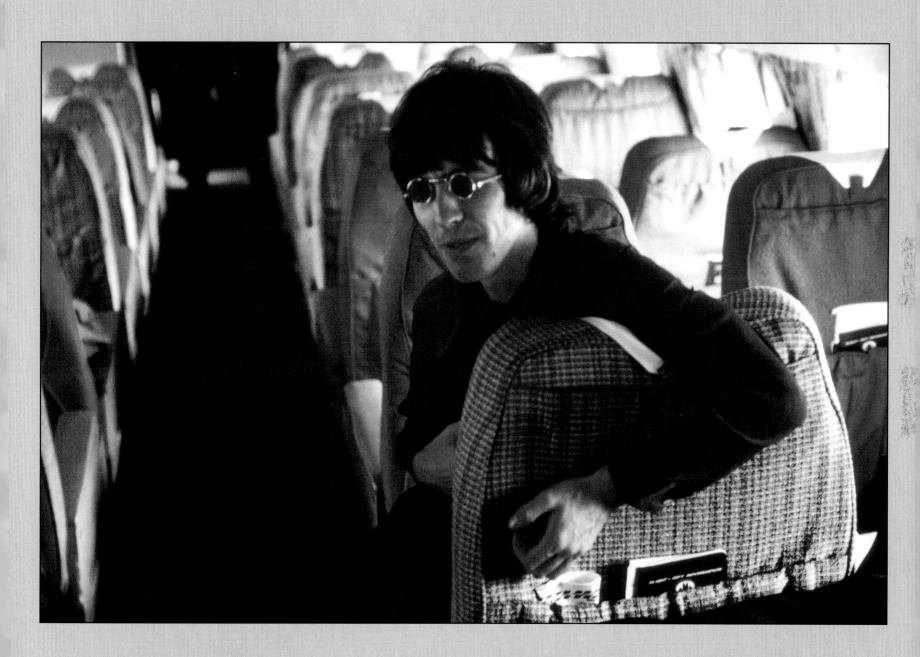

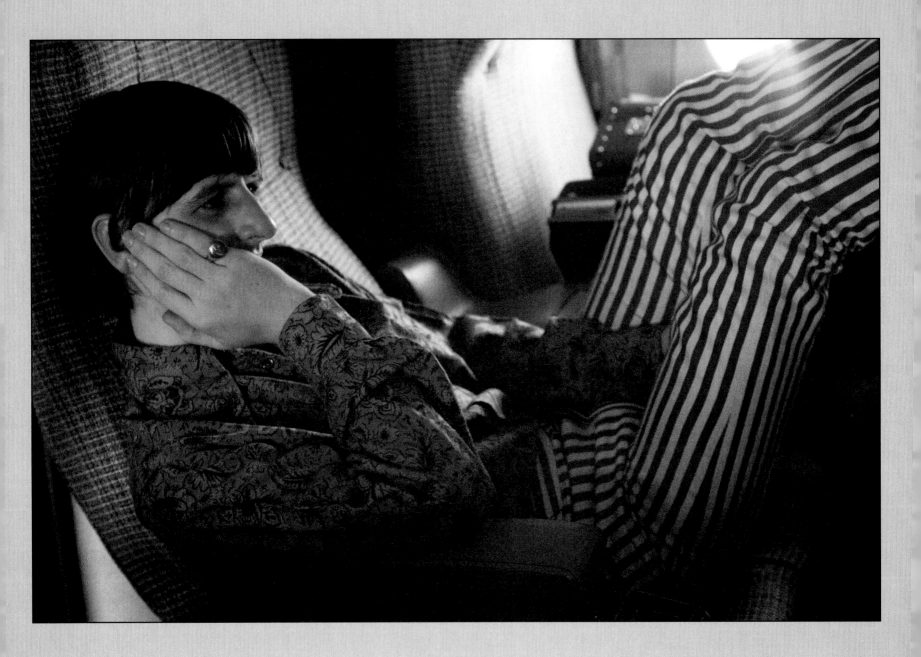

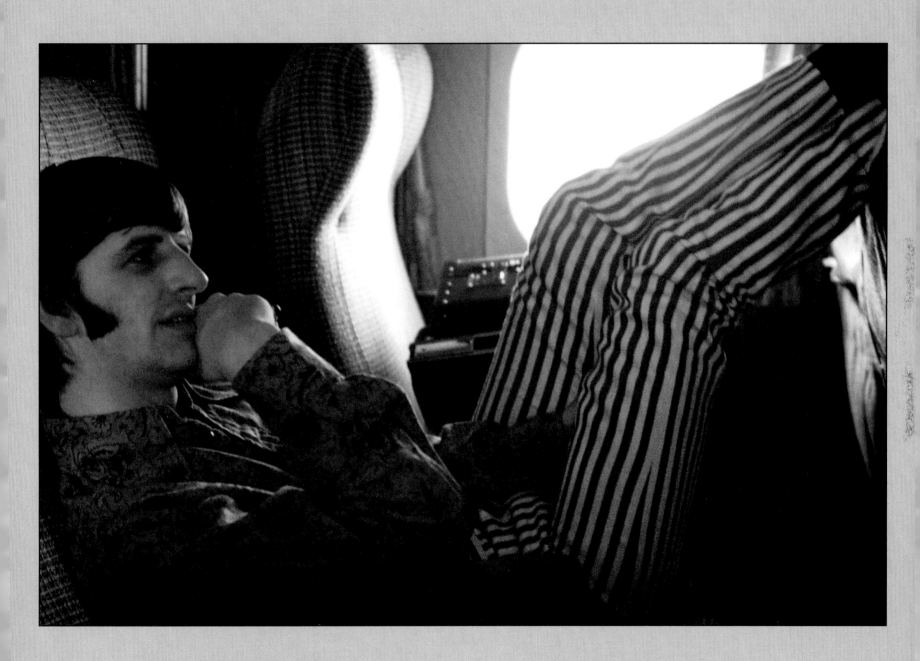

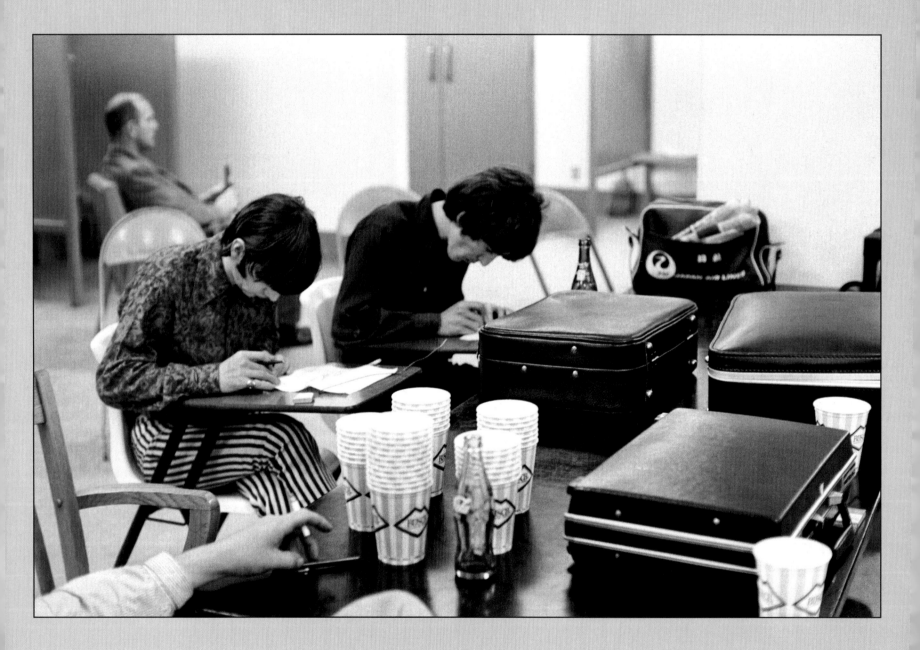

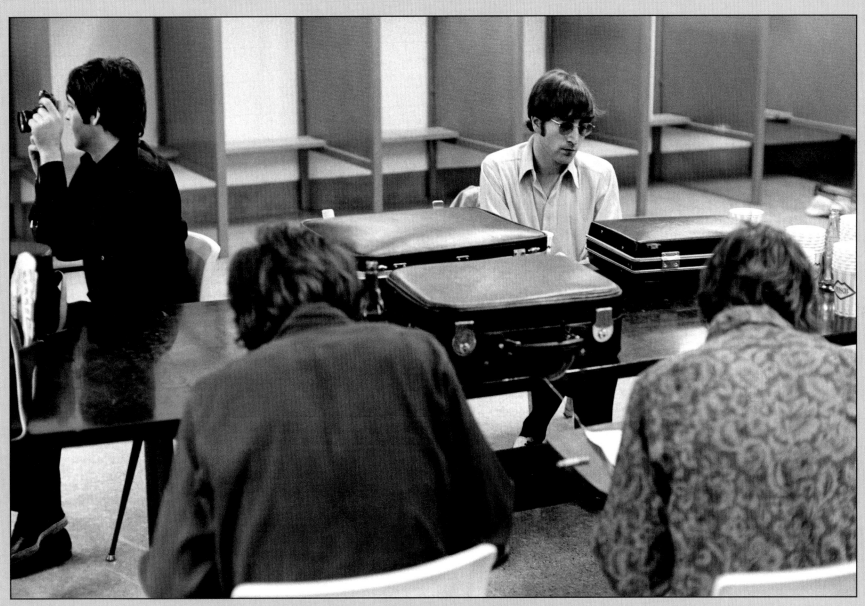

Before the show at Busch Memorial Stadium, The Beatles entertain themselves by replying to fan mail while Paul takes some photographs of his own.

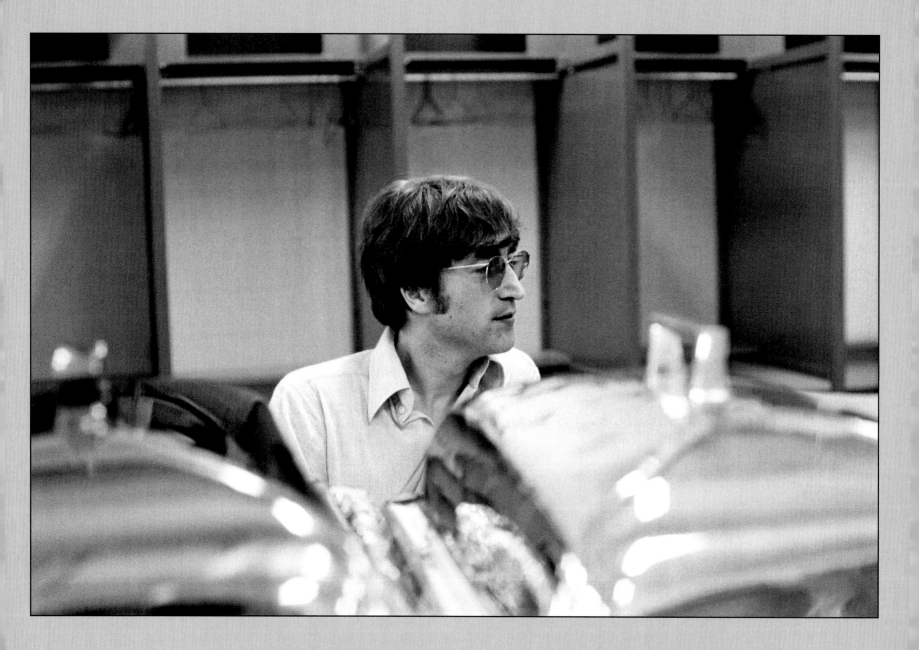

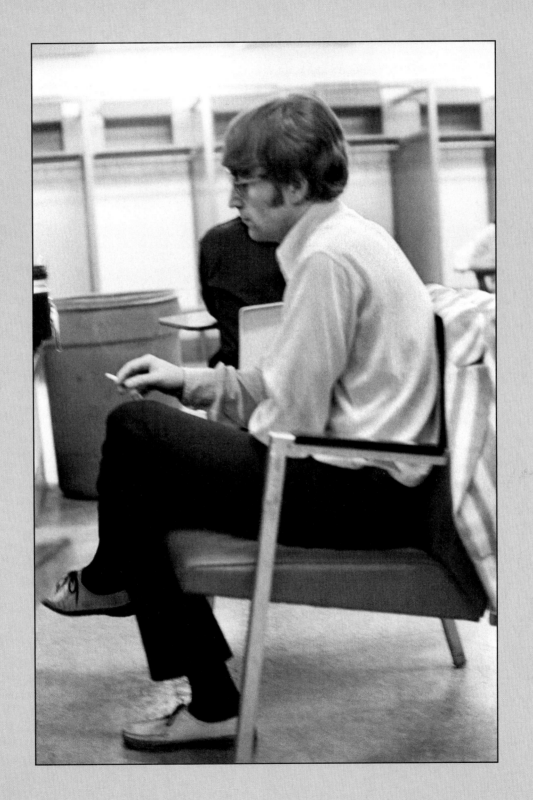

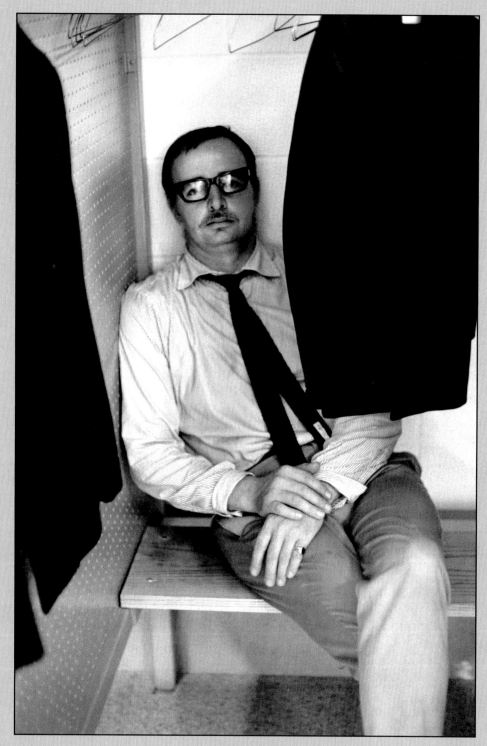

Alf Bicknell, The Beatles' chauffeur,
1964–1966.

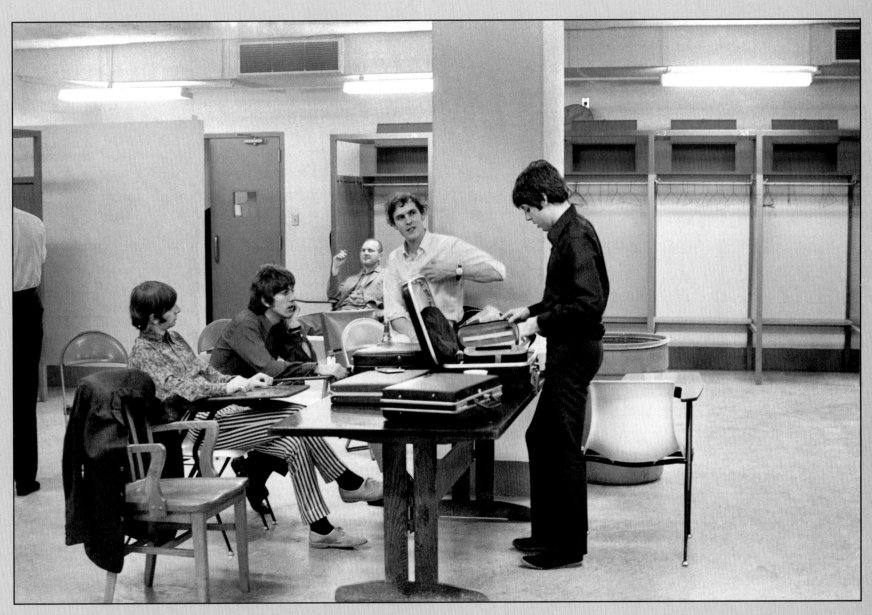

Ringo, George, and Paul with Neil Aspinall.

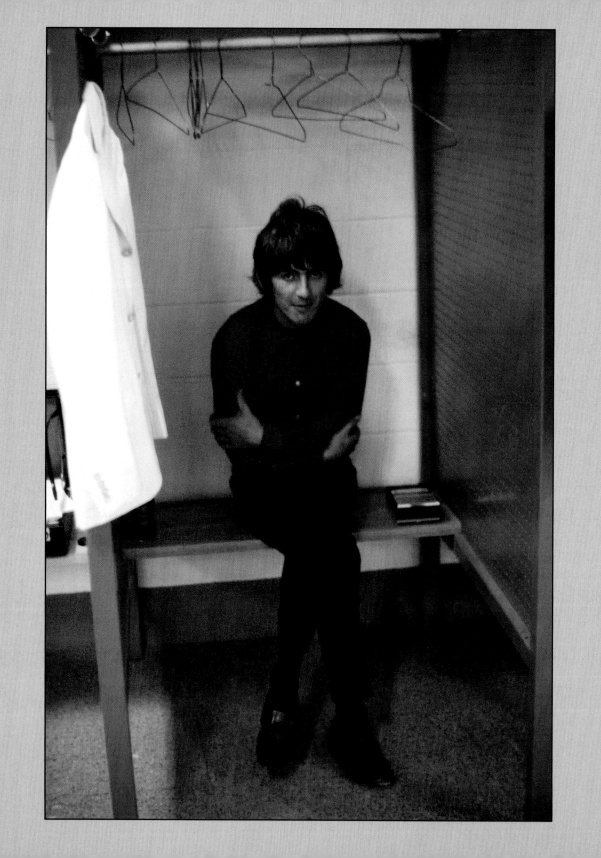

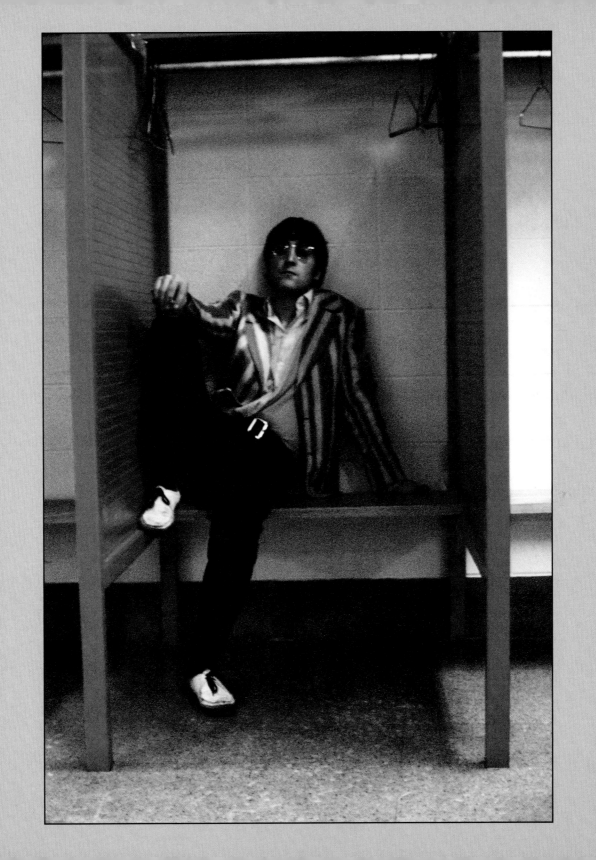

Bob served as U.S. tour manager for The Beatles beginning with their first full U.S. tour in August 1964 and continuing for their U.S./North American tours in 1965 and 1966.

(Note: The Beatles first came to America in February 1964 but not for a full tour. They appeared on *The Ed Sullivan Show* and performed only two concerts, in Washington, D.C., and at Carnegie Hall in New York City. As this was not a full-fledged tour, they did not require the services of a U.S. tour manager.)

First Visit to the United States

February 9	*Ed Sullivan Show,* CBS Television Studios, New York City
February 11	Washington Coliseum, Washington, D.C.
February 12	Carnegie Hall, New York City
February 16	*Ed Sullivan Show,* Deauville Hotel, Miami

First U.S./North American Tour—August–September 1964

August 19	Cow Palace, San Francisco, California
August 20	Convention Hall, Las Vegas, Nevada
August 21	Seattle Coliseum, Seattle, Washington
August 22	Empire Stadium, Vancouver, British Columbia, Canada
August 23	Hollywood Bowl, Los Angeles, California
August 26	Red Rocks Amphitheatre, Denver, Colorado
August 27	The Gardens, Cincinnati, Ohio
August 28	Forest Hills Stadium, Queens, New York
August 29	Forest Hills Stadium, Queens, New York
August 30	Convention Hall, Atlantic City, New Jersey
September 2	Convention Hall, Philadelphia, Pennsylvania
September 3	State Fair Coliseum, Indianapolis, Indiana
September 4	Auditorium, Milwaukee, Wisconsin
September 5	International Amphitheatre, Chicago, Illinois
September 6	Olympia Stadium, Detroit, Michigan
September 7	Maple Leaf Gardens, Toronto, Ontario, Canada
September 8	Forum, Montreal, Quebec, Canada
September 11	Gator Bowl, Jacksonville, Florida
September 12	Boston Gardens, Boston, Massachusetts
September 13	Civic Centre, Baltimore, Maryland
September 14	Civic Arena, Pittsburgh, Pennsylvania

September 15	Public Auditorium, Cleveland, Ohio
September 16	City Park Stadium, New Orleans, Lousiana
September 17	Municipal Stadium, Kansas City, Missouri
September 18	Memorial Coliseum, Dallas, Texas
September 20	Paramount Theatre, New York, New York

Second U.S./North American Tour—August 1965

August 15	Shea Stadium, Queens, New York
August 17	Maple Leaf Gardens, Toronto, Ontario, Canada
August 18	Atlanta Stadium, Atlanta, Georgia
August 19	Sam Houston Coliseum, Houston, Texas
August 20	White Sox Park, Chicago, Illinois
August 21	Metropolitan Stadium, Minneapolis, Minnesota
August 22	Memorial Coliseum, Portland, Oregon
August 28	Balboa Stadium, San Diego, California
August 29	Hollywood Bowl, Los Angeles, California
August 30	Hollywood Bowl, Los Angeles, California
August 31	Cow Palace, San Francisco, California

Third U.S./North American Tour—August 1966

August 12	International Amphitheatre, Chicago, Illinois
August 13	Olympia Stadium, Detroit, Michigan
August 14	Municipal Stadium, Cleveland, Ohio
August 15	Washington Stadium, Washington, D.C.
August 16	Philadelphia Stadium, Philadelphia, Pennsylvania
August 17	Maple Leaf Gardens, Toronto, Ontario, Canada
August 18	Suffolk Downs Racecourse, Boston, Massachusetts
August 19	Mid-South Coliseum, Memphis, Tennessee
August 21	Crosley Field, Cincinnati, Ohio
August 21	Busch Stadium, St. Louis, Missouri
August 23	Shea Stadium, Queens, New York
August 25	Seattle Coliseum, Seattle, Washington
August 28	Dodger Stadium, Los Angeles, California
August 30	Candlestick Park, San Francisco, California—The last concert of The Beatles

ACKNOWLEDGMENTS

Prints of the photographs are available at www.NFAgallery.com.

Many thanks and appreciations are extended to those who have made this book possible, and who have been instrumental in preserving the Bob Bonis Archive for all to enjoy.

Thanks, first and foremost, go to Alex Bonis for preserving the extraordinary photographs taken by his father and for allowing me the privilege of working with him to bring them to the public's attention. It is my sincere hope that this book properly honors his father's legacy. Without Alex's help and cooperation none of this would have been possible.

Alex thanks Josie Wilson, Cayenne, and Wade.

Additionally we thank the following people, without whom the Bob Bonis Archive; 2269 Productions, Inc.; and Not Fade Away Gallery would not exist today: Martin Marion; Lawrence Wolfe; David Filler, Esq.; Tom Hansen; John and Jordan DiPrato.

Without the following people's help and guidance this book would not have been possible:

Mauro DiPreta, Jennifer Schulkind, Lorie Pagnozzi, Paula Szafranski, and Jeremy Cesarec at HarperCollins; Frank Weimann and Elyse Tranzillo (my agent and his assistant) at the Literary Group International; Russ Lease of BeatleSuits.com for his invaluable research assistance; Andy Babiuk, author of the book *Beatles Gear: All the Fab Four's Instruments, from Stage to Studio,* for his extraordinary knowledge of The Beatles' gear; Chuck and Paul Gunderson and Beatletix.com for permission to use photographs of tickets and memorabilia from their amazing collection; Mike McGear of RareBeatles.com for permission to use photographs of his memorabilia; and Cliff Yamasaki, Larry Kane, Bob Pratt, Bruce Colebank, Tom and James Liverani, and especially Alison Graham for her assistance with the graphic design, editing, and work to restore and preserve the photographs.

For their help with creating the Bob Bonis Archive and Not Fade Away Gallery, and with the exhibition The British Are Coming: The Beatles and The Rolling Stones, thanks are due to: Andrew D. Epstein, Esq., for his legal advice; Bob Kapoor, Duggal Visual Solutions, and Jim Braden for their skill and talent in producing the prints for Not Fade Away Gallery and the Bob Bonis Archive; New Yorker Picture Frames for their excellent work framing the photos for exhibition; Christian Bies for hanging the show; Ron Higgins and Cogneato for creating and maintaining our Web site (NotFadeAwayGallery.com); Alexandra and Theodora Richards for hosting our opening night party; Susan Blond, Carol Strauss Klenfner, Eric Wielander, and Alison Daulerio, publicists extraordinaire, for guiding us and for their help launching the show.

We also owe a debt of gratitude to: Jodi Okun, Michael Alfano, Gianluca Rizza, Rocco Pietrafesa, Stanley B. Burns, M.D., Steeve Henry, Margie Beck, Patrick McMullan, Shoshana Frishberg, and Marc and Deb Zakarin.

Larry dedicates this book to Marcie Frishberg, without whose support, advice, and love this book would not have been completed and as beautiful as it turned out, and to my parents, Flora and Norman Marion, who would be so proud of me. Thank you!